ISBN 978-1-330-62183-7
PIBN 10083644

This book is a reproduction of an important historical work. Forgotten Books uses state-of-the-art technology to digitally reconstruct the work, preserving the original format whilst repairing imperfections present in the aged copy. In rare cases, an imperfection in the original, such as a blemish or missing page, may be replicated in our edition. We do, however, repair the vast majority of imperfections successfully; any imperfections that remain are intentionally left to preserve the state of such historical works.

English
Français
Deutsche
Italiano
Español
Português

www.forgottenbooks.com

Mythology Photography **Fiction**
Fishing Christianity **Art** Cooking
Essays Buddhism Freemasonry
Medicine **Biology** Music **Ancient**
Egypt Evolution Carpentry Physics
Dance Geology **Mathematics** Fitness
Shakespeare **Folklore** Yoga Marketing
Confidence Immortality Biographies
Poetry **Psychology** Witchcraft
Electronics Chemistry History **Law**
Accounting **Philosophy** Anthropology
Alchemy Drama Quantum Mechanics
Atheism Sexual Health **Ancient History**
Entrepreneurship Languages Sport
Paleontology Needlework Islam
Metaphysics Investment Archaeology
Parenting Statistics Criminology
Motivational

Modigliani:

Man and Myth

by Jeanne Modigliani

Translated from the Italian by
Esther Rowland Clifford

with 153 illustrations, 16 in full color

The Orion Press / New York

Distributed by Crown Publishers, Inc.

Contents

List

List of Illustrations

List of Plates

(Following the text)

22. Standing Nude, 1908. (28 3/4 x 20") Dr. Paul Alexandre Collection, Paris.
23. The Cellist, 1909. (51 1/4 x 31 1/2") Dr. Paul Alexandre Collection, Paris.
24. Egyptian Bust, 1909. Private Collection, Paris.
25. Portrait of Maurice Drouard, 1909-1910. (23 1/4 x 17 1/3") Dr. Paul Alexandre Collection, Paris.
26. Portrait of Raphael Chantérou, 1911-1912. (35 2/5 x 21 2/3") Marchesini Collection, The Hague.
27. Head of a Woman, 1912-1913.
28. Portrait (José Pacheco?), 1913-1914. (25 3/5 x 21 1/4").
29. Portrait (José Pacheco?), 1913-1914. (18 x 15").
30. Portrait of Diego Rivera, 1914-1915. (39 1/3 x 31") Museu de Arte, Sao Paulo.
31. Portrait of Pablo Picasso, 1915. (13 3/8 x 10 1/4") Georges Moos Collection, Geneva.
32. Head of a Woman, 1913-1914.
33. Bride and Groom, 1915-1916. (21 3/4 x 18 1/4") Museum of Modern Art, New York. Gift of Frederic Clay Bartlett.
34. Portrait (Fabiano de Castro?), 1915-1916. (32 2/3 x 17 2/3") Private Collection, Milan.
35. Portrait of Max Jacob, 1915-1916. (36 2/3 x 23 2/3) H. P. Roché Collection, Paris.
36. Portrait of M. Lepoutre, 1916. (36 1/4 x 23 2/3").
37. Nude with a Blouse, 1916. (34 1/2 x 25 3/5").
38. The Servant Girl, 1916. Private Collection, Paris.
39. Portrait of a Young Girl, 1916. (21 2/3 x 13 4/5") Toso Collection, Venice.
40. Portrait of Anna Zborowska, 1917. (51 1/4 x 32") Museum of Modern Art, New York, Lillie P. Bliss Collection.
41. Woman with a Necklace (Portrait of Jeanne Hébuterne), 1917. (22 x 15") R. Eichholz Collection, Washington.
42. Nude Lying on a Sofa, 1917? (23 1/4 x 36 1/4") Private Collection, Paris.
43. Portrait of Dr. Devaraigne, 1917. (21 3/4 x 18") John W. Garrett Collection, Baltimore.
44. Portrait of Chaim Soutine, 1917. (39 1/3 x 25 3/5") Private Collection, Paris.
45. Girl with Lace Collar, 1917. (36 1/4 x 23 2/3") Private Collection, Paris.
46. Seated Girl, 1917-1918. (35 4/5 x 20 4/5").
47. Portrait of a Young Woman, 1918. (19 x 17 4/5") Private Collection, United States.
48. Portrait of the Actor Gaston Modot, 1918.
49. Portrait of a Bald Man, 1918. Private Collection, Paris.
50. Portrait of Leopold Survage, 1918. (24 x 18") Atheneum Museum of Art, Helsinki.

85. Portrait of a Woman, 1914-1918?. (19 3/8 x 11 7/8″) Museum of Modern Art, New York, given anonymously.
86. Seated Nude, *c.* 1914?. (21 1/4 x 16 3/8″) Museum of Modern Art, New York, Gift of Mrs. Saidie A. May.
87. Seated Nude, *c.* 1918. (17 3/8 x 11″) Museum of Modern Art, New York, Gift of Mrs. John D. Rockefeller, Jr.
88. Portrait of Vlaminck.
89. Portrait of Chana Orloff. Property of Chana Orloff.
90. Portrait. Property of Chana Orloff.
91. Portrait of Ortiz de Sarate.
92. Portrait of Soutine.
93. Head of a Woman.
94. Portrait of Bernouard.
95. Portrait of Jeanne Hébuterne, 1917-1918.
96. Nude, 1918?. J. W. Alsdorf Collection, Chicago,
97. Seated Nude, ?. Pierre Lévy Collection, Troyes.
98. Nude with Raised Arm, 1918. Private Collection, Paris.
99. Water Carrier, 1919. Survage Collection.
100. Man with a Hat (Study for Mario), 1920. (19 1/4 x 12″) Museum of Modern Art, New York, Gift of Mrs. John D. Rockefeller, Jr.

Introduction

At home they were always talking to me about "your poor father." My grandmother spoke of him with sorrowful tenderness; my aunt and adopted mother, in tones that were at once remorseful and heavy with innuendo. They insisted upon an attitude of unquestioning admiration for him, an admiration stiffened and maintained by their sense of the injustices that he had suffered — his life of poverty, the attacks of the Fascist critics, etc.

Every morning as I began to polish my shoes before going to school, they handed to me, always with the same affecting gesture, a strange little cushion made of pieces of brown corduroy sewn together, scraps of "your poor father's jacket." At least one part of my childhood image of him consisted of these early morning claims to my filial devotion, made as I sat at the big black marble table, still half asleep, trying to gulp down my *café au lait* and review my lessons. Luckily no one at school, or almost no one, knew who "my poor father" had been.

Whether because her sorrow was still too fresh in her mind, because she was too shy herself, or because she respected my childish reserve, my grandmother rarely spoke of her son. It was my aunt who told me, always in the same words, the stories of Modigliani's childhood, of how he took up painting and of the time that he had spent at Leghorn. I had not yet begun to doubt her accuracy; what irritated me was the manner of her telling. The tone of voice, the gesticulations, the clipped phrases, all seemed to say: "That is what geniuses are like — childish, rather silly, self-centered and impossible to put up with. Steady, common-sense people like us, aware of our responsibilities, can accept

them; in the end we can even admire them, but we can never
hope to understand them."

Years later in Paris, as I listened to a police official, whose
specialty was uncovering fakes, discuss Modigliani's disorderly
life, I realized that the family's forbearance was above all a
defense mechanism. Once they are dead, we can forgive artists
their eccentricities and immoralities, but only because they belong
to a different race of mankind. By detaching ourselves from
them and refusing to include them in our common humanity,
we are spared the necessity of having to explain them.

Some hints that my aunt let drop, some of my grandmother's
reminiscences of little Dedo's childish doings, did clearly suggest,
in spite of their stereotyped paucity, that he had been rather a
touchy and hot-tempered little boy. But the family of which
he was a part was rich in queer characteristics, and he was certainly
no more eccentric than many of his forebears and relatives. Their
eccentricities, however, met with affectionate understanding, so
that their images remained psychologically consistent and as well-
defined as the photographs bound together in our albums. Instead,
as the little boy grew up, he seemed to split into two distinct
persons: on the one hand, and with a terrifying break in continuity,
he became a sentimental fiction, "my poor father"; on the other,
that turbulent yet familiar tragic figure, a painter of the School
of Paris.

This psychological parallel found its exact counterpart on
the material plane. Thank Heaven! we spared the critics and
art-lovers who visited us the corduroy shoe-cloth, but we led
them into the dining room where, under a wooden bracket and
between the Benozzo Gozzoli reproductions, five drawings wilted
in the light of the imitation wrought-iron fixtures. After which,
we all had to come to a reverent stand-still before the death-
mask that lay, together with its black velvet cushion, on a small
fake-Renaissance table.

From time to time I tried to sneak into the room and look at
the drawings — three fine nudes, the portrait of a seated man,
and a slight profile of Jeanne Hébuterne — just as I would
have looked at those of any other painter, but the all-pervading
presence of that mask and the immediate intrusion of the family
resulted in my really *seeing* them for the first time only a few

years ago, reproduced in a catalogue, for by then we no longer owned them.

As soon as I could read, I was given permission to go through all the books and articles on Modigliani and Montparnasse with which the house was crammed, but my reading, needless to say, was done to a running accompaniment of corrections from the family. Some of these were valid — I have verified them bit by bit: for instance, it was true that, though poor, they had never abandoned their "Parisian" and that when they had heard of my father's death but before they heard of my mother's, they had invited her to come and live with them. But others were inspired by purely moral considerations: my mother would never have killed herself had she been legally married; my father had indeed been a victim of drugs but never of drink, as befitted one who sprang from a family that drank in moderation but admired Baudelaire and De Quincey.

If my childhood image of "poor father" is still colored by the pale uncertain light of dawn coming into our huge kitchen, that of the Parisian painter calls up the red-and-blue vibrations of the old Turkish carpet on which I squatted with articles and reproductions spread all around me. In spite of the family emendations, this world of conventional myth, of reddish nudes with unseeing eyes, seemed confusedly different from my own, a forbidden but alluring country. I did not try to free myself from this tangle of contradictory themes, strongly though they aroused my feelings, by appropriating or by overcoming them, as a grown person would have done. I endured them, blunting their impact and retreating behind the opaque inertia of childhood.

In 1930 my aunt dragged me with her to Venice to see the retrospective Modigliani exhibition. I remember that she refused with haughty rhetoric to be the guest of the Biennale, and it was from a respectable, dreary little hotel, frequented by middle-class German couples and full of mosquitoes and the stench of the canal, that, hand-in-hand with her, I embarked on the discovery of Venetian painting and the visit to the exhibition.

Like Italian children in general and Florentines in particular, I had willy-nilly seen a great deal of painting, to an extent unknown in other countries. Even so, the memory of certain Tintorettos, which I did not see again for twenty years, was to

haunt me through the long years of the war. In this state of
pictorial awareness, it was difficult not to *see* the Modiglianis as
well, difficult to regard the whole trip merely as a family duty.
But I had barely made room among all my new experiences for
the opulent nudes, the exuberant portrait of Diego Rivera, and
the bright orange background of the *Portrait of a Bald Man,*
when my aunt pointed to a bunch of roses lying at the foot of a
yellow and blue profile of Jeanne Hébuterne. She had ordered
them herself, and they were a summons to the usual pause for
sorrowful recollection . It was too much even for a child's immense
powers of resistance. Down came the curtain.

It was Sebastiano Timpanaro — a modest, intelligent man
and, with his one eye, so like a Modigliani himself — who showed
me the first reproductions of Van Gogh that I had ever seen
and thus drove me forcibly back into the world of painting. Then
at the university I realized that Fascist ideology was hostile to
researches in art taken as a whole, and I devoted myself to the
study of German Expressionists and the School of Paris. For the
moment I set Modigliani to one side, even though I was convinced
that sooner or later I should have to study him as I did the others.

When I arrived in Paris in 1939, I was twenty, straight from
the background of a Spanish-Italian Jewish family living the life
of middle-class Tuscan intellectuals. I lost no time in exploring
the city, from the North African quarter around La Chapelle
and the questionable district of the Bastille to Montmartre and
Montparnasse, these last now neatly catalogued and put in order
for the tourists.

I met people who had been Modigliani's friends and models
but, in that state of sickly acquiescence peculiar to emigrants
during their first few months, I was afraid that I might fall
dizzily into a sentimental attachment which would lead to a kind
of research that might spoil my chances of later writing a critical
study of him. Instead of taking notes, questioning his contem-
poraries, verifying dates, I turned my back on his whole envir-
onment and plunged headlong into the everyday life of France.
Many of these eye-witnesses are now dead, or else their memories
have crystallized through old age, but in reading what they said to
the journalists and writers of the twenties and thirties I do not
think that the difficulties that confront me now are much greater

than they would have been in 1939 or immediately after the Liberation.

In 1952 on a scholarship from the Centre Nationale de la Récherche Scientifique, I started doing research in France and Holland on the materials necessary for a critical study of Van Gogh. The contrast between his own ideas and artistic aims, as seen in his letters, and the myth of the ill-fated painter whose genius was conditioned by his madness, led me to examine the crystallization of this type of legend and the profound ideological motivations to which it corresponds. I had already established analogies between certain aspects of Van Gogh's life and that of Modigliani and, above all, the transformations that these had undergone, when an enthusiastic specialist in Dutch painting, to whom I was complaining of the difficulties that the artist's family placed in the way of my tracing vanished letters or verifying certain biographical data, asked me why I did not devote myself instead to a study of Modigliani, since for that it would be easier to overcome family reticences. At that time, I answered that I preferred Van Gogh.

If I now propose to follow this advice and reconstruct the essential stages of Modigliani's career, it is a question neither of conversion, with the resultant alteration of my whole scale of values, nor of a sentimental attempt to recreate the image of the father whom I never knew. With the help of and in spite of the Parisian myth and the family distortions of it, I want to try to retrace Modigliani's odyssey.

Being the artist's daughter has made it harder for me than for others to collect and weigh the evidence. Collectors have suspected an indiscreet prying into their transactions. His old friends cling doggedly to the myth that is also that of their own youth, and I, just because I am flesh and blood, represent a shameless intrusion of reality into the unchanging walled garden of their imaginations. On the other hand, my intimate knowledge of the family, the rediscovery of my grandmother's diary — although it does not cover the most interesting periods, it still contains a few incontrovertible facts — and of a history of the family from 1793 on will, I hope, allow me to examine certain aspects of Modigliani's personality in the light of his antecedents and to suggest interpretations of some of the controversial points

of his artistic development based on an analysis of the background in which he grew up.

In the midst of these fixed points, some incontrovertible dates and facts and a certain amount of trustworthy evidence, I think it useless to list the innumerable anecdotes with all their variation and elaborations and hopeless at this distance to try to establish their authenticity.

A complete and well-documented biography of Modigliani does not and never will exist. The elements indispensable for such a work are lacking. Those scholars who have given the most adequate accounts of his work, such as Lionello Venturi or Enzo Carli, either because they go on the theory that the works themselves, independent of any references to the artist's life, tell their own story best or because they were discouraged by the confused jumble of irrelevant episodes, have deliberately disregarded its biographical aspects. Nevertheless, without prejudice to their importance, I should like to go into details about the "facts," few though they are.

I should also like to isolate the essential characteristics and common elements of the Modigliani myth, with the conviction that by making an inventory of all the things that we do not know, I may open the way for subsequent and more decisive research.

Acknowledgments

The author would like to express her profound gratitude to all those friends of Modigliani, without whose co-operation the realization of this book would have been impossible. She would like to thank especially the following: Dr. Paul Alexandre, Mr. and Mrs. Diriks, Gabriel Fournier, Paulette Jourdain, Augustus John, Chana Orloff, M. Osterlind, Chantal Quenneville, M. and Mme Francis Smith, Germaine and Leopold Survage, Germaine and Roger Wild, Lunia Czechowska, Anna Zborowska, M. and Mme Galanis, Aristide Sommati and Gino Romiti.

In addition, the author and publishers would like to express sincere appreciation for those who helped in the gathering of photographic material: Professor Abis, of the Academy of Fine Arts, Venice; Mayor Badaloni of Leghorn; Franco Crovetti; M. and Mme Deltcheff; Sig. Paulo Ferreira; Galerie Bernheim; Museum of Modern Art, New York; Mme Lacour and M. Cartier of the Musée Cantin, Marseilles; M. Nacenta, Director of the Galerie Charpentier, and his assistants; Mme. Netter; M. Georges Renand; Dott. Nello Ponente; Sig. Giovanni Scheiwiller; Arthur Tooth Gallery, London; Professor Lionello Venturi; Sig. Lamberto Vitali.

Finally, the publishers would like to express special thanks to Enrico Vallecchi, publisher and discerning art collector, for his helpful co-operation.

Modigliani: Man and Myth

Banł

This

biograph

family an

are of tw

sometime

ideas;

notice

partly

and p

another

a comple

contain a

things as

which he

can be

to questio

Bankers and Philosophers

Amedeo Modigliani was born at Leghorn on July 12, 1884.

This simple statement is the only one about which all his biographers are both unanimous and accurate. The accounts of his family and even of his parents are full of errors. In general, these are of two kinds. There are ordinary mistakes, which their authors sometimes emphasize in order to bolster their own preconceived ideas; and there are misstatements, based on the short biographical notice drawn up by his sister, which appear over and over again, partly because they seem to come from an unimpeachable source and partly because they help to build up the myth. How much time he spent in Italy, the exact date when he gave up sculpture, the names of the friends whom he saw and of the painters whom he admired, all these differ according to the writers' own ideas as to how much of an Italian and how devoted a sculptor he was and also according to their own partiality for one artist or another of the period. Moreover, ninety per cent of these studies — a complete bibliography would list almost four hundred titles — contain a series of dogmatic and unverified assertions about such things as his father's financial situation and the brilliancy with which he passed various examinations, more or less all of which can be traced to family sources.

The scholars who came to Florence from all over the world to question his mother and sister deceived themselves into thinking

that they were finally getting information that was indisputable. I think it absolutely necessary to set this straight, even when it deals with matters of only secondary importance, so as to block at the source these distortions of fact that, with various orientations, we find in almost all the statements made about Modigliani.

At home they always said — and Modigliani, who believed it, often boasted of it in Paris — that his mother, Eugenia Garsin, was descended from the philosopher, Spinoza. [1] According to the family history written by Eugenia herself, the truth is more prosaic. Modigliani's greatgrandfather, Giuseppe Garsin, who was born at Leghorn in 1793, was the son of Solomon and Regina Spinoza Garsin. That she was of Spanish origin is certain, for her daughter still spoke the dialect of the Spanish Jews, and she may even have been related to the family of the Dutch philosopher, but one has only to open any textbook to discover that the austere Baruch Spinoza left no children. Later on we shall see what deep-rooted convictions sprang from this childhood belief in a descent from the excommunicated philosopher.

Another widespread legend is that Modigliani was the son of a rich banker. Here we see the combination of a simple misuse of words — after the failure of his wood and coal business, the father Flaminio Modigliani, ran a small agency [2] at Leghorn — with a family tradition. "The Modiglianis used to be bankers to the Pope," they would sigh at home on days when it was particularly hard to make ends meet. The less pretentious truth seems to have been that a Modigliani ancestor, who may or may not have been a banker, once did make a loan to one of the Roman cardinals and believing after that that he could break the Papal law that prohibited Jews from owning land, he bought a vineyard. But he was ordered to sell it within twenty-four hours and, in indignation, he left Rome for Leghorn.

In the eyes of the Garsins and Modiglianis banking operations

[1] Arthur Pfannstiel, *Modigliani* (Preface by Louis Latourette), Editions Marcel Seheur, Paris, 1929.
[2] *Banca* — bank; *banco* — agency:

had an aura of abstract speculation that made a perfect counter-weight to the philosophical speculations of their supposed ancestor, Spinoza. For strangers, the pathetic life of the "ill-fated painter" had its drama heightened by the existence in far-off Italy and in the industrial city of Leghorn of a rich and hard-hearted family of bankers.

The

deep im
much to
For
about th
developr.
have onl
the chror

she allo

The Garsins and the Modiglianis

His family background and his mother's influence made a deep impression on Modigliani and, to my way of thinking, did much to determine his tendencies and aspirations.

For the first time it is possible to give some of the basic facts about the Modigliani family and about Amedeo's early years and development, drawing on two extremely important documents that have only recently been discovered: the history of the family and the chronicle of their life, both compiled by the painter's mother.

To please her son Umberto, Eugenia Garsin wrote a history of the family; her style is lively and graceful, and the whole thing is conceived more as an analysis of character and background than as a precise record of events. Affecting reminiscences alternate with sharp and sometimes pitiless comments.

During the eighteenth century a Garsin had made a name for himself in Tunisia as a commentator on the Sacred Books and as the founder of a school for Talmudic studies that was still in existence at the end of the nineteenth century. The practice of passionate Talmudic discussion was still very much alive in the family during my childhood.

Towards the end of the eighteenth century the Garsins moved to Leghorn and it was there, on February 6, 1793, that Giuseppe, the son of Solomon and Regina Spinoza Garsin, was born. Regina, left a widow with seven children, encouraged them to study and set them to work as soon as possible. A strict and energetic woman, she allowed herself the luxury of kissing her children only after

they were asleep. It was she who introduced an austerity that endured through several generations and that was relaxed only a century later for the benefit of Amedeo, the Benjamin of the family.

Her son, Giuseppe, started a company with branch offices in Tunis and London, but the vague wording does not make it clear whether this was a credit agency or a commercial business. But by the time that old Giuseppe, who was known as Josè, died at the age of ninety, after having been blind for thirty years, the family was financially ruined.

Boldly conceived enterprises and frequent failures, which were immediately followed by brisk recoveries, were typical of the nineteenth-century middle classes, but certain other aspects of their life were more specially characteristic of Mediterranean Jews.

They knew nothing of the Ghetto. Not only did they move freely from one end of the Mediterranean to the other, with frequent brief trips to England, but also, in contrast to this gypsy life, they had no sooner settled in a city than they bought a house in the country, in an effort to strike roots in the soil as they did in the social life around them, where the circle of their acquaintance stretched far beyond the purely Jewish group.

Giuseppe had moved to Marseilles in 1835: his son Isaac, the painter's grandfather, after a short stay in Algeria, where in 1849 he married his cousin, another Regina, returned there in about 1852. The four-story house at 21 rue Bonaparte sheltered four generations of the family from the old grandmother, Regina Spinoza, to the sons of Isaac and Regina Garsin, and it was there that Eugenia Garsin's own reminiscences begin.

The figure of her grandfather, Giuseppe, dominates this small, patriarchal community. Cultured, devoted to philosophical discussions, he set the tone of their life, a liberal and unaffected Judaism. (Modigliani's contemporaries frequently mention his aggressive racial pride and tell how he often introduced himself as a Jew and picked quarrels with anti-Semites. At Marseilles and Leghorn the Garsins had never met with anti-Semitism, and Modigliani was to encounter it for the first time in Paris, in the writings of the journalist, Edouard Drumont.)

More strongly entrenched than their racial pride was the cultural tradition of the Spanish Jews. The heroes held up as examples to the young Amedeo and later on to me were Spinoza, Uriel Da Costa, who after having been thrice excommunicated, killed himself in front of his "Treatise of an Atheist," and Moses Mendelssohn, one of the enlightened philosophers and a fervent and obstinate believer in racial assimilation. Among themselves the Garsins spoke of Amsterdam with overwhelming emotion as the headquarters of freedom of thought. These tendencies go back to Eugenia's blind grandfather and to his son, Isaac.

Eugenia was brought up by an English Protestant governess, Miss Whitfield, and was later educated at a French Catholic school. "From eight in the morning to six in the evening, except for two hours at noon, she was a pupil in a worldly, Catholic, French institution: at home, she was Italian, Jewish, patriarchal and serious-minded," Eugenia says of herself, adding that this dual existence made her feel a stranger in both surroundings and aroused in her an early tendency towards critical analysis.

More important was the superimposing of Miss Whitfield's Protestantism on the less uncompromising morality of the Garsins. Even I felt its influence to a certain extent, and I imagine that it must have been still stronger during Modigliani's childhood. The Garsin austerity covered only the more material aspects of life such as food and clothing. Miss Whitfield instilled in her young pupil a religious horror of falsehood and even of those little white lies that simplify everyday life; she taught her that happiness is not necessarily the aim of existence; and that she should bear uncomplainingly with small annoyances even when they were not essential for self-discipline. Later Eugenia tried to revert to the Garsin tradition, which cultivated instead of rejecting the higher joys of life, and she succeeded so well that she even became a disciple of Emerson; but she never completely freed herself from a tendency to suffer in silence rather than to free herself from her difficulties. Later in her diary she describes the rather gloomy atmosphere in which Amedeo spent the first years of his life.

Another marked characteristic of the Garsins was their attitude towards money. "It seems to me," writes Eugenia, "that the

thing most typical of our family was a sort of shamefacedness about mentioning money. I never heard them discuss it.... Never, when I was little, did I get the impression that I was not allowed a dress or a hat because they cost too much but always for reasons that were so vague that there was no way of answering them; a child of your age... your father does not want you to get used to such luxuries... it is too showy." This scorn for money in its more utilitarian aspects was joined to an amused admiration for financial transactions. The Stock Exchange was an intellectual game like chess or philosophic speculation. At Paris Modigliani boasted in the same breath of his descent from Spinoza and, which was at least half true, from a line of brilliant bankers.

The Garsins did not indulge only in intellectual amusements. Eugenia talks of certain spicy episodes in the family history with an open-mindedness that is almost French. Suffice it to say that her maternal grandfather, an unrepentant Don Juan, died young of pneumonia, caught while he was escaping in nothing but his shirt from the bed in which he had been surprised by a jealous husband.

One other important fact must be mentioned; since the Renaissance, the ban on representing the human figure had been lifted for the Mediterranean Jews, so that at Marseilles or Leghorn a painter's calling seemed less absurd than it did at Vilna or Vitebsk, the cities that gave birth to the two other great Jewish painters of our day, Chaim Soutine and Marc Chagall. Angiolo, one of Eugenia's uncles, had "if not talent at least the ambition to become a painter," but after deserting his family, he went to Egypt where he died of typhus.

The strangest individuals throng this history of the Garsins written by Eugenia. It is impossible and impracticable to describe them all here. Acute intelligence, which, however, was often disorganized and unproductive, and a lack of social adaptability seem to me to be their outstanding characteristics. These same characteristics perhaps explain in part — but only in part — the devastating force with which the Parisian atmosphere was to act upon Modigliani.

Dedo

In 1870, when she was fifteen, Eugenia Garsin became engaged to Flaminio Modigliani, who lived in Leghorn but whose family came from Rome. She married him at Leghorn in 1872. At that time, the Modiglianis had a wood and coal busines and also had mining interests in Sardinia. Eugenia, who had accepted this marriage unquestioningly, as girls did in those days, was at first overcome by the atmosphere of luxury in which she found herself. "The house in Via Roma, huge and full of servants, the meals fit for a Pantagruel, with the table always set for an endless number of relatives and friends, great receptions in a series of vast drawing rooms on the second floor or in the ground-floor hall that opened into the big and still well-tended garden:" poor Eugenia profited little from all this luxury. Her smallest expenditures were supervised and discussed by her parents-in-law, and in order to avoid this vexation, she soon resigned herself to reducing them to a bare minimum. The Modiglianis, Jews of the strictest observance, appeared to Eugenia as uncultivated, overbearing and authoritarian. Like her own, this was also a patriarchal family, but while with the Garsins respect for one's elders went hand-in-hand with affection and family relationships were shot through with tender irony, here even the grown-up married sons addressed their father in the third person and kissed his hand. Old Modigliani, tall, fat, and slightly apoplectic, who had been in Rome and had dealings with cardinals, ruled the group with bombastic phrases and gestures.

During the first years of their marriage until the failure of

1884, Flaminio spent more time in Sardinia than at Leghorn with his wife. His direct influence on his family and therefore on Dedo was very little and that little was negative; his indirect influence seems to have led on the one hand to a complete acceptance of the social conformity of the Modigliani's obligatory calls at fixed hours and the complete submission of the women of the family to their husbands, their parents-in-law and the prescribed rules of etiquette, and on the other, to a passionate exaltation of the Garsin family virtues.

Between 1873 and 1884 four children were born to them: Emanuele, the future Socialist deputy, Margherita, who never left her parents and who became my adopted mother, Umberto, the engineer, and on July 12, 1884, Amedeo.

When he was born the financial situation was desperate, the furniture had been seized, and my grandmother often told me how, when the bailiff entered the house just as her labor was starting, the family piled all their most valuable belongings on top of a woman in childbirth. Superstitious like all Garsins, in spite of their philosophic rationalism, Eugenia always saw in this an omen of bad luck. [1]

In the meantime the Garsins were scattered between Marseilles, London and Leghorn. The blind, lonely grandfather, who lived with a daughter-in-law, had died. Regina, Eugenia's mother, already ravaged by tuberculosis, had come to Italy to see her grandson, Emanuele, but had then returned to Marseilles, where she died soon afterwards. Shortly before the birth of Margherita, Eugenia's father, Isaac, by then a ruined and neurotic man, had come to live with her, and her sisters, Laura and Gabriella, also stayed with her for long periods of time.

Encouraged by some of her friends in Leghorn, Marco Alatri, Rodolfo Mondolfi, Giuseppe Moro and a priest, Father Bettini, whom she had met during a holiday in the country, Eugenia had

[1] That Modigliani himself was superstitious can be seen from the prophecy of Nostradamus which he transcribed on the back of the drawing reproduced in this volume as Plate 98. (See illustration 53 in the text.)

begun to shake off the Modigliani yoke. On May 17, 1886, she started keeping her diary, but it was unfortunately often interrupted for long intervals and it is not written with the sincerity and acumen that she showed in the family history.

In 1886 the family consisted of her husband, Flaminio, who was almost always away from home on business trips, the four children, her maternal grandmother, whom all Leghorn, in French-Italian jargon, called Signora "Nonnina," her father, Isaac, and her sisters, Laura and Gabriella.

Until old Isaac's death he and little Amedeo, nicknamed Dedo, were inseparable, and as soon as the child was big enough, his grandfather would take him for walks beside the harbor.

When he was young, Isaac had been very handsome, not tall but well-built and lively in his movements. He read everything that he could lay his hands on and was especially fond of history and philosophy: he spoke Italian, French, Spanish and Greek perfectly and also knew some Arabic and English. A great chess-player, with a passion for conversation and discussion, he spent most of his time at his club, the Phocéen, and apart from putting in two or three hours at the Exchange every morning, he left most of his business responsibilities to clerks and to his father.

In 1873 when the London and Tunis branches went into liquidation, Isaac, once so brilliant, had a bad nervous breakdown; he turned with such bitterness on his brothers, sons and business associates and became so unbalanced that they suspected him of insanity and, to get rid of him, sent him to stay with Eugenia at Leghorn, even though she was then pregnant. It does not seem to have been so much his financial difficulties that brought on his breakdown, for he had been through others, but rather his clashes with relatives and associates. From that time on he became an embittered and irascible old man, suffering from a persecution mania. His daughter Laura and to a lesser extent his granddaughter Margherita were also victims of this same form of neurosis. Modigliani's Paris friends tell of times when he burst out with aggressive and violent bitterness that even his addiction to drink and drugs does not adequately explain.

After having spent several months in the country with Eugenia

and little Margherità in a villa at Antignano where he managed
to feel that even the gardeners were persecuting him, Isaac Garsin
went back for a short time to Marseilles and from there to Tripoli
as director of a bank. His daughter, Clementine, went with him
but died only a year later, in May 1884. She had been no more
than sixteen when her mother died and all the family responsibilities
had devolved upon her. In her photographs she looks slim,
harrassed and insignificant, but in real life "her smile that radiated
goodness and her marvelous black eyes" made her perhaps the
most feminine of all the Garsin daughters. Her unfailing kind-
heartedness was strengthened by an intensely mystical religion,
surprising in a family that professed nothing more than a vague
deism. It was in her honor that Modigliani was named Amedeo
Clemente.

In 1886 Isaac came back once again, to stay for the rest of
his life with Eugenia at Leghorn. We do not know what stories
he told his grandson, but they gave the child a precocious seriousness
that earned him the nickname of "the professor."

The diary has very little to say about his relations with his
Aunt Gabriella. She kept house and "spoiled the grandchildren."
One of the family once said that Modigliani was very fond of her,
but I cannot find anything more definite on the subject. She
committed suicide, perhaps at Marseilles, around 1915 when Modi-
gliani was in Paris.

Eugenia had two other brothers, Alberto, the youngest, who
after having worked as foreman in a mill at La Drôme, settled
in Marseilles, and Evaristo, the eldest, who was married and lived
in London. Neither of them ever saw much of Dedo.

Amedeo Garsin, on the other hand, who was Eugenia's
favorite brother, had a determining influence on his namesake's
career if it is true, as Emanuele Modigliani later said, that it was
he who paid for the young painter's trip to Venice. Even during
my childhood, Amedeo's short life was already surrounded with
such a brilliant and legendary halo that I am tempted to fill in
with hearsay the gaps in the diary and the family history.

He was born in 1860, so that he was only thirteen when the
crash came. "He finished his studies as best he could at a business

school and immediately afterwards became an apprentice at Rabauds'. Like Clementine he was always small and slim, because he had eaten too little and worked too hard in the critical period of adolescence. He also had a serious attack of typhoid that left him with a lesion on his lung." In the family history, Eugenia emphasizes his intelligence and moral qualities. In the diary, she speaks only of a crisis that he went through in March 1887 but does not say whether it was financial or not; then there is nothing more until these lines, written in February 1905:

"This notebook was sent to me from Marseilles after they had finished sorting out the papers of my poor dear Amedeo. I could not get hold of it any sooner and now I cannot take up the thread of that pitiful story. Nothing can fill the void that his death has left in my life. My feeling for him was too complex and too greatly made up of family affection and trust and above all of our complete communion of spirit. But even in the midst of my own selfish thoughts I realize that he never could have been happy and that it is better this way."

Amedeo was thus so much a part of the family life at Leghorn that at the end of one of his visits, he took the famous diary away with him, either as a memento or as a proof of affection. Eugenia's adoration for him was shared by her sons: whenever he had the chance he hastened to Leghorn and his passage always left behind a breeze of fantasy, generosity and warm enthusiasm. But no two accounts agree as to his career. Eugenia speaks of his goodness, of the fact that "he never could have been happy"; Margherita, on the contrary, used to tell me of the extraordinary adventures of this man who died when he was only forty-five after having made and lost three large fortunes, and who threw himself into rash speculations not because he loved money but like an impatient gambler, to see how they turned out.

That Margherita intended to draw a parallel between the two Amedeos is self-evident; she even ended by saying that both of them had died at thirty-three. It is quite possible that there was a profound sympathy between uncle and nephew, based on their common habit of burning their candles at both ends, but this cannot be more than a conjecture.

In May 1886, when the diary begins, Dedo was a baby of two, "a little spoiled, a little capricious, but *joli comme un coeur*." Eugenia and her sister Laura had started giving lessons and, encouraged by Rodolfo Mondolfi, had really started a school in their house. "Rodolfo Mondolfi is a dreamer," wrote Eugenia, "a man who lives only for his books, even though necessity compels him to work hard. He teaches for twelve or thirteen hours a day but in spite of this, is still in the clouds." A convinced spiritualist, in whom active goodness was united with delicacy of feeling, he was Eugenia's loyal and loving friend. Almost every evening he turned up at the house in Via delle Ville, and later on we find him helping Dedo with his Latin.

Dedo's first great friendship was with one of Rodolfo's sons, Uberto, whom Eugenia called her "extra" child and whose life is intimately bound up with that of the Modiglianis. From 1890 to 1898 he was particularly close to Dedo, but after 1898, when he took an active part in the struggle for Socialism — from 1920 to 1922 he was mayor of Leghorn — his friendship centered on Emanuele. Until 1939 Eugenia's "extra" son was also my marvelous "extra" father, and his political loyalty and quiet courage were all the more admirable because he seemed to me to be more a man of letters than a politician. A great humanist, open-minded and sensitive to any form of culture, his influence on Amedeo, who was seven years his junior, was certainly very great. If so many of Modigliani's Parisian friends considered him a monument of learning, he owed this reputation in part to their own ignorance of classical literature but even more to his friendship with Rodolfo and Uberto Mondolfi.

According to the family tradition that was first launched by André Salmon[1] and afterwards repeated by almost all other biographers, it was during an attack of typhoid in 1898 that Amedeo, who up to then had not only never touched a brush but had not even shown the least interest in art, terrified his mother by breaking

[1] André Salmon, *Modigliani*, Paris, 1926.

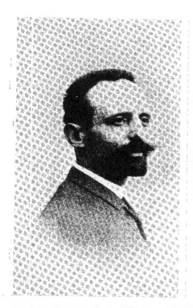
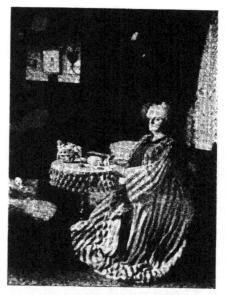

1. Amedeo Garsin, Modigliani's uncle; 2. Eugenia Garsin Modigliani;
3. Modigliani (seated, far right) and friends in Gino Romiti's studio.

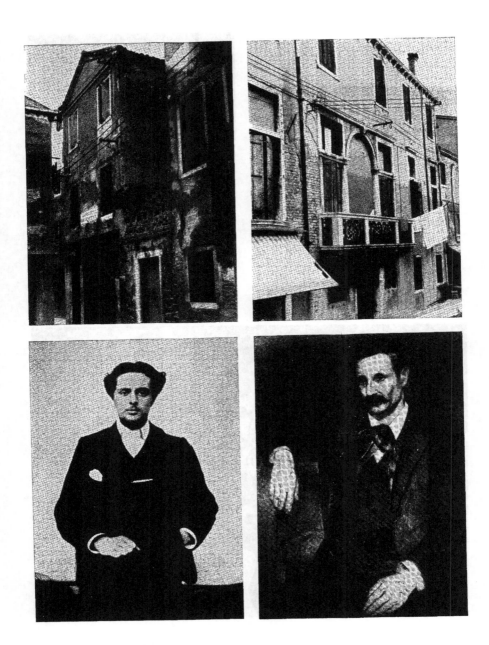

4. The study in San Sebastiano, Venice; 5. Campiello Centopiere, Venice;
6. Modigliani, before 1905; 7. *Portrait of My Father,* by Gino Romiti, 1899.

out into a violent and surprising delirium: the fever had set free
his unconscious artistic aspiration and he raved of paintings, even
speaking of some that he had never seen.

Shortly afterwards, according to Margherita, Amedeo and
Uberto Mondolfi decorated a bookcase, painting on it two heads
and a skull. Uberto, on the other hand, dates this in 1896, which
is more probable, because by 1898 Mondolfi was completely taken
up with politics and teaching and had little time left for such
amusements. Amedeo was then only twelve, but according to
Mondolfi, he already showed a precocious imagination and an
impatience of family restrictions, above all of his father's authority,
to such a point indeed that Rodolfo Mondolfi once had to take him
to task for it.

One fine day they decided to "try something new to amuse
themselves with." The woman's head and the skull painted on
one side of the bookcase were to symbolize "love in all its
destructive power," while "the man, a partiarch with a long
divided beard, was to symbolize the male 'succubus,' which is
what he too often is." The words are Mondolfi's: as literature it
is puerile and as painting it was mediocre, and it seems absurd to
see in this boyish prank, as some of Modigliani's admirers have
tried to do, any signs of future promise.

I think it important to deny the very beginnings of this legend
of an artistic vocation suddenly springing from the depths of the
subconscious, on account of something as extraneous, contingent
and pathological as a feverish delirium. The truth is that little
Dedo had started painting before he fell ill, just as ten years later,
he started his career as a Parisian painter before becoming the
picturesque drunkard.

Here I must say, in parenthesis, that it is true that during the
famous attack of typhoid and the resulting delirium, Amedeo
revealed to his mother a passion for painting that until then had
been concealed behind a modest and disdainful reserve, just as
it is true that, during the fourteen years in Paris, alcohol and drugs
helped to break down his inhibitions and insecurities, but these

phenomena went hand-in-hand with his creative urge or were
even subsequent to it and were not the necessary condition, the
sine qua non, of his artistic development. That it is not enough
to have typhoid or get drunk to become an artist, seems plain
common sense, but after so much false romanticism it seems
necessary to repeat it.

During the summer of 1895, "Dedo had a bad case of
pleurisy," writes his mother, "and I still have not recovered from
the terrible fright that it gave me. The child's character is still so
unformed that I cannot say what I think of it. He behaves like
a spoiled child, but he does not lack intelligence. We shall have
to wait and see what is inside this chrysalis. Perhaps an artist?"
This last phrase, strangely prophetic so long as we believe that
he had never painted nor drawn until 1898, now seems to be
only the simple realization that this child, who was different from
the others, appeared to have leanings towards the plastic arts.

In July 1897, in an unformed style but not a childish handwrit-
ing. Amedeo wrote in his mother's diary: "I am taking my exams
and have to take my *bar mitzvah.* The exams are to pass from
the fourth to the fifth class. This is for the accuracy of the
Modigliani family annals."

The *bar mitzvah* is the rite of confirmation by which a young
Jew at thirteen is received into the Jewish community.

On July 31, 1897: "I wrote several days ago in this family
diary, saying that I was taking my exams. I now announce that
I have passed them." And on August 10, his mother comments:
"Not only has Dedo passed his examinations but he is just about
to take his *bar mitzvah.* Oof; there is another one out in the
world or almost!"

These are insignificant details, but we can deduce from them
the close affection between Amedeo and his mother, for he
was the only one of the children whom she allowed to write in
her diary.

His two older brothers, Emanuele and Umberto, were by now
leading their own lives. Emanuele, a young lawyer, was completely
absorbed in politics; Umberto continued his engineering studies
at Pisa and Liège.

His aunt Laura Garsin had left Leghorn for Marseilles in August 1896, and on July 29, 1896, Eugenia wrote: "Gabriella left this morning. This is the first time in twenty-four years that I have none of the family at home."

At this period of her life, the futures of Emanuele and Umberto, Margherita's difficult character, and her painful quarrels with her two sisters, which were made worse by financial difficulties, preoccupied Eugenia more than did the artistic leanings of little Amedeo.

On May 4, Emanuele was arrested at Piacenza, and on July 14 the Military Tribunal of Florence sentenced him to six months in prison. Eugenia wholeheartedly approved of her son's Socialist ideals, even though she saw clearly that it would mean for him a life full of difficulty and struggle, and with fresh energy and helped by the warm sympathy of Mondolfi, she faced the hostility of the Modiglianis.

How did Amedeo react to his brother's arrest? Thanks to the ferocious stinginess of so many of his relatives and friends and to the oppressive family atmosphere when it comes to giving information, we can never know precisely how he felt.

On July 17 his mother wrote: "Dedo did not do brilliantly in his examinations, which did not surprise me much, because he has not studied well all year. At the beginning of August he starts drawing lessons, which he has wanted to do for some time. He already sees himself as a painter; I do not want to give him too much encouragement for fear that he will neglect his studies to pursue a shadow. All the same, I wanted to do what he asked, to get him out of this state of apathy and sadness in which we all, more or less, are wandering at this moment."

This completely confirms Mondolfi's statement: since the age of twelve, Amedeo had been patiently and obstinately moving towards painting, nagging at his mother to let him take " drawing lessons." It even seems — if Gina Micheli, his teacher's daughter, remembers correctly — that he had already begun to study with him before the famous typhoid of 1898: "Modigliani had had typhoid and as he came into the sitting-room, Mamma Micheli,

the master's wife, went forward to greet him and stroked his cropped hair, saying, 'How well your head turned out, Amedeo!' " [1]

His mother does not mention the exact date of his illness but writes on April 10, 1899: "Dedo's illness and his recovery have left their mark on the family's memory too strongly for me to have to go into details."

Eugenia's sister, Laura, had come home after a two years' absence only three days before Dedo fell ill. This means that the most probable date for it was August 1898.

The family atmosphere had changed considerably during that year. Sympathizing with her Socialist son, Eugenia had burnt the bridges that united her with the more conservative of the Modiglianis, and she had finally freed herself from the local prejudices as to the rôle of women and the possibilities open to them. It had already caused a scandal when she started working in 1886, but at least that had been a modest occupation, undertaken only to balance the family budget. Emanuele's passionate political convictions and the artistic ones of Amedeo seem to have convinced her that the placid path towards one of the liberal professions and an assured future was not the only aim of existence. She not only allowed Amedeo to cut short his classical studies and resigned herself to seeing her sister Laura neglect teaching in order to devote herself to philosophic and sociological articles, but she herself turned to literature: "I am doing a translation of D'Annunzio's poetry, and last summer a publisher brought out a short story of mine, so I hope to write a whole novel. At any rate, writing it amuses me." She soon gave up writing just to amuse herself: soon afterwards, she became the ghost-writer for an American, for whom over the years she composed a series of studies on Italian literature.

It is no wonder that Eugenia Garsin wrote on April 10, 1899: "Dedo has completely given up his studies and does nothing but paint, but he does it all day and every day with an unflagging ardor that amazes and enchants me. If he does not succeed in

[1] Silvano Filippelli, *"Testimonianze livornesi per Modi,"* *Rivista di Livorno* (July-August 1956), p. 225.

this way, there is nothing more to be done. His teacher is very pleased with him, and alhough I know nothing about it, it seems that for someone who has studied for only three or four months, he does not paint too badly and draws very well indeed."

André Salmon, in his romanticized life of Modigliani,[1] imagines that there was a conflict between Amedeo and the family who had destined him for a business career and that his mother was the only one to encourage him, not from conviction but only from maternal affection. The truth is completely different. Modigliani grew up in what we should now call an intellectual atmosphere and was always homesick for it, so much so that during one of his visits to Leghorn, in 1910, he started writing articles in collaboration with his aunt Laura.

Laura Garsin gave Modigliani Kropotkin's memoirs to read as well as his small volumes on "Bread" and "The Unwed Mother," and she discussed with him the works of Nietzsche and Bergson. Eugenia, a well-balanced and sensible woman, soon realized her sister's intellectual and emotional abnormalities, but Modigliani took her for his favorite confidante. In 1911 he decided to spend several months with her in Normandy, and when, a victim of a persecution mania with philosophical overtones, she had to be put in a sanitarium, he still spoke with feeling of her "marvelous intellect."

In a study published in *Commentari* for 1952, Nello Ponente, although he asserts that Modigliani "as an artist, first saw the light in Paris," still thinks it indispensable to "define his early tastes and to take stock of the paraphernalia of ideas that he was gathering together during his first Italian experiences." A great part of this paraphernalia, for Modigliani as for all young Italians of his generation, consisted of Nietzsche and D'Annunzio.

We shall better understand the persistence in his work of a literary quality "showing traces of the worst of D'Annunzio"[2] even after his artistic development was completed, if we always

[1] André Salmon, *La vie passionée de Modigliani*, L'Inter, Paris, 1957, pp. 21, 22.
[2] Enzo Carli, *Modigliani*, De Luca, Rome, 1952, pp. 15, 16.

were tragedies.

Micheli's Studio and Italian Travels

By 1898 Modigliani had definitely given up his classical studies and was constantly at Micheli's studio, a large room with three windows on the ground floor of the Villa Baciocchi.

Guglielmo Micheli was a pupil of Fattori and belonged to the school of the Tuscan post--Macchiaioli in its last and most attenuated phase. In the retrospective showing of his works recently organized by the Casa della Cultura of Leghorn (September 1957) there are some small pictures that are sensitive and full of life and some of the portraits show a solid, rational equilibrium between their psychological content and their refinement of color. But there are no signs of the search for new plastic values that Fattori's best pupils, like Lega, were able to find even in the work of the old teacher himself, altrough it is true that he often looked at these heirs of his with mistrust, as though he did not recognize them as such and suspected them of being too French. In one of Micheli's letters, which overflows with bitterness, he gives the impression that Fattori preferred only those most provincial of his pupils who limited themselves to the more anecdotal and transitory aspects of painting — the *macchiette*, which gave the school its name, and sentimental landscapes — thereby shutting themselves up in a suffocating regionalism that was completely cut off from the more vital currents of European art.

Fattori still showed an affectionate interest in Micheli and often visited the school where that tolerant and unassuming teacher patiently introduced his pupils to every kind of painting and to

all the little tricks of the trade. Filippelli [1] writes: "On Martinelli's first day at the studio Dedo was doing a charcoal drawing on *carta intelaiata,* a still-life with drapery behind it; the technique of these drawings consisted in partly burning the paper and using the smoked parts as half-tints. Fattori saw the drawing and was very pleased with it."

Modigliani's fellow-students at that time were Gino Romiti, Benvenuto Benvenuti, Manlio Martinelli, Renato Natali, Llewelyn Lloyd, Aristide Sommati, Oscar Ghiglia and Lando Bartoli.

Filippelli's accounts of this period show us a Dedo who admired the Pre-Raphaelites and was infatuated with Baudelaire, D'Annunzio and Nietzsche (the good-natured Micheli used to call him "the superman"); it was also said that he was quite ready to seduce the housemaid but was, all the same, kind-hearted, docile and well brought-up.

On Sundays they all used to meet at Romiti's studio to draw from the nude, and little by little they stopped working with Micheli to go off on their own and paint in the country. Martinelli reminisces of the good old days, such as the time when they were all busy painting a view of the Ardenza near the bridge under the railway viaduct and a little boy started throwing stones at them, hitting their paint-boxes with such unerring aim that they had to take refuge with all their belongings under the arches; or the other time when two of them were going cross-country with their paint-boxes slung on their shoulders and a farm wife asked them whether they had any combs for sale. And Llewelyn Lloyd writes that he found them one winter day after sunset painting a country road near Salviano.

Renato Natali, who saw Modigliani again in Paris in 1914, remembers that some of young Dedo's favorite haunts were the dubious alleys in the old part of Leghorn.

All in all, Amedeo was an obedient pupil, quite ready to wander through the countryside and the poorer quarters of the town in the best Macchiaioli tradition. "It was only in his nudes,"

[1] Silvano Filippelli, *op. cit.,* p. 230.

says a friend of those days, "that he showed a certain independence, giving free expression to his interest in line."

All the Modigliani's friends of that period speak with solemn respect of their "bourgeois decorum." Aristide Sommati, the painter who later became a baker, says that at their house he even went so far as to taste tea for the first time, "which in the beginning seemed to me just like camomile." Romiti says that almost all Dedo's Leghorn friends speak of "their high social standing," partly from sincere goodwill and from small-town solidarity with a family that they all knew and admired and partly to furnish yet another argument in support of their thesis about the pernicious influence that Paris had on him. In fact, everyone at Leghorn, except for Natali and Ghiglia (whose artistic development soon made him break with the post-Macchiaioli) considered that although Dedo had been a nice young man with a future, the Parisian Modi lost not only his good manners and bourgeois respectability but also all the promise that he had shown in his youth, going in for stylistic distortions that completely destroyed his authentically Italian vein, even though after his death they did gain for him a doubtful glory.

The problem of how strong Modigliani's Italianism was has called forth various answers. In the beginning there were only two schools of thought. His old Leghorn friends were convinced that the fame of their fellow-townsman had been built up as a business speculation; the critics who admired nothing but the work of his Parisian period after 1914 simply tried to trace in it the influence of the Sienese, of Botticelli, and also of the School of Ferrara. More recently attempts have been made on the Italian side to evaluate the very earliest of his Leghorn works that are known to be authentic — the *Seated Boy*, [1] the *Road at Salviano* — and to identify in all his work a constant Italian factor that he owed to the influence of Fattori.

One of those who believes in this continuing Italian factor

[1] Albertino, Micheli's son, posed for the *Seated Boy* in his father's studio. It must therefore be dated before 1901 and not 1906 as Parronchi thinks.

is Gino Romiti, the most faithful of Micheli's pupils, at whose studio Modigliani worked during his visits to Leghorn in 1909, 1910 and 1913. According to Romiti, Modigliani owed his limpid line to Fattori's teaching, which came to him either indirectly through Micheli or directly from Fattori himself, for the old teacher often visited Micheli's studio and, when that group was broken up, the studio of Romiti. (There is no doubt that Modigliani had a great admiration for Fattori; in 1902 he worked at the Scuola Libera di Nudo run by the old painter and he made his family buy a series of Fattori's etchings.)

According to Romiti, the real successor of Fattori was Mario Puccini, but Modigliani, in spite of the perverting effects of Paris, still kept in his drawing some of the sensitivity that he had learnt from Fattori in his youth.

Gastone Razzaguta,[1] a journalist and painter contemporary with Romiti, at one time disregarded the "distortions" and wished to include Modigliani in Fattori's orbit.

"When Amedeo Modigliani, known as Dedo, was a young man working with Micheli," he writes, "he was distinguished, disciplined and studious, and all his drawing was done with the utmost care and without a trace of distortion." He goes on to say: "His way of showing the sitter almost always with his hands folded in his lap is not only an instinctive gesture of repose but also had something typically Tuscan about it and can also be seen in the work of Fattori. In short, it is our own placid way of seeing things, which Modigliani took with him to France and there made more dramatic."

As an example of "our own placid way of seeing things," let us look at the *Seated Boy.* If we want to find the first traces of Modigliani's own way of looking at figures, it is better, as Enzo Carli[2] suggests, not to draw attention to its placidity but to emphasize instead the pathetic aspect of this earliest ancestor of the Parisian porter's children. In the off-center placing of the child

[1] Gastone Razzaguta, *Virtù degli artisti labronici*, Società Editrice Tirrena, Leghorn, 1943, p. 103.
[2] Enzo Carli, *op. cit.*, pp. 13, 14.

one sees the beginning of the diagonal composition that was so dear to Modigliani and which, by simultaneously suggesting the spatial depth from which the figure emerges and the basic difference in kind between that space and the figure itself, makes the subject seem so solitary.

If we compare the *Portrait of My Father,* painted by Romiti in 1898, with the portraits of Modigliani's first Parisian period, we must admit that the latter was still somewhat influenced by Fattori. But we must not forget that in 1907 Modigliani had seen the great retrospective exhibition of Cézanne and that however he placed any of the figures in his portraits — after all, to fold one's hands in one's lap is not a Tuscan monopoly — from now on it will be through a new dimension of plastic space and a new way of seeing modulations of color that he will try to nail down his subject.

The so-called *Portrait of the Painter Benvenuti,* a drawing in the Museo Civico at Leghorn, does not belong to his Leghorn period but was done during a summer vacation, probably in 1908. Benvenuti and Modigliani, having run across one another at the Café Bardi, each decided to try a portrait of their friend, Aristide Sommati. Benvenuti's first attempt was unsuccessful, and he had barely started his second, when Modigliani snatched the paper from him and finished the portrait. Benvenuti signed it as a present to his friend. One has only to compare the drawing with a photograph of Sommati to realize what a telling likeness it is. Sommati, who in 1912 decided to give up painting professionally in order to support his already numerous family by running a bakery, still owns an unpublished drawing of Modigliani's, a rather academic study of a longshoreman. Its honest and unpretentious technique is reminiscent of the young Van Gogh's drawings of miners. I saw Aristide Sommati in the little house to which he has retired on the road to Montenero. Certainly he now looks more like the portrait that Modigliani left of him than he can have done when he was still young. He speaks of Modigliani as "my poor Dedo, my poor boy." In 1908 Dedo was able to perceive in his young friend the bony structure of the old Tuscan as he was when I met him, shrewd, soft-hearted and lonely, dust-stained with

the ochre-yellow of Tuscany, between the portrait of his son who was killed with the Partisans and the tender rose tints of some unpretentious and sensitive post-Macchiaioli landscapes.

Along with serious and legitimate research into the Italian influences in his work, such as that of Enzo Carli, or the importance for his later development of his Italian cultural and ideological background, his Italianism is also used to explain some of the legendary Modigliani's characteristics, his nobility, graciousness and generosity. "Modigliani summed up all the native genius of Italy," said Soutine, admitting, "that when in the evenings the new Socrates from Leghorn used to hand out pearls of wisdom to his friends, I could follow him only at a distance." Here it is no longer even a question of the Modigliani legend but only a watered-down version of the myth of the dashing Italian painter.

His Italian origin also plays a part in some of the psychological interpretations of the self-destructive and almost suicidal frenzy (with explicit references to Van Gogh) that took possession of the artist during the last years of his life. These literary digressions could be overlooked if they did not also imply aesthetic judgments and take the place of critical reflection and biographical documentation.

A typical example of this can be found in San Lazzaro, who in 1947 [1] gives us two parallel explanations. A sense of failure owing to "his wonderful but useless experience as a sculptor" and to the fact that his friends, who liked his drawings better than his paintings, considered him as neither a painter nor a sculptor but only as a dilettante on the fringe of art, justifies his attacks of rage, his bitterness and his seeking refuge in drink. But then Italy is added to all this as well. "What Modigliani found again in Paris was Italy." Thanks to "that feeling of complete liberty without any remorseful scruples that can be found only in Paris," Modigliani rediscovered the Italian Primitives: "Cézanne led him back to Giotto."

San Lazzaro does not believe in the legend of the eccentric

[1] G. di San Lazzaro, *Modigliani*: *Peintures*, Editions du Chêne, Paris, 1947.

Montparnassien, half Don Quixote, half Don Juan. He sees instead a Modigliani made ill by loneliness like all exiles and suffering more from a thirst for liberty tham from tuberculosis. "For him this was another form of liberty, since it freed him from the weighty burden of good health.

In a monograph published ten years later [1] San Lazzaro does not make Modigliani die of an overdose of liberty but from an Italian complex. In Paris modern art rejected Italy. The drama of Modigliani's life was his love for his country. "He poisoned himself with alcohol and drugs as an antidote to the poison of Italy." Sculpture ("no one ever understood why he suddenly gave it up," says San Lazzaro, and here we can agree with him) freed him momentarily from his complexes and gave back to him "the Italy of the people, noble, gracious and purged of its Italianism." But he still continued to drink, "drinking to kill himself," because "perhaps he realized that there was no way out for him and in the end he would find that he was once again a prisoner." A prisoner of what? Of Italy?

If San Lazzaro could hold two such contradictory opinions between 1947 and 1957, it is because neither of them is founded on fact. Ignorance of Modigliani's Italian background, whether wilful or not, leaves the way open to every kind of fantasy.

In an effort to find out whether Modigliani was a refugee from Italian art or not, Alessandro Parronchi [2] has made a far more serious study of his Leghorn background, of his reasons for becoming an expatriate in Paris and of the artistic and emotional ties that always brought him back to Italy. He agrees that there have been very few people who were as homesick for their native land as Modigliani. This homesickness was not only emotional but also aesthetic. In his works there is a concentration of color, the model for which could never have been found in the surroundings of Paris but only in his far-off province of Leghorn and in the solid construction of old Fattori. If Modigliani, the

[1] G. di San Lazzaro, *Modigliani,* Hazan, Paris, 1957.
[2] Alessandro Parronchi, "*La lezione di Modigliani,*" *Illustrazione italiana,* November 1955, pp. 48-53, 56.

former. pupil of a landscape painter, Micheli, painted while he was in France only those two "despairing" southern landscapes, [1] it was because "his exile's eyes wanted to open only on the landscape of Italy." This hypothesis would explain "the unhappy secret" that Parronchi perceives in Modigliani's artistic vicissitudes.

Towards the end of 1900, this quiet working existence at Leghorn. was interrupted by illness. Amedeo's attack of typhoid in 1898 had probably left him with a lesion on his lung and after he had a serious relapse, Eugenia decided to have him pass the winter of 1901 in the south. Amedeo Garsin paid for the trip.

Dedo stayed at Naples, Capri and Amalfi and then came north from Rome to Florence and Venice. The letters that he wrote to Oscar Ghiglia from his various stopping-places not only bear eloquent witness to his admiration for the worst of D'Annunzio but also to his adolescent desire to embark on the discovery of his own personality; what is new in them is the overwhelming revelation of Italian painting and of the stimulation to be found in the atmosphere of the big cities. He had definitely passed beyond the narrow horizons of Leghorn.

Modigliani was then seventeen, an age at which aesthetic impressions are unusually strong. To my way of thinking, it was on this trip that he first came under the influence of some of the great Italian schools, an influence that he got at first hand and not indirectly through *linearismo liberty* and the sculpture of Elie Nadelmann. [2]

His sister had stated that during his brief stay in Naples in 1901-2, Dedo had been influenced by Morelli, but to Ortiz de Sarate, whom he met a year later in Venice, Modigliani expressed for Morelli only the most intolerant scorn. Margherita Modigliani admitted to me that there had been very little sympathy between her and her brother and that Amedeo had steadily refused to

[1] They are far less despairing in their muted but tender grays, azures and rose than they look in reproduction.

[2] Alessandro Parronchi, *op. cit.*, p. 53.

discuss painting with her, so that any details that she gave about his artistic development are apt to be rather confused.

Of all the Italian artists mentioned in connection with Modigliani, the name of Tino di Camaino is the one that carries the most weight. Enzo Carli,[1] struck by the surprising quality that links Modigliani's sculpture to that of the Sienese, points out that even in Florence he could have admired the tomb of Bishop Orso or the *Charity* in the Bardini Museum. But it was rather in Naples, which he visited before Florence, that "a good quarter-century before the scholars" he was struck by Tino's originality. Knowing our family, I am sure that his conscientious mother had told Amedeo to visit an impressive number of churches. In Santa Chiara, San Lorenzo, San Domenico and Santa Maria Donna Regina, young Dedo found himself confronted with the monumental and successful solution of those plastic problems with which he would be dealing all through his short artistic career; the oblique placing of the heads on cylindrical necks, the synthesis of decorative mannerism with with sculptural density and above all, the use of line not only as a graphic after-thought but as a means of composing his volumes and holding his masses together in a way that even seems to accentuate their heaviness. From that time on, critics of Modigliani's work see it as a continual oscillation, which at its best results in a synthesis, between the demands of his clean rhythmic line and his love for full, solid and rounded volume.

On the evidence of Ortiz de Sarate published by Charles Douglas,[2] we are assured that after he discovered Tino, Modigliani aspired to use sculpture as a means of resolving the contradictions between line and volume. When they met in Venice during Modigliani's brief stay there in 1902, the latter "expressed a burning desire to become a sculptor and was bemoaning the cost of material. He was painting only *faute de mieux*. His real ambition was to work in stone, and this desire stayed with him during his whole life..."

As soon as he got back to Leghorn, Modigliani went to Pie-

[1] Enzo Carli, *op. cit.*, p. 18.
[2] Charles Douglas, *Artist Quarter*, Faber and Faber, London, 1941.

trasanta, near Carrara. We have proof of this sculptural activity of his in a letter that he wrote to Romiti; it is undated, but the latter puts it in 1902.

. To Parronchi's question as to whether Modigliani's real vocation was not that of a sculptor, we can now say that at least it was his first; when he was just leaving childhood behind and was "being born artistically" in the fullest sense during the trip to Naples, his real love was sculpture. The undeniable influence on him of Tinò di Camaino, the hopes that he confided to Sarate and to his first friends in Paris, the letter to Romiti, all agree that his great ambition was to be a sculptor and that this impulse first came to him in Italy as early as 1902 and not in Paris in 1908 as most of the critics aver.

R. ISTITUTO DI BELLE ARTI DI VENEZIA

N. *28*

Venezia 19 Maggio 1903

Scuola libera di Nudo anno scolastico 1902-1903
Signor Modigliani Amedeo
figlio di Flaminio di condizione Commerciante
e di Garsin nato a Livorno
Provincia di Livorno il giorno 12 Luglio 1884
dimorante a Venezia in Parrocchia S. Marco
Via 22 Maggio
(la famiglia abita a Livorno Piazza
Magenta N.º 2 —

IL SEGRETARIO

8. Certificate of the Institute of Fine Arts, Venice. Bottom, left, a notation confirming Modigliani's enrollment at the Scuola di Nudo of Florence.

9. The Bateau Lavoir, Montmartre, Paris.

10. Passage de l'Elysée des Beaux Arts.

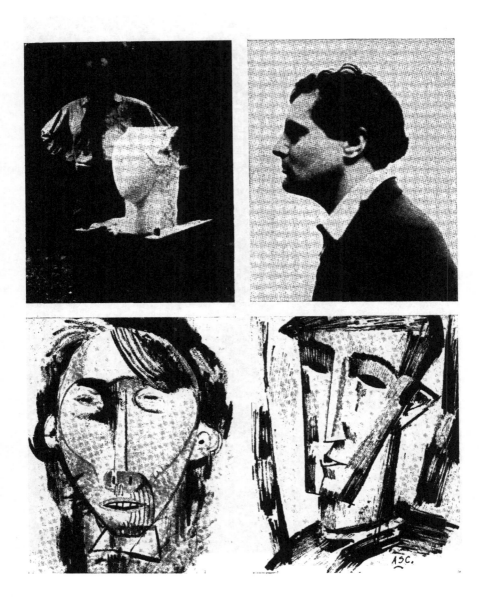

11. Modigliani in the courtyard of the Cité Falguiére, Paris; 12. Modigliani,
circa 1 14. W t ol d 12

Florence and Venice

In the meanwhile, on May 7, 1902, Modigliani had put himself down for the Scuola Libera di Nudo in Florence, where old Fattori, in a squalid and badly-heated attic, was gathering around him the young men who were eager to escape from the stultifying atmosphere of the last of the Macchiaioli and to get the master's teaching at first-hand.

In March 1903 he was back in Venice. We are reproducing in this volume the entrance form for the Scuola Libera di Nudo of the Institute of Fine Arts at Venice, because there has been much discussion as to whether he ever went there and if so, when; besides, it gives us some other dates and information.

First of all, it gives the date of his enrollment at Florence, written in pencil at the bottom, which confirms some of the hypotheses and confused memories of his Italian contemporaries. Secondly, his father, Flaminio, is described as a "businessman" — so much for the journalists who would rather have him a banker!

As his address, Modigliani gives the elegant Via 22 Maggio. His uncle Amedeo had paid for his stay in Venice, but even so his means were limited, and he soon moved into lodgings that were more appropriate to a penniless student. This was one of Amedeo's manias; whenever he arrived in a new town, he would allow himself several days of luxury or at least of moderate comfort; he later did the same in Paris in 1906.

This little form also enables us to scotch one of the family legends. His sister Margherita both wrote in her biographical notice and also told everyone who came to her for information

that Amedeo did not really want to study at the Accademia in Venice and that it was only in a spirit of bravado that he entered the competition, which he won, by the way, in fine style. Charles Douglas, in his book, which does not pretend to be either a critical study or a biography but which the author's caution makes all the more trustworthy, doubts this spirit of bravado, even though he went to Florence to question the artist's sister, since according to Ortiz de Sarate and Brunelleschi, Modigliani's work at that time was more academic than revolutionary.

The truth is that then as now, no competition was necessary for entering the school. On the other hand it is true, as Modigliani's Venetian friends still remember, that he did not follow the courses regularly but preferred to do his drawings in cafés and brothels. Among these friends were Guido Marussig, Mario Crepet, Cesare Mainella, Fabio Mauroner, Umberto Boccioni and Guido Cadorin.

Cadorin, who was then a precocious boy of fourteen, has told me how he often visited churches with Modigliani and also went with him to certain gatherings run by a Neapolitan of the minor aristocracy called Cuccolo or Croccolo. The plump little baron, always elegantly dressed in gray, used to pick them up at the Accademia in the evening and take them to the Giudecca, where, along with two girls who lived in that quarter, they learned the joys of spiritualism and hashish. That it was not necessary to go to Paris to discover the use of drugs, we can well believe, and Cadorin confirms this.

A portrait of Fabio Mauroner done in 1905 was exhibited at the 1930 Biennale. After Mauroner's death, his widow was never able to find this picture, so that the only known work of this period has disappeared.

In a study on etching, [1] Elio Zorzi published Mauroner's reminiscences, in which the latter speaks of a portrait of the lawyer, Franco Montini, that Modigliani painted at this time, but Montini's son has never heard of it. Mauroner also tells of having introduced Modigliani to etching and of having given him Vittorio Pica's *Attraverso gli albi e le cartelle degli incisori*.

[1] *Arti grafiche friulane*, 1955.

At the end of 1905, Mauroner says, Modigliani's mother paid him a visit and brought him a fine edition of Oscar Wilde's *Ballad of Reading Gaol* as well as a small sum of money to pay his traveling expenses to Paris.

In February 1905, Eugenia Garsin wrote in her precious diary: "In Venice Dedo has finished the portrait of Olper and talks of doing others. I still do not know how he will turn out, but since up to now I have thought only of his health, I cannot yet, in spite of our financial situation, attach much importance to his future work."

Leone Olper's daughter, Albertina, an intimate friend of the Modiglianis, had moved to Venice in 1897. Eugenia speaks of "my poor Albertina" as a sad, lonely creature, who felt only too deeply the numerous troubles with which her life had been filled. I knew her in 1933, and the pale, elongated oval of her face might well have inspired Modigliani. She did not remember whether he had done her portrait or not, but she did say, and of this I am sure, that Dedo was often at her house, that a friendship had sprung up between them, and that she did not know what had become of the portrait of her father but that it was in oil and was a good likeness.

The *Portrait of a Man* shown at the Galerie Charpentier and dated 1905-1906 might well be this portrait of old Olper.

All the efforts to trace the drawings and paintings of this period have so far been fruitless. All the same, it seems probable that these youthful works were lost through the negligence of their owners and the indifference of art historians and not, as has so often been stated, destroyed by the artist himself. His sister started the story, and she also maintained that the youthful Amedeo, "never contented, destroyed every attempt that he made as soon as he had a new idea for it that seemed better." I do not know whether this phrase was dictated by the unconscious wish to explain why the family had saved nothing and did not even know about his early work or whether it is a romantic simplification of the artist's perennial dissatisfaction. Be that as it may, almost all the scholars and critics state: "The earliest works of Modigliani that we possess and that still show signs of outside influences date

from 1908, because the earlier work that he did in Italy was all destroyed by his own express wish." [1]

If these affirmations have discouraged the search for works that may have been lost but not necessarly destroyed, they have also strengthened the myth of the Modigliani who became an artist only after he reached Paris, thanks to alcohol, drugs and even poverty.

There is no doubt that if the painters of the School of Paris had stayed in their own countries, their artistic experience would have been more limited and in some cases would have been confined within a weak provincialism. But the originality of all of them comes precisely from their having grafted on to the cultural life of Paris the elements that had gone into their own development, whether Italian, Russian or German, and in spite of the conventional or unformed quality of their youthful work, these elements, taken together with their cultural and family background, afford valuable material for understanding their whole personality.

[1] Catalogue of the retrospective exhibition of Modigliani at the Galerie de France, December, 1945.

Paris 1906-1908

When Modigliani reached Paris at the beginning of 1906, he stayed for several weeks in a hotel near the elegant quarter of the Madeleine.

Ortiz de Sarate had given him a letter of introduction to the painter and sculptor Granowski, but since Granowski could barely speak French, conversation between them was difficult. In spite of this, Modigliani managed to convey to him that he intended to become a sculptor, not of mere portrait busts but of colossal monuments.

Granowski remembers him as a shy, well-dressed boy, who did not smoke, drank only wine and even that in moderation.

The diligent Charles Douglas tried to find out from Emanuele Modigliani whether their uncle Amedeo had paid for this trip as well, but Emanuele could not even remember whether his uncle had still been alive. Douglas has to content himself with the statement that "at this point of the family history, the good uncle fades out of the picture and is never heard of again." He had, in fact, died in 1905, and the small sum of money that Modigliani took with him was all provided by his mother. This is only one of the many examples of how little the biographer can rely even on the most direct evidence.

'e know very little about Modigliani's life and work from
) 1907; a few addresses, a few anecdotes, a few drawings.
ie problem of sources now becomes particularly acute. The
nesses, taken all in all, can be divided into three categories.
are the indulgent sentimentalists who melt as they tell of
adsome and elegant young man, so lordly, so cultivated and
uisitely kind-hearted. There are the intolerant for whom
tist does not excuse the unbearable buffoon, who could
: stand alcohol nor keep away from it, the weak author of
n downfall, the boring, drunken spoil-sport. Finally, there
e self-centered, for whom Modigliani is only an excuse to
their own youth. Using much or little of this varied evidence
rafting on to it their own reminiscences, some writers like
Cendrars, André Salmon and Francis Carco have created
ionality, charming or exasperating as the case may be but
ɔly as far from the real Amedeo Modigliani as Don Giovanni
n Miguel Manara. It seems impossible at this late date to
:ute for this legendary figure a man of flesh and blood. We
nly verify the sources and use the most commonly quoted
ɔtes as signposts or as sketches for an interpretation.
'or Modigliani's first three years in Paris, the financier and
/er, Louis Latourette, the critic, André Warnod, and André
the painter, confirm and complement one another in turn. ·
:o them that we owe the beginning of the legend but also
w probable facts.
ιs soon as he arrived, Amedeo entered the Académie Colarossi.
is desire to work quietly soon faded away before the urgent
ity of finding his bearings in the varied currents of Parisian
He rented a studio at Montmarte in the famous "maquis"
: Rue Caulaincourt, one side of which was still taken up with
s, and he begged stone for his work from the masons who
putting up the new buildings. When he worked directly in
the dust irritated his throat and lungs, so that he was always
ʒ to stop, but these interruptions were only temporary and
: never long before he took it up again.
Vith his corduroy jacket, his red scarf about his neck and
:oad-brimmed hat, Amedeo made an occasional appearance

among the strange fauna that inhabited the Butte, where real poets and artists were in the minority. His first friend was the coachman-poet, Deleschamps; the one to whom he always remained loyal was the poor drunkard, Maurice Utrillo, for whose innocence, talent and impressive drinking-bouts he had a great admiration.

As the new buildings went up, he was driven from the Rue Caulaincourt and wandered from room to room, from the Hôtel du Poirier to the Hôtel du Tertre; he sought refuge at the Bateau Lavoir — he gave this to his mother as his address; and he ended by renting a shed, flimsily built of tile and wood, at 7 Place J.-B. Clément on the corner of Rue Lépic.

The small sum of money that Eugenia had given him was soon exhausted, and Amedeo started on that life of gypsying through Montmartre in search of food and lodging that, according to some, was not the consequence but the cause of his over-indulgence in drink and drugs. The handsome Italian, shy and well-dressed, lived in a decent, almost bourgeois, manner so long as his means allowed, but at the first onslaught of poverty, which was particularly hateful to one of his refined tastes, he threw himself for comfort and distraction into grandiloquent drinking-bouts.

According to others, Modigliani, who got a regular allowance from Italy, the money that his mother earned with such difficulty, was never so penniless as to have to go without food. But even in those happy days, when drugs seemed to be within reach of everyone, they still cost more than honest soup, and it was this vice of his that brought him down to the depths of poverty.

Both sides agree that he was feeling his way, imitating Toulouse-Lautrec, Steinlen, Picasso and even Van Dongen, and that he found his own personality only after he had abandoned himself "to misfortune, suffering and debauchery."

For thirty years Modigliani's biographers, basing their findings on the memoirs of André Utter, particularly for the earlier Parisian period, have elaborated down to the last detail the legend of genius taking its rise from the exaltation induced by drugs. They state that although it certainly was not hashish that first gave him his originality as a painter, he never would have had such a dazzling revelation or his own personality without the liberating effect of

alcohol and drugs. Before undergoing this magical transformation, Amedeo had lived in a studio furnished, in the taste of the provinces, with a grand piano. Needless to say, the piano never existed, but in the legend it symbolizes bourgeois conformity.

One fine day, or rather one fine evening, during a gathering enlivened by hashish, Modigliani leapt to his feet, grasped pencil and paper, and began to draw feverishly, shouting that at last he was on the right road. When he had finished, he triumphantly brandished the head of a woman with a neck like a swan.

There is no doubt that Amedeo was uncertain and hesitant during these first years. The artistic atmosphere of Venice, the landscapes and small homespun scenes, had certainly not prepared him to enter with any ease among the Cubists, Fauves and Expressionists. Latourette [1] tells of visiting his studio around 1907. There was a bed, two chairs, a table and a trunk. The walls were covered with canvases. There were portfolios bulging with drawings, in which his personal style could already be discerned. The color was uncertain and disconcerting. "My Italian eyes cannot get used to the light of Paris... Such an all-embracing light... You cannot imagine what new themes I have thought up in violet, deep orange, and ochre... There is no way of making them sing just now."

And as his friend was admiring the head of a girl, a young actress who used to recite the poetry of Rollinat at the Lapin-Agile, Modigliani declared: "No, that's not it yet. It's still Picasso, but it's turned out wrong. Picasso would give that monster a kick in the pants." A few days later, he announced to Latourette that he had destroyed everything except two or three drawings and the head that he had admired and he had finally decided to go back to sculpture. He was also driven to destroying his work by the frequent necessity of stealing off without paying his rent, taking what little remained with him.

Nevertheless, Anselmo Bucci [2] states that one winter evening

[1] Arthur Pfannstiel, *op. cit.,* pp. v, vi.
[2] Anselmo Bucci, *Picasso, Dufy, Modigliani, Utrillo. Ricordi di Parigi 1906,* All'insegna del pesce d'oro, Milan, 1955.

in 1906, as he was passing the Art Gallery, a little shop almost at the corner of Rue des Saint-Péres and the Boulevard Saint-Germain, which was run by the round and rubicund English poet, Laura Wylda, he saw in one of her windows something new: "The bloodless heads of three women suffering from hallucinations, almost in monochrome, thinly painted with *terra verde* on small canvases." They were the works of his compatriot, Modigliani, on whom Bucci called at the Auberge Bouscarat on the Place du Tertre. They quarreled at once. For Amedeo, there was no good painter in Italy except Oscar Ghiglia, and in France there were only Matisse and Picasso. The following year they became friends; they saw one another fairly often and took hashish together at the Café Vachette. One day Modigliani made a present to Bucci, the portrait of another Italian, the critic, Mario Buggelli: "a simple sketch, signed and with a dedication; a wonderful *orthodox portrait* without the long neck, without the slapped cheeks; a drawing that he had just made, while his guardian angel stood at his shoulder." Looking at the drawing, I am inclined to believe that the guardian angel was Toulouse-Lautrec.

In the autumn of 1907 Modigliani met his first admirer. Dr. Paul Alexandre and his brother Jean had rented a tumbledown house at 7 Rue du Delta and there, with the help of Drouard, the sculptor, and the painter, Doucet, they had organized a sort of phalanstery for artists. Modigliani never lived in it, but he took all his books and pictures there in a wheel-barrow, at which time he sold *The Jewess* to Alexandre for a few hundred francs and gave a small picture to each of the inhabitants.

Dr. Alexandre was not rich, but he had a passion for painting, and he wanted to help the young artist for whom he had developed a warm friendship and sincere admiration. Even today he still has about twenty-five oils as well as portfolios crammed with drawings that go from 1907 to 1912. A handsome old man, tall and erect, with the same bony structure to his face and the same blue eyes that Modigliani painted fifty years ago, he is a type that is becoming more and more rare, an amateur in the strict sense of the word, the real lover of art who is the joy and despair of scholars. The joy, because he has kept intact a collection of the

of Modigliani's formative period, whose authenticity cannot
ubted; the despair, because he broods over them jealously
) one has ever been able to boast of having seen the collection
hole. As to the drawings, he has never let them be reproduced
he most that he will allow, and this only as an exception,
ipid and furtive glance into a barely opened portfolio.

\t the end of 1907 Alexandre persuaded Modigliani to enter
ilon des Indépendants, where in 1908 he showed five works:
ewess, two nudes, a study for the *Idol,* and a drawing.

n April 1909 Alexandre introduced Modigliani to his family:
a well brought-up young man, take my word for it, in
of everything that has been written about him." His father
iissioned his own portrait and those of his sons (six pictures
.)

Modigliani was then living on the Place J.-B. Clément. From
iindow he could see the cherry-tree in Rue Lépic. He had
ed it and Latourette [1] tells us that he took the picture with
when he moved from Montmartre to Montparnasse, but no
ias ever been able to find it again.

We do not know why he decided in 1908 to go and work
ue du Delta. It may have been to escape from his isolation.
inhabitants of the phalanstery exchanged ideas and impressions
even put on plays. The discussions were heated and bitter;
:ding to legend, one evening Modigliani, drunk with wine
rage, destroyed the works of his friends, thus bringing to an
this brief attempt at communal living.

Dr. Alexandre was a firm believer in hashish when taken
oderation, but although he appreciated its power of intensifying
il sensation, he realized that Modigliani was taking rather too
i of it, though he had not yet fallen into those frantic
iitions described in so many of the anecdotes.

Even so, both Warnod and Utter remember Christmas Eve
New Year's Eve 1908, the first at Rue du Delta, the second
7arnod's house, 50. Rue Saint-Georges, when Modi again let

[1] Arthur Pfannstiel, *op. cit.,* p. xiv.

himself go and, among other things, started a conflagration and burst into a D'Annunzian invocation to fire.

The evenings at Rue du Delta were probably noisier than good Dr. Alexandre now remembers. But he and all the others who tried drugs in their youth firmly state that they never saw Modigliani or any other artist paint or draw while under their influence. However full of genius their visions then may have been, their real creative work could be done only when their heads had cleared. Douglas, that connoisseur of common sense, says that without doubt the liberating effect of alcohol and drugs in breaking down inhibitions can have a lasting influence on the personality, but it is impossible to work while their effect is at its height or during the ensuing phase of prostration. This is what he calls the "problem of the morning after."

As a painter, Modigliani continued his patient and obstinate search for a solution of the plastic problems that tormented him, in spite of, and apart from, tuberculosis, poverty, and drunkenness. It is permissible, however, to try to bridge the gap between the painter and the man and to ask why he so soon became a real addict and, after that, was never able to take hold of himself again.

Charles-Albert Cingria [1] lightheartedly cuts the Gordian knot: "He certainly drank and sometimes got excited, but no more nor less than all his contemporaries... The people to whom he owed this reputation were probably anti-alcohol — a lot of Italians have this annoying drawback — and considered even normal drinking a peculiarity. I hardly ever saw him take more than the amount normal for any civilized human being, a quart with each meal." Cingria's robust constitution allowed him to live until 1957!

Even when Modigliani first reached Paris he was not a young man in perfect health, fresh from the provinces. Physically he was wasted by tuberculosis, his nervous system had been delicate since childhood, when he would alternate between shy reserve and abnormally high spirits or violent tempers, and stimulants and drugs produced rapid and irreparable changes in both body and mind.

[1] C.-A. Cingria, *Introduction to the illustrated catalogue of the Modigliani Exhibition at the Kunsthalle, Basel,* Basel, 1934.

The only thing that might have helped him would have been to take a cure, and his family claims that while he was in Leghorn in 1912, he gave the idea some thought. But his eagerness to get things over and done with, the pressure put on him by the dealers, and the dissuasions of his friends led him to a simpler solution, which was to take little drinks at regular intervals all the time he was working.

Both his deep-seated timidity and his unabashed aggressiveness cut him off from the world; at moments he lost faith in himself; he worked hurriedly and tensely; the dealers misunderstood him; and above all, he could not bear the thought of having to give up sculpture. All these things could have driven him to take refuge in drink, but this is a purely psychological problem and now seems incapable of solution.

Most of the critics state that Modigliani's first works date from 1908, paying no attention to the early work that he did in Italy or to the paintings and drawings previous to that date that are mentioned by Latourette and other contemporaries. On the other hand, the works shown at the Salon d'Automne in 1908 are generally considered to have been done in that same year. When Alexandre first knew Modigliani in November 1907, he had already painted *The Jewess*; he was enormously attached to this picture, whose angular dissection of the planes and sensitive chromatic modulation in the background already showed the use to which he intended to put the lessons that he had learned from Cézanne. The *Portrait of Survage,* painted at Nice in 1918, is the last of the long line of experiments that made up his whole work.

This work has been divided into five periods: the period of transition, influenced by Gauguin, Toulouse-Lautrec, Steinlen and Picasso; the Cézanne period; his sculpture, inspired by African art and by Brancusi; his hesitating return to paintings that were full of contradictions; and the fluent, coherent production of his last years. Even a fleeting glance through Dr. Alexandre's collection convinced me that these divisions are completely arbitrary. The few dates of which we can be sure upset this whole chronology, and an unprejudiced examination of his work in its entirety

reveals that up to his death he was working along several different lines at one and the same time.

Pfannstiel [1] reproduces a watercolor drawing of 1906, showing Maud Abrantès and obviously inspired by Pont-Aven. The technique of another portrait of Maud Abrantès, oil on canvas, shows the influence of Gauguin, in spite of the excessive expressionism of its content. It seems to me to be earlier than 1908. As to the portrait of M. Lévy that Pfannstiel dates 1910, we know from Dr. Alexandre that Modigliani obtained this commission shortly after he had been introduced to the Alexandres in April 1909. Moreover, Modigliani always considered it a very bad picture.

The *Sorrowful Nude* and the *Horsewoman* of 1908, the former an example of expressionism, the latter of stylized caricature, are both more literary than pictorial and already show one characteristic by which we can recognize Modigliani's authentic works — the movement of the background, which is devoid of figurative content but vibrates with converging currents of color put on with broad brush-strokes.

The *Standing Nude,* a portrait of little Jeanne, a young prostitute who was being treated by the Alexandres, leaning against a bed with her hands clasped in front of her, was shown in 1908. The reserved expression of her sulky little face on its cylindrical neck, the calm solidity of the forms, the slightly asymmetrical displacement of the figure to the left, the extremely simple but shrewd organization of the background into two zones divided by a rising curve, the higher one a dark riot of lines pointing in different directions, the lower one lighter, tenuous, and only a third as high, her two breasts, one perfectly round, the other conical, and the functional value of the signature as a support for the lighter surface — all these make it a perfectly balanced work, whose style is thought out to the last detail. This is the same technique that he used for his nudes, both on canvas and in drawings, ten years later. And yet Pfannstiel [2] sees the productions of this period only as hallucinations induced by drugs.

[1] Arthur Pfannstiel, *op. cit.,* p. 34.
[2] Arthur Pfannstiel, *op. cit.,* p. 90.

Paris

Wh

his succe:
monograj
cession o.
re-examin
friends w
having se
a studio a
are usuall

Aest
definite c
experime.
in the ex
come to l
Cardoso
that seem:

Defi
In the s
worn-out
3 July 1
wife: "
I am hap
a great b

In 1
was also

Paris–Leghorn

When it comes to Modigliani's visits to Leghorn as well as to his successive addresses in Paris, utter confusion reigns and all the monographs contradict one another. Only the chronological succession of his various living quarters or studios could permit the re-examination of the chronology of his works. But even his friends with the most exact visual memory, who can remember having seen him paint such-and-such a picture in such-and-such a studio and whether it was cold or the cherry-tree was in flower, are usually unable to give the year.

Aesthetic criteria seem to me to be inadequate bases for a definite chronology; early successes, later failures, simultaneous experiments along different lines, all these happen too frequently in the experience of any artist. The few dates that have recently come to light, thanks to such things as family documents and the Cardoso exhibition of 1911, have overthrown even the opinions that seemed authoritative and worthy of credence.

Definite dates for the period from 1909 to the war are scarce. In the summer of 1909 Amedeo went back to Leghorn, tired, worn-out and under-nourished. On a card, postmarked Leghorn, 3 July 1909, Eugenia wrote to her daughter-in-law, Emanuele's wife: "Dearest Vera; Dedo has arrived. He seems very well. I am happy about it and felt that I had to tell you and send you a great big kiss."

In 1909, Laura spent her summer vacation at Leghorn. Dedo was also there and they wrote philosphical articles together.

Eugenia's letters written at that time do not give the impression
that the family was sheltering a Dedo completely worn out with
alcoholism and poverty.

Eugenia had sent for Caterina, a dressmaker who came in by
the day and was celebrated in the family annals for the foul-
mouthed liveliness of her conversation and for her dedicated
devotion to a beautiful daughter, who was expensively kept but
hard-hearted. She set about tidying up the son of the house and
decking him out in fresh feathers, but Margherita writes that Dedo
was extravagant and ungrateful. He shortened the sleeves of a
new jacket with one slash of the scissors and tore out the lining
of his Borsalino to make it lighter.

A few months later he was back in Paris, eager to show
Dr. Alexandre a picture that he had painted in Italy: "Dear P.
Have been in Paris for a week. Paid a fruitless call at Av. Malakoff.
Want very much to see you again. Regards, Modigliani."

All the critics agree that this picture is *The Beggar of Leghorn,*
dated 1909 and shown at the Salon des Indépendants in 1910.

His mother's diary and letters give us some interesting details
about this important work.

The diary mentions that they had moved to Via Giuseppe
Verdi and that, around 1909, they had received a legacy from
someone called Castelnuovo. Moreover, in three letters that are
undated but that refer to Castelnuovo's complicated will and speak
of the baths at Pancaldi, Eugenia writes to Margherita: "Dedo is
out of the house all day with a friend who has a studio." (This
was Romiti.) "Caterina comes in by the day. Dedo and Laura are
writing articles together, but they are too much up in the clouds
for me." And at the end: "Dedo has seen the pictures, which
he says are worthless, and also the famous statue." The statue
was a late-Renaissance copy of a Greek Hermes, the pictures were
a pastoral scene attributed to Salvator Rosa, a seascape by Tempesta,
and a seventeenth-century Neapolitan picture of a beggar. In the
famous *Beggar of Leghorn,* the watered-down Cézannesque structure
reminds me of the Neapolitan composition; it seems to be a
modern interpretation of an old picture and not an authentic
portrait done from a model.

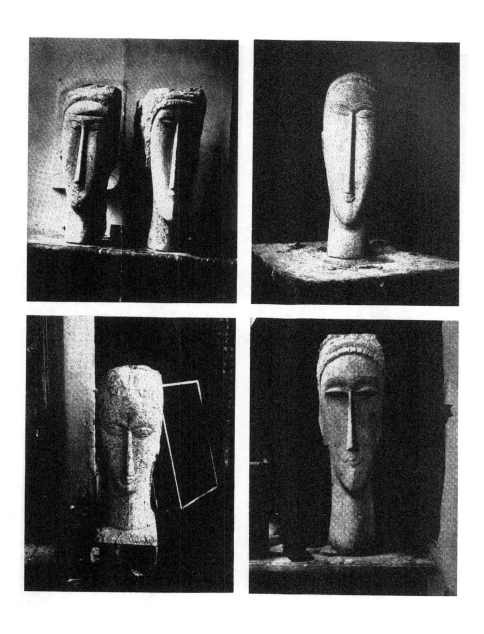

15, 16, 17, 18. Sculptures of Modigliani, at Cardoso's studio in 1911.

Works of Tino di Camaino: 19. Bishop Antonio Orsi (The Duomo, Florence); 20. La Prudenza (Santa Maria Donna Regina, Naples); 21. Giovanni di Durazzo (Santa Maria Donna Regina, Naples); 22. La Carità

At the Salon des Indépendants in 1910, Modigliani exhibited six works: *The Cellist, Lunaire,* two studies — one of which was the portrait of Piquemal —, the *Beggar,* and the *Beggar Woman.* Of these six works, one besides *The Beggar of Leghorn* was probably painted in Italy and two while he was working at the Cité Falguière; that means that four of them were executed after Modigliani had gone back to sculpture.

The Cellist, and a study for it, belong to Dr. A., who thinks it "better then Cézanne." Without sharing his excessive admiration for it, I consider that it is one of the most complex and significant works of a period in which all his contradictory tendencies met. The contrast and balance between the cool harmonies of green, blue and gray-white and the warm browns, reds and ochres; the composed lines of the face and the interminable curve of the arm; these all balance the volumetric density of the cello that is the real protagonist of the picture.

(The cellist lived at the Cité Falguière, where, from 1909 on, Modigliani had a studio on the first floor. Among other things, the sittings gave the poor devil a chance to practice in the warmth from his neighbor's wood stove.)

The critic, Arsène Alexandre, when faced with the works that the Italian painter showed at the Salon des Indépendants, was enthusiastic in his praise of Modigliani, but Dr. Alexandre remained his only purchaser, and in spite of the esteem and warm friendship that some of the critics, artists and poets had for him, no dealer was interested in his work.

As I see it, the turning-point for Modigliani was the year 1910. Although he had thrown himself headlong into sculpture, he still kept on painting. The funds sent him by his family were not sufficient to allow him to rent a decent studio. He moved to and fro between the Ruche, 216 Boulevard Raspail and 16 Rue du Saint-Gothard, Montparnasse; then again he stayed in Montmartre at 39 Passage de l'Elysée des Beaux-Arts, in the Couvent des Oiseaux, Rue de Douai, which Apollinaire speaks of in his *Flâneur des deux rives,* and on and off at the Bateau Lavoir.

The journalist and poet, Guillaume Apollinaire, who was then working in a bank, sold some pictures for him, and Amedeo

decided to explore the French provinces. Laura Garsin tried to
arrange for a quiet stay in Normandy, a sad attempt on the part
of two such troubled spirits. She wrote to Lamberto Vitali: "In
August 1911... more worried than ever, I decided that I must
tear Dedo away from his Parisian setting and arrange for him to
lead a healthy, quiet life in the country, if only for a short time.
Récha Rothschild was spending the summer in Normandy, and I
asked her for the address of a *pension* or a small apartment where
we could spend the autumn by the sea. Knowledgeable and obliging
as ever, she was able to find me a small house for rent, and pretty
into the bargain, at Yport, a village of the Seine-Inférieure. I cannot
remember what excuse Dedo gave for not leaving Paris with me;
I only remember clearly that when he did join me at Yport in the
beginning of September, he had already been given his traveling
money three times over. I knew perfectly well how he was spending
it in Paris; he was buying paints and settling some small debts,
and up to that point I understood his behavior and approved
of it. What I could neither understand nor approve of was his
arrival at the Villa André in an open carriage, soaking wet. With
the little money left over from the third lot after he had paid his
traveling expenses, he suddenly decided to treat himself to a trip
to Fécamp. He had heard of the beauty of its beach, a few miles
from Yport, and in spite of the downpour he wanted to have a
sight of it without wasting any time.

"You will understand what a weight his amazing folly placed
on my shoulders. I felt that I had made an enormous mistake in
bringing to such a damp climate an invalid who calmly exposed
himself to all weathers. I was haunted by the terrifying idea
that I would find myself with no means of heating the house,
with no means of avoiding a return of his illness, in a village
where I knew no one except the peasant woman whom I had
taken on as maid-of-all-work. No! it was absolutely impossible to
do anything to help him. We left Yport — Dedo thought, because
of a whim of mine — without, so far as I can remember, having
spent even a week together."

It has been said of Modigliani that, like Van Gogh, he could
get on only with his inferiors. It is useless to list Apollinaire,

Jacob, Zadkine, Lipchitz, Utrillo, Ortiz de Sarate, who died in America under the knife of a surgeon who thought that he could bring him back to normal by amputating a piece of his brain, and even Laura Garsin herself. Like Van Gogh's Postman, the Woman of Arles, Mademoiselle Ravoux, the "guardian" of the Camargue and the Zouave, each was in his own way an exceptional human being, and "the inability to live like everyone else" was certainly not all that Van Gogh and Amedeo had in common.

It was during the winter of 1911-12 that, according to Max Jacob, Dedo became daily more bitter and more sarcastic. A woman who was a very dear friend of his and whom he often painted during his last years, has talked to me of his "Jewish sarcasm," but I cannot see that there was anything specifically Jewish about it. Chagall and Soutine, whom even the most convinced "Judaizers" admit with no hesitation, had a completely different quality, both in their way of living and their way of painting. Modigliani's outbursts, his sarcasms and rages, even his exhibitionism, seem to be more Mediterranean. Arabs and Spaniards, when faced with the restrictions of daily life and the incomprehension of the more solid members of society, have this same shameless, sad insolence. In the legend that makes Amedeo the typical Italian, there is some truth. His sarcasm was that of a Mediterranean Jew; it holds the same note, but pitched higher that one hears again and again among the ill-fated Garsins who abound in the family chronicles.

Between the shy, reserved and gentle Amedeo whom some remember and the over-bearing, swaggering buffoon, there is no real contradiction. Alcohol and drugs can loosen the bonds of reason, especially with people for whom it is not second nature, and when they do so, they often make a person under their influence behave in just the opposite way to what he would do in his normal state.

Mod
has said
and that
from wo
sculpture
climbed t
which w
"his scul
dimensio
sold at a

To t
which m
for belie
are certa
preferred
for fake
that is r
doubtful
is certain
business
being ab
relationsl

¹ In
date too

Sculpture

Modigliani had not given up sculpture. The painter Doucet has said that in 1907-1909 he was living in Place J.-B. Clément [1] and that while there, in order to avoid the bad effects he suffered from working directly in stone, he had decided to try wood sculpture instead. In order to steal some, Modigliani and Doucet climbed the fence around the Métro station of Barbès-Rochechouart, which was then being built, and Charles Douglas has noted that "his sculptures in wood of this period are all of the exact dimensions of the ties on the Métro." One of these pieces was sold at auction in 1951, and the others have disappeared.

To this period possibly belongs a little clay head of a woman, which most of the critics doubt but which I have several reasons for believing to be authentic. Everyone knows — and the forgers are certainly not the last to be aware of it — that Modigliani preferred working directly in stone. On the other hand, the market for fakes has its own rules, and no one tries to pass off a work that is not typical; I have often seen famous dealers prefer a doubtful Modigliani of his last period to pictures whose provenance is certain but that belong to his Cézanne phase. The mystery of business transactions, which I cannot solve, has kept me from being able to trace the history of this sculpture. The stylistic relationship between this head and that of *The Jewess* and the

[1] In all possibility this place reference is incorrect, in which case the date too would be incorrect.

sharp intersections of the concave planes in the manner of Gargallo convince me that this is a work executed during his first years in Paris or even earlier in Italy.

The direct influence of the figures from the Ivory Coast and the indirect influence of Picasso are already apparent in the *Idol*, which was shown at the Salon of 1908, and in the studies, drawings, the many watercolors and the paintings in oil on cardboard in Dr. Alexandre's collection, which covers the years from 1907 to 1912. It is difficult to establish their precise chronology, but the recollections of Dr. Alexandre — even though he amuses himself with a scientific analysis of his lapses of memory — and the progressive elimination of some stylistic uncertainties, make me think that between the caryatids that were probably done in 1908 and those of 1912, now in the Verdirame collection, there is a steady continuity.

A limestone figure (1914), formerly in Kurt Valentin's collection, shows the influence of Negro art in the schematic simplification of the body; on the other hand, the face with its more subtle modeling of the planes, seems to me, like all the other hermae of Modigliani, to be influenced by his early memories of Tino di Camaino.

His discovery of Negro art, about which he would talk endlessly and enthusiastically, and the example of Brancusi, Lipchitz, Nadelmann and Metchaninoff, certainly encouraged Modigliani towards 1909 to devote himself primarily to sculpture, but this was no sudden conversion. To become a great sculptor was his one idea, his burning ambition, and he had never given it up, as he completely gave up painting while he was living in the Cité Falguière.

For most of his critics, his sculpture was only a stage in his career, a discipline necessary to mature his personality as a painter, but others maintain that the painter had always to fight against his overwhelming ambition to be a sculptor, an ambition that was, however, incapable of realization.

Maud Dale, who knew Modigliani very well, wrote, in her preface to the catalogue of the Brussels exhibition, that he was born in Leghorn in 1884 and after having completed his studies

at the Liceo, decided to become a sculptor.... When Negro art began to make its influence felt on the Montmartre group, Modigliani was still a sculptor. The heads in stone and the many drawings for caryatids that he has left us show to what an extent he understood the formal power of sculpture. But his health became worse, she writes, and he turned definitely to painting. The anonymous author of the preface to the catalogue of Arthur Tooth's exhibition in London, where the heads from Augustus John's collection were shown, confirms Maud Dale's version of the story and adds that Modigliani resigned himself to translating onto the plane surface of his painting the plastic problems of sculpture.

Nina Hamnett, who met Modigliani in the spring of 1914, states that he always thought of sculpture as his real métier.

Enzo Carli, [1] the first to see the affinity between the work of Modigliani as a sculptor and that of Tino di Camaino, has based his convictions on an aesthetic analysis of the works of the two artists. The chronology of these works upholds his findings. There is no doubt that Brancusi, who was Modigliani's neighbor at the Cité Falguière, encouraged the Italian in his decision. But we do not know whether Modigliani moved to the Cité Falguière to be near him or whether he met him there, a calm and affectionate friend, after he had already thrown himself headlong into sculpture. There is no relationship between Modigliani's plastic experiments and those of the Roumanian.

In opposition to Carli, Parronchi[2] writes: "If memories of the primitive art that he had seen gave Modigliani the impetus towards his linear quality and stylization, they came back to him not directly but through the substitutes provided by the Parisian art market, the *Man in the Square-topped Hat* and the women's heads of Elie Nadelmann, through whose successive works runs a constant strain of the primitive and archaic." But it was only in 1913, at the exhibition at the Galerie Drouot, that Modigliani discovered Nadelmann's sculpture.

[1] Enzo Carli, *op. cit.*, p. 18.
[2] Alessandro Parronchi, *op. cit.*, p. 53.

Lipchitz had met Modigliani through Max Jacob. "Modigliani invited me to his studio at the Cité˙ Falguière," writes Lipchitz. [1] "At that time he was making sculpture, and of course I was especially interested to see what he was doing. When I came to his studio — it was spring or summer — I found him working outdoors. A few heads in stone — maybe five — were standing on the cement floor of the court in front of the studio. He was adjusting them one to the other.

"I see him as if it was today, stooping over those heads of his, explaining to me that he had conceived all of them as an ensemble. It seems to me that these heads were exhibited later the same year in the Salon d'Automne, arranged in step-wise fashion like tubes of an organ to produce the special music he wanted."

On the other hand, according to Pfannstiel and after him to the writers of all the other monographs, Modigliani exhibited in only two Salons, the Indépendants of 1908 and 1910.

But in an undated letter that he sent to his brother together with a drawing — of the same type as the Egyptian idol — Amedeo says:

"Dearest Umberto. Thank you first of all for the unexpected help. I hope in time to disintangle myself; the important thing is not to lose my head. You ask me what I plan to do. Work, and exhibit. In the depths of my heart I feel that in that way I shall end up sooner or later by getting on the right track. The Salon d'Automne was a relative success, and it is comparatively rare for those people, who pride themselves on being a closed group, to accept things en bloc. If I come out of the Indépendants well, it will be a definite step forward. Love, Dedo."

This letter, published here for the first time, testifies to the strong links that bound Dedo to his family, who always tried to help him whenever they possibly could; it also bears witness

[1] Jacques Lipchitz, *Amedeo Modigliani*, Abrams, New York, 1952; English edition, Collins, London, 1956.

to how serious he was about his work and confirms Lipchitz's uncertain memories of Modigliani's taking par as a sculptor in the Salon d'Automne. The works accepted *en bloc* could well be the famous hermae, shown one beside the other in the courtyard of the Cité Falguière. In the archives of the Salon d'Automne, the catalogue of the tenth Salon lists. "Modigliani. Nos. 1211-17. Heads, a decorative ensemble."

Moreover, Piquemal wrote me of meeting Modigliani in 1910 in the studio of an Armenian painter, Cazamian (?), at 7 Rue Belloni, near the Cité Falguière. Modigliani at that time made a quick pencil sketch of Piquemal and a few days later, in the latter's house at 37 Rue de la Gaieté, did a portrait of him in oil that was shown that year at the Salon. Modigliani had given him his address on a piece of paper that I have seen: 39 Passage de l'Elysée des Beaux-Arts, Montmartre. It seems therefore that Modigliani went to the Cité Falguière only to do his sculpture and that simultaneously he was doing portraits from time to time.

Finally, incontrovertible documents prove that in 1911 Modigliani showed some statues and sketches representing caryatids in the studio of his friend Cardoso, at Rue du Colonel Combes.

The singular figure of Cardoso deserves to have some light thrown on it.

Amedeo de Suza Cardoso (1887-1918) had arrived in Paris in 1906. He came from a rich Portuguese family and had started studying architecture, but in Paris he soon decided to devote himself to painting and in 1909 rented a studio in the Cité Falguière, where other Portuguese artists were already working. We do not know exactly when Cardoso and Modigliani first met. It may have been thanks to Max Jacob, who always liked to bring his friends together, or perhaps they met by chance in Montparnasse, where Modigliani also saw a lot of the Spaniard, Juan Gris.

Cardoso's widow, as well as the Portuguese painter, Francis Smith, and his wife, a sculptor who was also working in 1909 at the Cité Falguière, have spoken to me of the extraordinary friendship between Modigliani and Cardoso.

Very handsome, proud in the grand manner, a bit of a buffon

but capable of exquisite gentleness, Amedeo Cardoso seems like
a more truculent but happier version of Amedeo Modigliani. But
it is true that the Portuguese lived in relatively easy circumstances
and also that he was absolutely sober.

The retrospective Cardoso exhibition organized by the Maison
du Portugal at Paris in February-March 1958 revealed a marvelously
inventive painter, whose experiments often preceded those of
Fernand Léger or Robert Delanuay. He was sensitive to all the
currents of modern thought; and for intensity of color and lyric
inspiration, some of his pictures are superior to those of the
best-known artists of that time. At the outbreak of the war,
Cardoso and his young French wife went back to Portugal, and
during the four years of life that remained to him, he worked
by himself in a village in the north, always with a marvelous
intuition of what was happening in the artistic world of Paris.

His drawings of the nude and the stylization of some of his
portraits show the intimate freedom with which the two artists
compared experiences. Only his more highly colored use of
drawing, in pencil, pen or brush, and the more decorative value
of his line allow us to distinguish his works from those of Modi-
gliani. It is in this very contrast that the sculptural quality of
Modigliani's drawing stands out. Cardoso's line is an arabesque,
an end in itself, or is used to suggest color; Modigliani's is an
outline meant to suggest volume and depth of plane.

It would be absurd to speak of imitation in either case.
Cardoso was not only Modigliani's one intimate friend during
that period but was also the only person with whom he could
ever work.

When in 1918 the news reached Paris that Amedeo de Suza
Cardoso had died at thirty of Spanish influenza, Modigliani cried
like a child.

Photographs of the sculptures that Modigliani showed at
Cardoso's studio definitely fix the date as 1911. We should add
to these works other heads, a statuette and a caryatid, all in
limestone and now scattered between Paris, London and New York.

At that time Modigliani maintained that real sculpture could
be done only directly in stone but that it made little difference

whether the stone were hard or soft. The important thing was that the works give a feeling of hardness, and that depended entirely on the sculptor.

In some of these heads, the graphic element has an overwhelmingly expressive function (Herswell-Dailey Pomfret collection, Sketch for a Head in the Musée d'Art Moderne, Paris.) In others — the head in the Museum of Modern Art, New York, or the head with an archaic, Greek smile in the Musée d'Art Moderne — the hatchings are a running contrapuntal commentary on the precise rhythm of the heavy yet fluid masses as they develop the different planes. In the New York *Caryatid*, the two heads formerly in Augustus John's collection, and the head in the Victoria and Albert Museum, London, Modigliani finally achieved a perfect and organic balance between the sharpness of his line and the ample development of his volumes. Lipchitz writes that in spite of Modigliani's admiration for the art of Africa and Oceanica, he was never deeply influenced by it. Carli's [1] opinion seems more pertinent: the elementary schemes drawn from primitive art are completely "discounted" and integrated with decorative influences that recall the Orient, India and the Middle Ages. In his contact with Negro art and Cubism, in his discussions with Brancusi, Lipchitz, Gargallo and Zadkine, Modigliani found the necessary stimulus to depict in modern terms a purely plastic variation on decorative, architectonic volumes, devoid of any immediate cultural references.

Without bringing in, as San Lazzaro has done, any notions of a sentimental Italianism, it seems to me that in his sculpture, Amedeo not only successfully solved the contradictions between decorative linear rhythm and compact volume but also found a personal synthesis of his early cultural experiences in Italy and of his later ones in Paris.

Those who consider his sculpture merely as an interlude, a discipline intended to confirm and solidify the painter's vision by the use of other materials, base their argument on the existence of innumerable caryatids in pencil, watercolor, gouache and oil

[1] Enzo Carli, *op. cit.*, pp. 16-17.

and only one in stone. The cost of the material, his difficulties in finding a place to work (his studio was on the ground floor, and he had to work in the courtyard), his illness, the pressure put on him by the dealers and patrons who would rather buy paintings and drawings, all this adequately explains why Modigliani would have done dozens and dozens of drawings on one theme before attempting it in stone. Indeed, the perseverance that he showed up until 1916 in keeping to sculpture is wholly admirable.

His continual moves between Montmartre and Montparnasse — the two banks represent two distinct groups of artists, often hostile one to the other — and his own ambiguous attitude — in 1909-1910, while he was hiding his sculpture from ·Piquemal, he was hiding his painting from Mme Smith — all this, added to the critics' own preconceived ideas, explains why they find themselves in difficulties when they come to discuss his "sculpture period" and the chronology of the individual works.

Last

Brunelle

·— ·— ·—

Last Trip to Italy

During these last few years Max Jacob, Ortiz de Sarate and Brunelleschi, who was then in Paris, had been horrified by Modigliani's physical exhaustion and increased nervous tension. One day in the summer of 1912, Ortiz de Sarate found him lying in a faint on the floor of his room and, alarmed by this, his friends took up a collection and sent him home to his mother.

All the reports as to the date of this third trip to Italy are unreliable and contradictory. Pfannstiel and the majority of the critics do not mention it at all. Charles Douglas places it in 1912 or 1913, and Ida Modigliani, Umberto's wife, has worked out that 1912 is more probable. Eugenia's diary breaks off in 1910, and there are no letters or documents that mention a trip in 1912. All that we have is the indirect evidence of his Parisian friends and the rather vague memories of Ida and of Emanuele's wife, Vera, whom Dedo affectionately called his "little sister-in-law."

His friends in Leghorn, on the other hand, claim that Dedo made his last appearance in his native city during the war, in the summer of 1915 or 1916. As an invalid, he was not liable to military service, but all the same it seems improbable that he could have traveled calmly between the two countries, even though they were allies. When in 1920, more than a year after the armistice, Emanuele got a telegram telling of his brother's death, it took him almost a month to get his passport for Paris, even though he was a deputy.

The most probable supposition is that the visit of which his

old friends in Leghorn have such highly colored memories was
the one that he made there in 1912 or 1913. They scarcely
recognized their Dedo in this stranger — pale, uncared-for and
aggressive — who one summer afternoon burst into the Café Bardi,
demanding in strident, imperious tones, "Is Romiti here? Natali?"

"His head was shaven like that of an escaped convict,"
writes Razzaguta, "and more or less covered with a small cap
with the visor torn off. He was wearing a miserable linen jacket
and open shirt, and his trousers were held up by a string tied
around his waist. He said that he had come back to Leghorn for
the sake of the *torta di ceci* and to get some more of those
convenient and comfortable shoes. Then he added, 'Let's have a
drink,' and ordered an absinthe." [1]

Even if we discount the journalistic exaggerations and the
inevitable simplifications of memory, it is clear that by then neither
his return home, his mother's care, nor the zeal of Caterina, the
dressmaker, were enough to put Dedo back on his feet. On
Razzaguta he made the impression of an eccentric, "a phantom
who came and went when you least expected it."

Alessandro Parronchi [2] asks why Modigliani gave up sculpture
towards 1914 and what effect this last visit to Italy can have had
on his work. He finds Modigliani's success as a sculptor so
surprising that it makes him wonder along which of the two lines
he was developing, but from 1915 on, the artist found the clue to
his painting, "the golden thread of his color." Trying to discover
the genesis of this new assurance, Parronchi finds it in this last
trip to Leghorn, where "the natural beauty of the Mediterranean
could speak to him once again" and where "perhaps, he gave a
backward glance at the tradition of the Macchiaioli and of Fattori."

The testimony of Razzaguta, Romiti, Natali and Miniati,
repeated by Filippelli in the *Rivista di Livorno* [3] and by Ferreri in
an article published in *Oggi* in September 1957, tells a very
different story.

[1] Gastone Razzaguta, *op. cit.*, p. 175.
[2] Alessandro Parronchi, *op. cit.*, p. 56.
[3] Silvano Filippelli, *op. cit.*, pp. 224-239.

Obstinately refusing to discuss painting, Modigliani always had with him photographs of his sculpture which he wanted his friends to admire at all costs. "They were elongated heads, with great straight long noses and a sad secretive expression... and they all had necks that were long and round like their heads." This description clearly points to the series of hermae exhibited in Cardoso's studio in 1911. Since among all these photographs there were none of the caryatids nor of the limestone figure of 1914, I am convinced that this must have been in the summer of 1912 or at the latest, 1913.

"Dedo was most enthusiastic about them and kept gazing at them with an air of satisfaction. But the rest of us did not understand the first thing about them... It is true that at that time he thought of nothing but primitive sculpture. I can still see him holding those photographs, admiring them himself and calling on us to admire them too — while all the time, his enthusiasm and melancholy were increasing."

The enthusiasm was stronger than the melancholy, and Modigliani begged his friends to find him a place to work and to get him some paving-stones. He was so insistent that at last they gave in to him and allowed him to use a big storeroom near the market. They also got him some stones from the street. "... From the day that he got the room and the pieces of stone he disappeared from our sight," Filippelli goes on to say, "and it was some time before we saw him again. What he was up to in that empty room with that stone, no one ever knew. He never asked us there, we never even saw the storeroom nor the stone. Who knows what dreams he was having? But certainly he was up to something, because when he decided to go back to Paris, he asked us where he could store the pieces of sculpture that he had left behind. Did they really exist? Who knows? Modigliani either took them with him or followed our friendly and prompt advice. We answered him as one man, 'Throw them into the ditch.' "

Emanuele told Pfannstiel and Douglas that he gave his brother the money to look for a studio near Carrara. But the sweltering August weather, the light that was so blinding after that of Paris, to which he had at last become accustomed, and the exhaustion

brought on by working in marble, the hardest of stones, all this discouraged him.

According to Pfannstiel, this was the summer of 1909; according to Douglas, that of 1912. The latter, according to Vera Modigliani, is the most probable date.

In all his long struggle to realize his ambition as a sculptor, it was perhaps the incomprehension of his friends at Leghorn that was the most painful episode, and it doubtless influenced his later activity.

23. One of the last photos of Modigliani.

24. Jeanne Hébuterne, 1917.

1912-1914

Between 1912 and 1914 there are no reliable dates for Modigliani's life and work. In the autumn of 1912 he came back to the Cité Falguière with a great pile of books — Petrarch, Dante, Ronsard, Baudelaire, Mallarmé and Lautréamont. In 1913, the Nadelmann exhibition confirmed his belief in the validity of some of his own experiments. According to Douglas, who met him just at that time, he embarked on a period of intense activity in sculpture, drawing, gouache and painting. In 1913 he was sharing with another lover the favors of a certain Gaby, a handsome woman of thirty, who often sat to him as a model for his nudes. It was in that year that Chéron, the dealer of the Rue de la Boétie, used to lock him up in a basement, having first provided him with a model and a bottle of cognac. But if we look into the dates of the works that the monographs attribute to this period, we find no nudes that Gaby could have posed for nor any pictures painted for Chéron.

Enzo Carli[1] assigns to 1913-1914 the series of caryatids — gouaches, watercolors and drawings — in which the line encloses compact masses and at the same time increases in decorative rhythm. Some of these had already been shown at Cardoso's studio and must be assigned to 1911. On the other hand, the *Crouching Nude* in Chester Dale's collection, the *Seated Nude* belonging to Scheiwiller, as well as the *Opulentia*, formerly in the

[1] Enzo Carli, *op. cit.*, p. 17.

Zborowski collection, are most probably of 1914-1915. Pfannstiel in his catalogue [1] assigns to 1913 only a portrait of Dr. Alexandre, and the caryatid, oil on cardboard, in the Verdirame collection.

The number of works given for each year is extremely significant: eight oil paintings for 1914-1915; thirty-six oils and gouaches for 1915; forty-nine oils for 1916; *one hundred and twenty-five* for 1917; eighty for 1918; and eleven between 1919 and his death.

This distribution is based on the thesis that he almost entirely gave up painting between 1910 and 1914 and its parallel, that he definitely gave up sculpture after 1914. But the truth is more complex. In 1913, Modigliani not only painted for Chéron and did pictures of the handsome Gaby, but in that same year he formed a great friendship with Soutine, his neighbor at the Cité Falguière. And two portraits of the same model — one was photographed by Bernheim, the other by Giraudon — reveal, by the thickness of the painting and the exaggerated expressionism of the features, the influence of Soutine, whom Modigliani admired and whose rough edges he attempted to smooth down.

Still in the year 1913, Modigliani, like so many other painters of the School of Paris — among them Kisling, Vlaminck, Dérain and Osterlind — was often at the house of Descaves, a police-officer. He was the brother of the writer and the father of the pianist, and in those days he was buying canvases ten at a time for a hundred francs each. Other police officials followed his example, among them the famous Zamoron, who bought paintings by Modigliani and Utrillo and also let them out when they had been locked up for their frequent and noisy drinking-bouts.

It is therefore impossible that so few works could have been done in 1913, while a hundred and twenty-five are assigned to 1917. But those later than 1916 fetch the highest prices, which may have something to do with the chronology as it now stands.

Paul Guillaume began to buy Modigliani's work in 1914, though it is probable that some of the works that he bought in that year had been painted earlier. On the other hand, all the

[1] Arthur Pfannstiel, *op. cit.*, p. 6 of the "Catalogue présumé."

critics of his 1914-1915 period notice that Modigliani was still hesitating between Cubist disintegration of the planes or compactness of volume. His technique is sometimes fluid, with broad drawing, sometimes thick, with flaky impasto. My theory is that some of the paintings that the critics give to 1914-1915 are much earlier and that the sculptural solidity of his volumes are related to his experiments in actual sculpture.

Moreover, some other portraits that combine sculptural placing of the figures with the thick impasto of Soutine were probably done in 1913.

If it were possible, a biography, giving precise information about his models and the addresses of his studios or his dealers, could definitely resolve the chronological problem, but the contradictory dates that we now have leave room for the wildest guesses.

For example: the portrait of Juan Gris is assigned to 1916, but most probably Modigliani met him in 1909-1910 at Gertrude Stein's on Rue de Fleurus at the same time as his friend Cardoso.

Another extremely typical example is that of Elvira, nicknamed "La Quique." At a certain moment, we meet in Modigliani's work a woman with an oval face, black hair tied up in a bow, and a young but monumental body; the catalogues call her Elvira. She is portrayed nude, seated or standing, or sometimes in a high-necked dress like a school-girl, but it is obviously always the same model. The famous nude, *Elvira* — she is holding a shirt at the level of her thighs, and the composure of her gesture accentuates the splendor of her youthful body — is commonly dated 1919. The hieratic nobility of the attitude and the simplification of the face, which is at once a portrait and a type, and the perfect equilibrium of the compact masses emphasized by the purity of the line, as well as the transparent delicacy of the impasto, show that this portrait certainly belongs to the style of his last years.

But all the biographers mention his liaison with a dance-hall girl from Montmartre, Elvira, known as "La Quique," whom the abuse of drugs had not deprived of a certain dash and youthful ardor. The story is that she and Modigliani used to shut themselves up together in the studio on Place J.-B. Clément, well-provided

with canvases, paints, alcohol and drugs, and that out of that
cloistered existence would come mock-heroic drinking sprees as
well as innumerable paintings.

We do not know exactly when Modigliani left that address,
but we know for certain that he was not there after 1912. (He
moved in turn to the Cité Falguière, to 39 Passage de l'Elysée
des Beaux-Arts, to the Boulevard Raspail, and to Rue Saint-Gothard,
and in 1914 Paul Guillaume found him a studio in Rue Ravignan,
near the celebrated square of the Bateau Lavoir, now Place Emile
Goudeau. All his biographers, by the way, confuse the studios
of Place J.-B. Clément with that of the Rue Ravignan.) In any
case, we are a long way from 1919, the date that the critics give
for the famous nude, *Elvira.*

La Quique's personality and charm were so strong that after
the war Charles Douglas, who had known her before 1914,
thought it worth while to present several bottles of white wine
to Mme Gabrielle D., a well-known Montmartre figure, so that
she might tell him what had happened to Elvira and what she
could remember of the brief liaison with Modigliani.

He was thus able to reconstruct the history of this singular
personage. The daughter of a Marseillaise prostitute and a father
whose identity was officially unknown but who was supposed to
be a Spaniard ("La Quique" is probably short for "La Chica"),
Elvira ran away to Paris for the first time at the age of fifteen.
She then went abroad with one man after another and when she
came back to Paris five years later, it was from Germany, where
she had learned singing. Cocaine soon ruined her voice.

Encouraged by the white wine, worthy Mme Gabrielle told
Douglas that one evening she had seen two maniacs dancing naked
in the little garden of Place J.-B. Clément. She recognized her
old friend Elvira and the next day went to call on her and saw,
hanging on the wall, a fine portrait of her naked to the waist.
Elvira was shot as a spy in Germany during the war.

Even supposing that Mme Gabrielle confused the little garden
of Place J.-B. Clément with that next to Rue Ravignan, the scene
could be only a little later, in 1914, the year in which Modigliani
had the Rue Ravignan studio. But then who is Elvira, painted

half-nude in a picture assigned to 1919? Perhaps Modigliani repeated the pose and arrangement of an earlier canvas that has disappeared and called it *Elvira* in honor of his former friend. Perhaps even before 1919, exalted by his liaison and by his exceptional model, the painter had already found the limpid sureness that he would definitely achieve only much later.

At any rate, the story seems to me to be typical in all its details: the beautiful courtesan, poverty, crises of exhibitionism while under the influence of drugs, and above all, the improbability of the traditional dating for the work. Pfannstiel, for example, calmly dates the liaison 1913 and gives 1919 as the date for the portraits of Elvira.

Paul

In
On Apr

only pu
Zborow

and he
a studio

and wh
Th
Pilota"

before l

persona
met wit
and Léa
position
to the (
is also t
holding
The inf

¹ S

Paul Guillaume and Beatrice

In 1914 Max Jacob introduced Modigliani to Paul Guillaume. On April 6, 1932, Guillaume wrote to Scheiwiller:

"In 1914, through all of 1915 and a part of 1916, I was the only purchaser of Modigliani, and it was only in 1917 that Zborowski became interested in him. Modigliani was introduced to me by Max Jacob. He was then living with Beatrice Hastings, and he worked either in her house, at the painter Haviland's, in a studio that had been rented for him at 13 Rue Ravignan, or in a little house in Montmartre where he had lived with Beatrice and where he did my portrait."

The portrait of Paul Guillaume — with the words "Novo Pilota" written on the lower left-hand corner — was painted in 1915 at 13 Rue Norvins, the house where Beatrice lived and before her, Emile Zola. [1]

The rather angular quality of the portrait and the completely personal use that Modigliani made of Cubist teaching is also to be met with in his later works, such as the portraits of Jean Cocteau and Léon Bakst or in the seated *Margherita* (1916). The juxtaposition of the cool colors of Cézanne with warmer tones, according to the chromatic system that he had already tried in *The Cellist*, is also to be found in the portrait of the woman in a sailor collar holding a baby — *Gypsy Woman with Baby* — assigned to 1919. The influence of Van Gogh, photographs of whose works all the

[1] See *Les Arts à Paris*, October, 1925.

young artists were buying from Castellucci, Rue de la Grande
Chaumière, is apparent also in the portrait of Devaraigne, which
the artist himself dated 1917, and in the *Maud* of the Renaud
collection.

His sculptural training shows in the portraits of Juan Gris
and Kisling (1915), the series of portraits of the servant-girl with
a goiter, in *Madame Pompadour*, in *Antonia* and in the *Enfant gras*
in the Vitali collection, all of which date from 1915.

On November 9, 1915, Dedo wrote to his mother:

*"Dear Mother. It is wicked of me to have left you for so
long with no news. But... but so many things.... First of all, I have
moved; my new address, 13 Place Emile Goudeau. But in spite
of all these ups and downs, I am relatively happy. I am painting
again, and selling, which is something."*

From 1914 to 1916, Modigliani was living with the English
poet, Beatrice Hastings, and selling his pictures to Paul Guillaume.
Even so, he had not given up sculpture altogether. The Greek
painter Galanis, who still lives at la Bute, had met Modigliani in
1913. One morning, while Mme Galanis was marketing, a hand-
some young man approached her in the best Italian manner,
offered to carry her basket for her, and insisted on seeing her home
even after he learned that she was married. When they reached
the studio, Modigliani recognized Galanis, already well-known as
a painter and engraver. The Greek forgave the Italian his Gallic
behavior, and the three became great friends. Galanis remembers
that in Beatrice's apartment in the Rue Norvins some of Modi-
gliani's sculpture in stone was still to be seen and, in 1915, Modi-
gliani called on Berthe Weill and asked her to go and see some
of his sculpture. [1]

Luigi Tobia, the son of the Rosalia who kept a little restaurant
in the Rue Campagne Première — it still exists, but Rosalia was
giving it up in 1932 when I first met her, a beautiful old woman
with curly gray hair — remembers that around 1916-1917 a

[1] Berthe Weill, *"Modigliani chez Zborowski"* (and other writings on
Modigliani), Paris, 1933.

building was going up next to the restaurant on Boulevard Montparnasse. Modigliani had his eye on some of the stone blocks, and one summer midnight he secretly started a piece of sculpture. The next morning the workmen built it into the foundations, in spite of the prayers and imprecations of the artist. There are innumerable such stories of statues begun but then lost in gardens or "*terrains vagues*."

R.-K. Wilenski, a friend of Charles Douglas, thinks that it was only in 1915 that Modigliani *almost* gave up sculpture to devote himself to painting.

Charles Douglas, who in 1915 was living in Place du Tertre, next door to Modigliani and Beatrice, also remembers having seen some sculpture in the Rue Norvins. Modigliani tried to convince Douglas that Negro art was not a purely religious one, in which the objects, conceived in relation to a cult, had only a secondary aesthetic value in the eyes of modern connoisseurs; but that it was art in the fullest sense of the word, the result of conscious experiments in plastic expression on the part of real artists.

This is also the period of the most picturesque anecdotes. Douglas himself remembers that one morning, after an excursion into the "*milieu*," the street-sweepers picked Modigliani, bent double and dead-drunk, off a dustheap. He also remembers having heard him shouting some of Rimbaud's verses in the Café de la Mère Hubert. And one day, when they were both sober, they recited to one another alternate fragments of the *Chants de Maldoror* in the cemetery of Montparnasse.

These clownish exploits of Modigliani make up the better part of very many reminiscences for two reasons; the first, obviously, is because "a man can live quietly for months on end and no one pays any attention, but if one fine day, as often happened with Modigliani, he breaks out and becomes roaring drunk, everyone remembers and talks about it."[1] The second reason is because an aggressive and shameless truculence was one of the fundamental characteristics of the atmosphere of artistic

[1] Nina Hamnett, *The Laughing Torso*, London.

Paris in those days, and both those who looked on and those who took part in it, recall it all the more insistently because now, in their sober and steady old age, it throws a bright halo around the days of their youth.

And Modigliani is its symbol: his innate violence — Douglas was present at scenes of jealousy with Beatrice that had nothing to do with play-acting — and the intensity with which he suffered the knocks of fortune give a tone of authenticity to even the most well-worn legends. His own death and the suicide of Jeanne Hébuterne make a fitting conclusion to his violently colored life.

Modigliani explained to Douglas that hashish enabled him to conceive extraordinary combinations of color. To conceive them, yes; but could he carry them out? Sometimes he even mixed hashish and cocaine, reinforcing their effects with alcohol, and then he became impossibly quarrelsome.

Between 1914 and 1916 Modigliani painted about ten oil portraits and innumerable drawings of Beatrice Hastings and a series of portraits and compositions — among them *La belle épicière* and *Bride and Groom* — in which the formal elaboration of the themes that he had learned from Cubism, from Cézanne, and from his own experience as a sculptor go hand-in-hand with a consistent striving for phychological characterization. In some of these — *Lola de Valence, Paul Guillaume, Bride and Groom* — there are also elements of satire and caricature.

His desire and his capacity to place his sitters in their proper setting is obvious. *A propos* of this, Douglas recounts a curious episode. Modigliani had done a portrait of him, a drawing called *The Pilgrim,* which was afterwards stolen from Zborowski. "He showed me in shorts and with an open, short-sleeved shirt; I was wearing a Terai helmet, and the muzzle of a hunting dog was sticking out between my legs. I am practically certain that he could not have known that I had spent several years in central Africa."

Beatrice Hastings comes into the legend as a sort of eccentric Lady Brett, overbearing and seductive. According to some, it was she who encouraged Modigliani to drink and to poison himself with drugs; others say that she attempted to restrain him and to

make him work. It makes very little difference that, although she was beautiful, distinguished and rich, she amused herself by flaunting the most impossible English hats and that, according to Foujita, she used to wear on her arms baskets full of live and quacking ducks.

A woman of education, a poet and a journalist, she was not only Modigliani's mistress and model but a real companion as well. From that time on, his work became continually more sure, more intense, and more serene. Consider only two of the most finished portraits, *Beatrice in a Fur Cap* and *Beatrice in a Checked Dress,* in which Cubist influence (one even has a small piece of newspaper glued to it), the sharp drawing of the face, and the knowing intersection of the planes are like secondary themes in music, subordinate to the delicate and vibrant color modulation from which spring the dense, precisely articulated volumes of the curves of the eyelids, nose and mouth.

In the portraits of Diego Rivera, Frank Haviland and *Beatrice at the Piano,* the brush-work is Impressionistic. I should not go so far as to say with Venturi: "His line strove to emerge from the apparent chaos of Impressionistic strokes of color; his feeling for line as an idea preceded its material execution, by that process that is true art." [1]

If we study the portrait of Diego Rivera, the brush-work does not suggest Impressionistic vibrations of light, but it goes in spirals so as to bring out, according to Van Gogh's theory, the essential masses. From the swirling profusion of dark colors that surrounds the vast bulk of the enormous Mexican, his round face, so insolent and quickwitted, breaks forth like the sun; the long eyes under their drooping lids, the detailed drawing of the nose, the precision of the turgid mouth, all are comments in different keys on Rivera's pleased truculence. With Modigliani, line is never an end in itself nor essentially decorative. It has a double function: to contain the volumes and to comment on the plastic and psychological characteristics of the sitters.

[1] Lionello Venturi, "*Sulla linea di Modigliani,*" *Poligono,* February, 1930.

Zbor

In 1'
more and
It was in
he first m
Foujita's
ings, as :
that time
known a
woman v
and a si
entirely t
dealers, t
the newly
disposal
Joséph B
wife, An
sitters, th
little Pau
The most
but the s
his widov
completel
 Mme
flexible

Zborowski

In 1916 Modigliani's relations with Beatrice were becoming more and more stormy, and his health was deteriorating as well. It was in this period of great creative and emotional stress that he first met Leopold Zborowski. According to the legend, it was Foujita's first wife who urged the Pole to sell Modigliani's paintings, as she herself was selling those of the Japanese artist. By that time, Zborowski, a middle-class intellectual, was already well known as a poet. His wife was also Polish, of good family, a woman with a pale, perfect oval of a face, close-set black eyes, and a sinuous neck. Until 1920, Zborowski dedicated himself entirely to his new mission in life, which was to make known to dealers, to writers like Carco, and to great couturiers like Poiret, the newly discovered talent of Modigliani. He put at Modigliani's disposal not only the largest room in his apartment in the Rue Joséph Bara but also models who were often friends as well; his wife, Anna, who was to become one of Modigliani's best-known sitters, the distinguished and sweet-natured Lunia Czechowska, and little Paulette, the child with the ribbon in the well-known picture. The most contradictory opinions have been held about Zborowski, but the significant fact remains that he died so poor in 1932 that his widow was forced to sell his whole collection, which is now completely dispersed.

Mme Zborowska still carried her pointed chin above the most flexible neck that I have ever seen and still goes crimson with rage at the mere mention of Soutine. One day Modigliani had

painted a portrait of the latter on the door of the Rue Joséph Bara, but the aristocratic Pole could not bear to have in her house the sensual and troubled image of poor Chaim, the dirty, pathetic fugitive from the Vilna Ghetto. It was probably on his wife's account that Zborowski refused to patronize Soutine, in spite of the insistence of Modigliani, who considered Chaim one of the great painters of his day.

Some say that on his death-bed Amedeo murmured to Leopold, "It is all up with me now, but I am leaving you Soutine." Others tell how the handsome Italian taught the poor Jewish villager to blow his nose with a handkerchief instead of with his fingers, and to clean his nails. But both these stories are probably only part of the legend. Without doubt, Modigliani had the deepest admiration for Soutine as an artist and a warm-hearted indulgence for him as a man. For all his shameless behavior and gratuitous insolence, Modigliani could appreciate the work of Picasso, surround Utrillo with the most tender care — inviting him to eat with him at Rosalia's after Utrillo had escaped from the sanitarium at Sceaux — and in spite of the ridicule of others, put a true value on Chaim's genius. These are the characteristics handed down by the legend that still seem to fit in with the gentleness that he showed "*envers et contre tous*" in his early youth and that some of his friends still remember. He did two portraits of Soutine. In that of 1918, the attitude is tranquil, with the unmistakably prominent nose and sulky mouth, but behind the troubled gaze, the sitter is tragically alone; in the other (1917) the blotches on his face contrast with the Oriental fixity of his asymmetric gaze. And yet the man who painted these was to paint the shabby, awkward little boys — like the one that he had done so long ago in Micheli's studio — dreaming their ridiculous and pathetic dreams; the stupid, dignified servant-girls, their faces set slantwise on necks that are either cylinders, like those in Tino di Camaino's work, or else are swollen with goiter; maids-of-all-work and whores, withered and tragically tense as they face a dark and troubled future.

In the portrait of Margherita, the line of her eyebrows is a graphic echo of the thin folds of her apron and, at the same time,

a horrifying sign of her condition; the portrait of Toto, with her little cross at her neck, has the essence of caricature in the tuft of hair on her forehead and her plucked eyebrows, but the harmony of warm reds and browns raises it above a mere likeness and turns the sitter into a pitiable and human creature. Yet the man who painted these is also the unbearable drunkard who, during his liaison with Beatrice, tried to change his Tuscan accent into an English one and whom Beatrice herself, meeting him for the first time in a milk shop in 1914, found "ugly, fierce, and greedy." The next day she saw him again, freshly shaven, at the Rotonde. "He raised his cap with a graceful gesture and invited me to come and see his work." Beatrice added: "He despised everyone except Picasso and Max Jacob. He had never done any good work while he was under the influence of drugs." And it was the same Modigliani who, one day at the Rotonde, finding himself next to a friend who was even more penniless than he was, let fall a twenty-franc note as he was leaving and said, "Look out! I think you must have dropped something."

By that time Modigliani was no longer unknown. He was appreciated by writers like Apollinaire, Jacob, Salmon, Carco, Roger Wild and Jean Cocteau. Collectors such as Descaves, Paul Guillaume, Netter, Lavel, Chéron and Berthe Weill took an interest in his work. San Lazzaro claims that Kisling, Picasso, Zadkine, Soutine, Friesz and Chagall regarded him only as a sympathetic dilettante, but this is not in the least true. From 1914 to 1918, Modigliani had established himself in the esteem of his friends and of the more clear-sighted and courageous collectors, to such a point that at Cagnes in 1919, the famous Renoir, although old and ill, consented to receive him, because "I have heard that he is a great painter."

On a card to his mother, stamped Florence, July 7, 1916, Amedeo wrote that he had thought for a moment that he might be called back for military service even though he was an invalid, and that he had felt a slight wish to return to Italy, "but — I am still here." The year 1916 was a fortunate one for him. Zborowski could make him only a small monthly allowance, but it was at

least sufficient to give him some feeling of security. On November
16, 1916, he wrote:

"*Darling Mother. I have let too much time go by without
writing, but I haven't forgotten you. Don't worry about me.
Everything is going well. I am working and if I am sometimes
worried, at least I am not as short of money as I was before.
I wanted to send you some photographs, but they didn't turn out
too well. Send me your news. A big hug from Dedo.*"

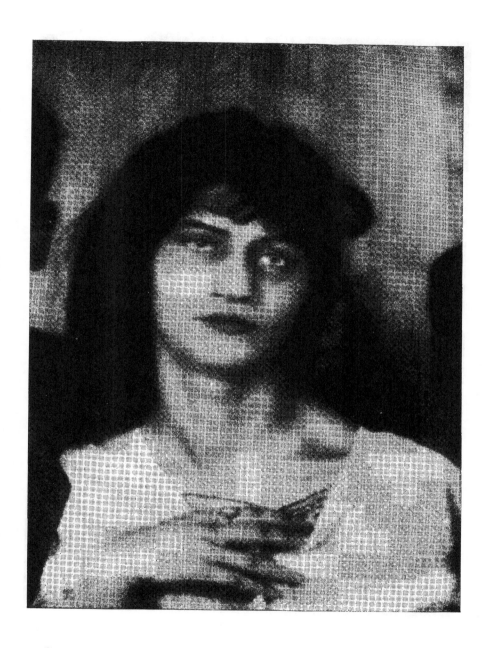

25. Jeanne Hébuterne.

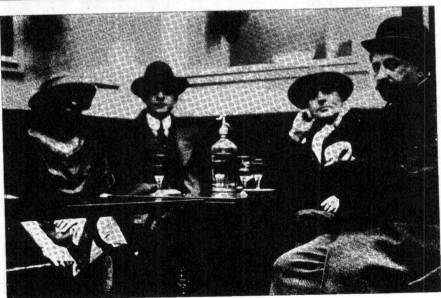

26. Leopold Zborowski; 27. Osterlind, Zborowski, Modigliani and
Osterlind's daughter; 28. Unidentified woman, Basler, Modigliani and Adul.

29. Oil painting by Jeanne Hébuterne, Nice, 1918.

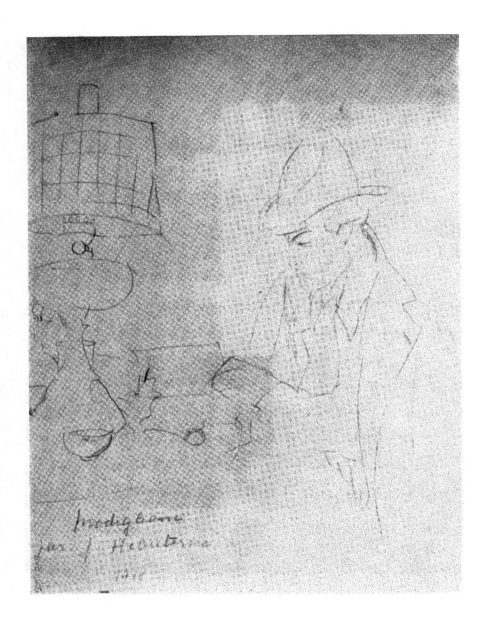

30. Portrait of Modigliani by Jeanne Hébuterne, Nice, 1918. The writing on the bottom, left, is by Paulette Jourdain.

1916-1920

To 1916 can probably be assigned some nudes usually dated 1917 or 1918, done with a flaky impasto and reddish in color. Anna Zborowska and Beatrice posed for them.

In 1916 Jacques Lipchitz and his wife decided to have Modigliani do their portraits. "I charge ten francs and a little alcohol for each sitting," said the painter. "He came the next day," recalls Lipchitz, "and made a lot of preliminary drawings, one right after the other, with tremendous speed and precision... Finally a pose was decided upon — a pose inspired by our wedding photograph.

"The following day at one o'clock, Modigliani came with an old canvas and his box of painting material, and we began to pose. I see him so clearly even now — sitting in front of his canvas which he had put on a chair, working quietly, interrupting only now and then to take a gulp of alcohol from a bottle standing nearby. From time to time he would get up and glance critically over his work and look at his models. By the end of the day he said, 'Well, I guess it's finished.' " [1] Lipchitz had wanted to help his friend earn a little money thinking that he would take several sittings to do the two portraits, and he insisted that Modigliani work some more. "If you want me to ruin it, I can go on," answered Amedeo. He did not ruin it, but this was certainly the only time that he resumed work after a first sitting.

We know very little about his methods; he preferred a

[1] Jacques Lipchitz, *op. cit.*

closely woven canvas and sometimes he spread a sheet of paper over the fresh paint in order to obtain a better blending of his colors.

Like Van Gogh — the portrait of Dr. Devaraigne is really an act of homage to the Dutch painter — he was interested above all in human beings. Occasionally he finished a picture alone but in order to begin one, he always had to have a model. "To do any work, I must have a living person," he explained to Survage. "I must be able to see him opposite me."

Lipchitz, Zborowski and little Paulette resigned themselves to the necessity of providing Modigliani with a bottle of wine or cognac during the sittings. Alcohol made it possibile for him to maintain his creative force at a high pitch. If the question as to why Modigliani drank is a purely psychological one, the question as to why he *had* to finish a picture at one sitting and why, after resting from it, he was unable to take it up again, is of fundamental importance. Perhaps to his knowledge that he had only a few years to live was added the anxiety of an artist tortured by conflicting aesthetic problems, and easily discouraged. He never ceased to long for the sculpture that he had abandoned, and it was this consuming regret, even more than his excesses and his poverty, that undermined his mental stability and his own faith in himself.

We can see this torment, purely artistic and neither mystical nor metaphysical, in the continual reappearance of sculptural tendencies in all his work up to the very end. In the portrait of Survage (Nice, 1918) and in that of Anna Zborowska (1918-1919), the face grows out of the cylindrical mass of the neck in a rigid articulation of hard volumes like that of the 1911 hermae.

In the last three years of his work, we can sometimes see two tendencies alternating with, or overlapping, one another. On the one hand, the composition becomes more flowing and takes on a calligraphic elegance; the canvas is visible between the thin brush-strokes, and the color recalls the luminous freshness of a Persian miniature. To this group belong the rose-colored nudes and the portraits of Jeanne Hébuterne done at Nice. On the other hand, there is the series of nudes (1917-1919) in which the joyous

opulence of the volumes has a broad, precise rhythm and is lit with a sumptuous color recalling that of Titian. Obviously inspired by Titian, too, is the pose of the *Nude with Necklace*, formerly in Francis Carco's collection. In this *Nude*, in the other *Nude with Necklace* — with her arms behind her head — formerly in the Fénéon collection, and in the *Seated Nude* that used to belong to Bignou, the technique is thick and clotted.

In all these *Nudes* with their rich impasto and warm tonalities, as well as the *Nude Lying on a Sofa* and *Nude Lying on her Left Side*, both formerly belonging to Zborowski, the balance between the sculptural solidity of the volumes, the linear rhythm, and the lyricism of the color, is perfect. They are creations teeming with sensual and poetic life. The faces seem to be treated in a simple and synthetic manner, but each one is as distinct and definite as though it were a portrait. A necklace, an earring, the fringe of an eyebrow, introduce an ironic and graceful note, an indication of the spirit behind the purely animal splendor, but like the dashes or spots of color in the background, they also have an essentially plastic function. Many of the drawings have in their otherwise empty spaces little touches of seemingly gratuitous whimsy, as though the artist were giving a smile and a wink at his public. But if we try to do away with them, we see that they represent elements that are indispensable to the complete structure of the composition.

In some drawings the line looks as though it had been spun; the curve consists of a series of minute tangents, not because Modigliani's hand was trembling, as Foujita supposes, but in order to suggest dimension in depth.

Modigliani's best drawings, in my opinion, are not the most elegant, like the *Seated Nude* (Greenless collection), but those that are freer and looser, like the portrait of Leopold and Anna Zborowski (dated May 19, 1917), of the painter Donato Frisia, or the more robust ones — the drawings of a born sculptor — like the *Seated Nude* of the Scheiwiller collection or the *Nude* that used to belong to the Modiglianis.

Art-dealers, publishers, and the public often prefer works that are exquisitely finished but that are too mannered for my taste. In

the *Roman Woman* and in the profile portrait of Lunia Czechowska, the line wins out, revelling in the decorative grace of its unmistakable style, but this happens to the detriment of more solid plastic values.

Modigliani's line, together with his once notorious distortions, never stands alone, but in his most successful works, it is always the connecting link between the plane surface and the depth behind it. In speaking of his distortion, it is well to remember that although he had a predilection for models with long oval faces and flexible necks, when he was faced with the completely opposite physical type, as in the portraits of Rivera, Germaine Survage and Lipchitz, he would accentuate the sherical quality of the volumes. In an analysis that could be applied to the *Portrait of a Young Woman* (Jeanne Hébuterne), formerly in the Gualino collection, Lionello Venturi wrote in 1930:

"This face, in an almost frontal position, was constructed in such a way that from the crown of the head to half-way down it appeared to be receding, while the lower half pointed in the opposite direction and emerged again into the foreground. That is, the face that seemed to be spread over a plane surface is painted in double perspective to suggest depth in space. "

This function of line that simultaneously develops the image in depth and turns it back from the surface is clearly seen in the best portraits of Jeanne Hébuterne (wearing a shirt, seated in profile, seated sideways with her hands in her lap, or leaning against the back of a chair), of Anna Zborowska, of Lunia Czechowska, and in the two *Maternities* of 1919. A chest of drawers or a door are used to build up a background of planes one behind the other, in a way that Modigliani had already experimented with in his youthful work, the *Seated Boy*.

Along with the plastic balance of this period goes Modigliani's quiet affection for his humble sitters. The apprentice, the peasant, the porter's son, the servant-girl at Cagnes, little Marie, the two Parisian children, all come into Modigliani's world composed and dignified in their heart-breaking sadness. Their inward gaze accentuates their spiritual loneliness and surrounds them with an air of poetry. Their life is certainly not a happy one, but it is

rich in nobility and in spiritual values that are expressed with classic reserve. They are convincing witnesses to the essential beauty and goodness of human nature.

For anyone who knew only the nudes and portraits of Modigliani's last years, his life would seem to be the pertinacious and quiet manifestation of a mild optimism.

Jeanr

Dur
from the
and she
with her
mother I
Her fath
perfume
and an
the war
of Pasca
Jeannett
family g
father's
averse to
great tea

Dur
where J;
wall, an
a sort of
middle.
pose of
are in th
was sma
it her co

Jeanne Hébuterne

During the Carnival of 1917, Modigliani met a young student from the Académie Colarossi. Her name was Jeanne Hébuterne, and she was nineteen years old. She lived at 8 bis Rue Amyot, with her father Achille Casimir Hébuterne, an accountant, her mother Eudoxie Anaiis Tellier, and her brother André, a painter. Her father had a square white beard and worked as cashier in a perfume shop. A passionate student of seventeenth-century literature and an atheist, he suddenly became a Roman Catholic. During the war of 1914, as an ardent neophyte, he used to read fragments of Pascal to his wife and children while they peeled potatoes. Jeannette Hébuterne later told her friend Germaine Wild of these family gatherings with a certain irritation in her voice, but her father's influence had its effect on her and she herself was not averse to abstract speculation. She considered Plotinus to be a great teacher.

During the Carnival, Jeanne was at the studio of some friends, where Japanese prints and sketches of ballerinas hung on the wall, and she had dressed herself up in a pair of high boots and a sort of Russian blouse made out of a cover with a hole in the middle. Her high chignon, her bangs, the somewhat languid pose of her hands are the same in a faded photograph as they are in the first portrait of her that Modigliani ever painted. She was small, her hair was chestnut with reddish lights, and against it her complexion was so pale that the contrast made her friends

nickname her "Coconut." Mme Roger Wild, who has devotedly
kept the only remaining photographs of Jeanne, remembers her
as a serious, intelligent girl with a strong personality. Paulette
Jourdain, the little Paulette who was Modigliani's model and
Zborowski's friend, gave me one of Jeanne's oil paintings, a
view of a courtyard seen above, sober in its warm tonalities of
dark red, brown and rose and composed with a bold assurance
surprising in such a young girl.

Legend has turned Jeanne Hébuterne into a sweet, humble,
docile creature, but Mme Wild, who knew her before she went
to live with Modigliani, asserts that she had great talent as a
painter, an opinion that is confirmed by some of her drawings.

In June 1917, Jeanne and Amedeo rented a studio on the
Rue de la Grande Chaumière. Léopold Zborowski hoped that
Modigliani, now that he was emotionally satisfied, could find the
energy to reform his disorderly existence. To encourage him, he
arranged for an exhibition at Berthe Weill's in October 1917. On
the day of the opening, the police removed the five nudes that
were being shown, on the grounds that they were an offense to
decency. No pictures were sold.

In the meantime Modigliani continued to work at an ever-
increasing speed. During the long hours that he spent at the
Rotonde, he drew portraits of anyone who happened to sit next
to him and often to sell them to the clients. Nina Hamnett
remembers seeing him offer these serene, limpid drawings with
his usual annoying insolence: "I am Modigliani. A Jew. Five
francs." Most of these drawings were bought by Swedes.

He continued his spectacular drunken scenes ("You would
think that Modigliani can't even get tight except at the crossroads
of Montparnasse," was Picasso's malicious remark), his arrogant
behavior and the violent aggressiveness that once, according to
Chantal Quenneville, the painter, led him to hit people over the
shoulders with a soda-water siphon; but at the same time, the
contrast between this way of life and the style of his painting
became increasingly more marked.

His health was growing worse and in March 1918, when
Jeanne confessed to her family that she was pregnant, the

Hébuternes and Zborowskis decided that the young couple must spend the winter in the south.

They all left together, the Zborowskis, Jeanne, her mother, and Amedeo, and, at Nice, they met the Survages.

They had rented an apartment on Rue Masséna, but relations between Modigliani and his mother-in-law became more and more strained, and Amedeo moved to the Hôtel Tarelli, 5 Rue de France. Zborowski went back to Paris but later made a flying trip to Nice to try and sell some pictures.

On November 29, a little girl was born at the Nice Maternity Hospital and registered as Jeanne Hébuterne. On February 6, 1923, Félicie Cendrars, the first wife of the writer, wrote to Eugenia Garsin:

"(Modigliani) was a great friend of Blaise Cendrars, my husband, and was often at our house when I lived in Paris in 1915-1917. I saw him at Nice in 1919... Jeanne was wearing two plaits round her head in a coronet. I saw her for the last time at Christmas, after the baby was born. They were both going to look for a wet-nurse, because neither she nor her mother could do anything with the child. The baby was only three weeks old, and Jeanne was still very tired. A tangerine that Modigliani gave me — we were in front of a fruit-shop — and another that he gave to his wife; that is my last memory of them."

From a postcard that they sent to Zborowski, we learn that Survage and Modigliani celebrated the end of 1918 together:

"On the stroke of midnight.
Dear Friend; I embrace you as I would have done if I could the day you left. I am hitting it up with Survage at the Coq d'Or. I have sold all my pictures. Send me some money soon. Champagne is flowing like water. We send you and your dear wife our best wishes for the New Year. Hic incipit vita nova.

The New Year!
Modigliani."

Survage added in French, "*Long live Nice! Long live the first night of the first year!*" and added in Russian, "*Happy New Year!*"

Years later, Survage, drinking champagne on his seventy-fifth birthday, said to me: "We were pretending that first time. It was only red wine."

The gullible Zborowski thought that Modigliani really had sold all his pictures and Modi soon wrote to him again:

"*Dear Friend. You are naïve and can't take a joke. I haven't sold a thing. Tomorrow or the next day I'll send you the stuff.*

Now for something that is true *and very serious. My wallet with 600 francs has been stolen. This seems to be a speciality of Nice. You can imagine how upset I am.*

Naturally I am broke, or almost. It is all too stupid, but since it is neither in your interests nor in mine to have me stop working, here is what I suggest: wire me, care of Sturzvage, [1] *500 francs... if you can. And I'll repay you 100 francs a month; that is, for five months you can take 100 francs out of my allowance. At any rate, I shall keep the debt in mind. Apart from the money, losing all my papers worries me enormously. That was all that was needed... and now, of all times, just when I thought that I had finally found a little peace. Please believe in my loyalty and friendship and give my best wishes to your wife. Most sincerely, Modigliani.*"

Modigliani never wrote so much as he did during that visit to Nice; there are nine letters to Zborowski, either asking for money or thanking him for what he had already sent. In all of them Modigliani shows great anxiety in regard to his friend and dealer, on whom he knew that he was a financial burden, even when it came to the little difficulties of life — the replacement of the stolen documents, pictures that did not dry fast enough in the cold weather, and so forth. The letters are very moving, for in order not to seem to be a parasite, the artist forced himself to

[1] Leopold Sturzvage, known as Survage.

paint a given number of pictures each month, just at a time when he most needed to stop for breath, to get used to this new light, this new rhythm, this new backgronud.

Soon afterwards, he was again asking Zborowski for money:

"*I have seen Guillaume. I hope that he can help me with the documents. He gave me some good news. Everything would be going well if it were not for this damnable piece of bad luck. Why can't you help me — and quickly — so as not to stop something that is going well. I have said enough. Do what you will — and can — but answer me — it's urgent. Time presses.*"

Zborowsky sent 500 francs and Modigliani wrote to him at once:

"*I have gone back to work. I must explain — though real explanations are impossible in letters — that there has been a 'vacuum.' I had a charming letter from your wife. I don't want you to wipe out any of my debts — on the contrary. Set up, or let us both set up, a credit for me.*"

It would seem that Zborowski, like Théo Van Gogh, was always ready to help but that Modigliani, like Vincent, always felt as though he were both culprit and victim.

In the meantime, he kept bombarding Zborowski with demands for a letter from Guillaume to the Italian consul at Nice. The idea of being held in the south for lack of the stolen papers tortured him; by now he was accustomed to the light of Paris, and the southern sun upset him. He tried some landscapes but was afraid that "the first canvases look like a beginner's."

On April 13, 1919, he sent a postcard to his mother from Cagnes: .

"*I am here near Nice. I am very happy. As soon as I am settled, I shall send you my permanent address.*"

A little earlier he had written in an undated letter:

"*Darling Mother. A million thanks for your loving letter. The baby is well and so am I. You have always been so much of a*

mother that I am not surprised at your feeling like a grandmother, even outside the bonds of matrimony. I'll send you a photograph. I have changed my address again; write to me, 13 Rue de France, Nice."

In January or February, 1919:

"*Dear Zbo. Thank you for the money. I am waiting until a head of my wife is dry before sending you — with the ones you know about — four canvases.*

"*I am like the Negro, just going on. I don't think that I can send more than four or five canvases at a time, because of the cold. My daughter is wonderfully healthy. Write if all is too much trouble...*

"*Please send the canvases as soon as possible. Don't forget the Place Ravignan business, and write to me.*"

What was the "Place Ravignan business?" Perhaps there were some pictures to be rescued from his old studio, but it is hard to know definitely.

On February 27, 1919:

"*Dear Friend. Thank you for the five hundred and above all for the speed with which you sent it. I got the canvases off to you only today — four.*

"*I am going to start work at 13 Rue de France. All these changes, changes of circumstance and the change of the season, make me fear a change of rhythm and atmosphere. We must give things time to grow and flower.*

"*I have been loafing a bit for the last few days. Fertile laziness is the only real work.*

"*Thanks to my brother, the business of the papers is almost finished. Now, as far as that goes, we can leave when we want to. I am tempted to stay here and to go back only in July.*"

In the interval he had taken up doing figures again, but models were lacking.

Before leaving Nice, Zborowski had entrusted Modigliani to the care of his friend, the painter Osterlind. Between his stays at

the Hôtel Tarelli and 13 Rue de France, Modigliani spent some
months in the Osterlind's villa, "La Riante," Chemin des Collettes,
Cannes. Osterlind and his beautiful wife, the golden-eyed Rachel,
had been living for years in the south. She was slowly dying of
intestinal tuberculosis, the result of Spanish influenza. Modigliani
painted her one day, seated in a rocking-chair, her face resting
softly on her right hand. The portrait was later stolen from
Osterlind and came to light again, slightly repainted, only a short
time ago.

Modigliani often escaped from his friends, who were
abstemious tea-drinkers, and took refuge in a bar at the top of
the Chemin des Collettes. There at a rustic wooden table, polished
to a marvelous luster by the elbows of the local workmen, which
Modigliani thought looked like "a table by Cézanne," he would
drink absinthe under a poster advertising Pernod, which for its
simplicity, made more noble by the haze of so much pipe-smoke,
seemed to him to be highly superior as a work of art to those
shown at the official Salons.

The portrait of the *Little Girl in the Blue Apron,* which has
touched so many spectators, was painted, it seems, in a ferocious
rage, because the child, instead of bringing him the liter of wine
that he had asked for, brought him lemonade instead.

Modigliani, like so many others, had had the famous Spanish
influenza and, terrified by his weakness and by his inability to
recover his strength, he stopped smoking and drinking for a
short time. Following this, there were months of intense activity;
the portrait of a servant girl at Cagnes, of Blaise Centrars, of the
actor Modot, and of Survage's wife. The latter was painted in
the following circumstances.

During the First World War, a Mme Meyer took refuge at
Nice with her two daughters. One day a friend of theirs, Pierre
Bertin, paid them a visit with his friend Modigliani. While Bertin
was speaking to Modigliani, the young Germaine Meyer (the
future Mme Survage) passed through the room. Bertin introduced
her to the painter who immediately expressed a desire to paint her
portrait. Germaine Meyer consented, and the next day Modigliani
arrived with his materials. He asked the young woman to sit

at the piano where she began to play a piece by Ravel. Modigliani watched her and suddenly ordered her to stop. He began to draw rapidly and then to paint the portrait. The next day he finished it and presented it to Germaine. He began a second portrait of her, but she became ill and, two weeks later, Modigliani declared that he was unable to complete the portrait he had to interrupt. But he did paint a third portrait of Germaine Meyer Survage.

Like a real Italian, Modigliani had introduced his wife only to his most intimate friends and never took her with him to cafés; even Osterlind had not yet met her. Modigliani was touchingly proud of his wife and baby, but at the same time he seems to have been terrified of this new responsiblity.

Every evening Osterlind went to call on Renoir, old by now and semi-paralyzed, sitting in a wheelchair with a mosquito-net over his face. He was so immobilized by his illness that Osterlind sometimes even had to blow his nose for him. Renoir detested callers and had refused to see Paul Guillaume, who was then at Nice, but he had heard of Modigliani, and the old painter was always ready to encourage younger ones. He prided himself on never having told anyone to give up painting, because he always said that some one who does daubs today may turn out to be a genius tomorrow. Osterlind therefore made an appointment for them to meet and, that evening, Modigliani kept his promise and stayed sober. They started by discussing painting, but the conversation was all at cross-purposes. Renoir told Osterlind and Modigliani to go up the hill to his second studio and look at the two marvelous nudes, the last that the great artist ever did. Modigliani looked at them, said nothing, and refused to go back to the room where Renoir was sitting. Osterlind urged him: " Even if you don't like them, he is old. He may be dead by tomorrow." Modigliani gave in, went back to the old painter, and sat down in a corner.

"Did you see my nudes?" asked Renoir. "Yes," said Modigliani. Timidly and at length, Renoir described how hard he had worked on them and with what affection he had "caressed" those lovely buttocks. Silence. "But that rose color, the rose of those

buttocks? Did you see it? I 'caressed' that bit of painting for days and days..."

"I don't like buttocks," snorted Modigliani and went out, slamming the door.

Renoir, the great Renoir, contented himself with shrugging his shoulders, and it is even said that soon afterwards he sold a canvas to Zborowski in order to help Modigliani. The anecdote, which redounds solely to the glory of Renoir, was confirmed to me down to the last detail by Osterlind himself; at that moment he would willingly have sunk through the floor, but he still speaks of Modigliani only with kindness and compassion.

An official document tells us that on May 31, 1919, Modigliani went back to Paris, to the Rue de la Grande Chaumière. On June 24, 1919, Jeanne Hébuterne, who had stayed in the south, wired to him care of Zborowski, Rue Joséph Bara: " Need money for trip. Wire hundred seventy francs plus thirty for nurse. Letter follows. Arriving Saturday morning at eight by fast train. Let nurse know."

The correspondence with the nurse, a good honest girl from near Paris, to whom little Jeanne was handed over, is a graph of Modigliani's ups and downs; telegrams, presents and baby caps alternate with long silences.

Jeanne Hébuterne was soon pregnant again. I have in my possession a strange document, written by Modigliani on a sheet of lined gray paper: "Today, July 7, 1919, I pledge myself to marry Mlle Jane (*sic*) Hébuterne as soon as the documents arrive. (Signed) Amedeo Modigliani, Leopold Zborowski, Jeanne Hébuterne, Lunia Czechowska."

Lunia Czechowska has told me that during the short time that the baby was in Paris before going off to the Loiret with her nurse, it was she who looked after little Jeanne in Zborowski's house in the Rue Joséph Bara. At night, Modigliani, roaring drunk, used to ring the doorbell to find out how his daughter was. Lunia would tell him not to make such a racket, after which he would calm down, sit for a while on the doorstep, and then go away.

He was beginning to be well-known as a painter. Douglas and Lipchitz both agree that he was highly esteemed by his

colleagues and could have sold more if it had not been for his
frightful disposition. Douglas tells of having seen him at the
Rotonde refuse the ten francs that a rich foreigner offered him,
because he charged only five francs a drawing. When the same
foreigner fell into a drunken sleep beside him, Modigliani delicately
extracted one hundred francs from his wallet and offered them to
a famished poet at the next table. Then he calmly went on with
his drawing.

Zborowski arranged an exhibition for him in London. The
critics T. W. Earp and Gabriel Atkins wrote enthusiastic articles
and, as usual, Modigliani sent the favorable clippings to his mother.

In a letter of August 17, 1919, he wrote:

*"Dear Mother. Thank you for your postcard. I am having a
magazine, L'Eventail, sent to you, with an article in it about me.
I am having a show with some other people in London. I have
asked them to send you the clippings. Sandro,* [1] *who is now in
London, will be going back through Paris before returning to
Italy. My baby, whom we had to bring back from Nice and whom
I have sent to the country near here, is very well. I am sorry not
to have any photographs. Kisses, Dedo."*

The records and recollections of his friends show us two
Modigliani's at this period.

There is the one who, even though he knows that he is
seriously ill, refuses to look after himself and wanders from café
to café, drinking in desperation. One night, according to Lascano
Tegni, after wandering in the rain, he collapsed on the steps of
the church of Alésia. Yet Chantal Quenneville, who first met him
at Christmas 1919 and often posed for him at the Closerie, was
amazed when she once saw Modigliani going twice for sandwiches
to the little all-night café on the Boulevard Vaugirard, where he
and so many others used to eat during the war. " 'Over-eating is
the only thing that can save me,' he said to me; it was the

[1] Uberto Mondolfi's brother.

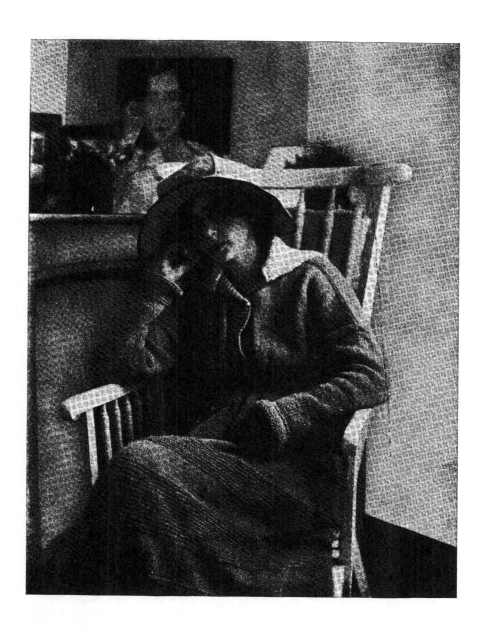

31. Rachel Osterlind, with portrait painted by Modigliani. (See Pl. 61).

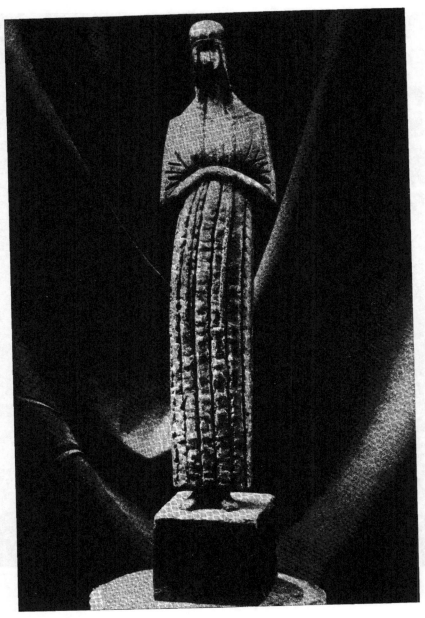

32. Wood sculpture (portrait of Jeanne Hébuterne) by Chana Orloff.

first time that he had spoken to me of his illness. He came with me as far as the dark steps of Marie Wassilieff's door and left me there with a bunch of violets." Modigliani rarely spoke of his tuberculosis, and this silence helped to create the romantic legend of a death due to hunger, alcohol, and Heaven knows what metaphysical torments.

From time to time Modigliani felt that he was near death, and one evening he went up to Montmartre to see Suzanne Valadon, for whom he always felt a filial affection. He asked for something to drink and then began to cry, singing under his breath a Jewish song. This was probably the *Kaddish*, the prayer for the dead, which was the only one known to the unbelieving Modiglianis.

The other Modigliani, on the other hand, hoped like all invalids that he would get better and be able to begin again. He wrote to his mother during the winter of 1919:

"Dear Mother. I am sending you a photograph. I am sorry that I do not have one of the baby. She is in the country with nurse. I am thinking about a trip to Italy in the spring. I want to go through a 'period' there. But I am not sure. I hope to see Sandro again. It seems that Uberto is about to go into politics, let him do it. Kisses, Dedo."

The last reply-paid postcards from Eugenia, dated the 10th and 18th of November and the 27th of December 1919, were found among Modigliani's papers. In a corner of his studio Emanuele also found a roll of drawings. They were studies of male nudes, one of which, a finished drawing in blue pencil, has a sculptural tranquillity. The *Portrait of Mario*, evenly balanced between the psychologically precise characterization, the density of the volumes and the articulation of the background, also seems to belong to his last days.

One day Kisling and Ortiz de Sarate found Modigliani in bed in the freezing studio with Jeanne, nine months pregnant, sitting beside him. All around lay empty wine bottles and open sardine tins.

Legend says that as he was dying he recommended Soutine

to Zborowski, asked his wife to follow him to the grave, "so that I can have my favorite model in Paradise and with her enjoy eternal happiness," and confessed to Ortiz that only a fragment of his brain remained to him. While he was being taken to the hospital, the legend adds, he murmured " Cara Italia!" Too many last words!

After his death, Kisling and another of his friends tried to take a mask, but they succeeded only in tearing off scraps of skin and wisps of hair. Lipchitz intervened and succeeded in putting the plaster back in place.

Paulette Jourdain, who was still a child, remembers that on the night Modigliani died in the hospital, Zborowski did not want Jeanne to sleep alone in the studio on the Grande Chaumière, and Paulette went with her to a little hotel on the Rue de Seine. "She was already waddling like a duck," Paulette told me. "And she seemed calm. But in the morning the maid found a dagger under her pillow."

The next day Jeanne went back to the hospital to see Amedeo for the last time. Her father, silent and hostile but always loyal, went with her. Dr. Barrieu and André Delhay have told me that he stayed on the threshold while Jeanne went over to the corpse. Stanislas Fumet and his wife Aniouta, Jeanne's childhood friends, write that she did not kiss him but "looked at him for a long time without a word, as though her eyes were trying to take measure of her tragedy. She walked backwards as far as the door and when we came up to her, she was still holding on to the memory of the dead man's face and was trying not to see anything else." [1]

When she got to the Zborowskis, she took little Paulette's hand, saying to her, "Don't leave me!" But when her father asked her to go with him, she rose — "They were very close to one another, even though they said so little," Paulette told me — and went back to the Rue Amyot. Chantal Quenneville wrote: "Jeannette Hébuterne had gone back to her parents, Catholics who had looked askance at her liaison with the Jewish Modigliani, and she never spoke a word."

[1] *Figaro Littéraire*, May 17, 1958.

.The next morning at dawn Jeanne threw herself from the fifth-floor window. [1] Mme Roger Wild says that several times in the night André Hébuterne, who adored his sister, had stopped her from committing suicide, but at dawn he had dozed off, and by the time that he heard the noise of a window opening, it was too late. To spare his mother the sight of the mutilated body, he told her that Jeanne was only hurt and asked them to take her away. Chana Orloff [2] still remembers that ridiculously tiny corpse. "She was an angel," writes Foujita.

Jeanne Hébuterne's funeral was simple and quiet. Her parents wanted to see no one and set the funeral for eight in the morning. Following the hearse were two taxis: in one were Zborowski, André Salmon, Kisling and their wives; in the other, Jeanne's parents and brother, Chantal Quenneville and Chana Orloff. The tragic procession moved slowly, under a cold, gray sky, to a cemetery on the outskirts of Paris.

Modigliani's funeral was altogether different from that of the woman who had so adored him; it is best described in two letters written to Emanuele Modigliani, one by Luigi Cesana, a family friend, and the other by Leopold Zborowski. Cesana wrote:

"*At the hospital there was a mob of friends, among them many women. Artists of all countries and all races: French, Italian, Russian, Chinese, etc. A large quantity of fresh flowers; one wreath on which was inscribed,* A notre fils, *and one with the words,* A notre frère. *The entire crowd followed the hearse to the Père Lachaise. At the cemetery, a rabbi recited the prayers...*"

[1] A year after Jeanne Hébuterne's death, a Canadian student named Simone Thirioux also died. Simone Thirioux, who had posed for many painters of Montparnasse, had given birth to a son of Modigliani's. After her death, the child was adopted by a French family, and a few years later the woman who had arranged for the adoption received a photograph — without accompanying letter — of a boy who greatly resembled Modigliani. This woman, the only one to know the name of the adoptive family, is now dead. (See Letter 50-51.)

[2] An intimate friend of Jeanne Hébuterne's, who had carved a portrait of Jeanne in wood, reproduced in this volume. This piece of wood sculpture was lost during World War Two.

And Zborowski, who did so much for Modigliani during his lifetime, wrote:

"Today Amedeo, my dearest friend, rests in the cemetery of Père Lachaise, covered with flowers; according to your wish and ours. The world of young artists made this a moving and triumphant funeral for our dear friend and the most gifted artist of our time... He was a son of the stars for whom reality did not exist..."

Bibliography

Adlow, D.: *Modigliani· and l'Art Nouveau.*. ("Christian Science Monitor." Boston. June 27, 1931).

Apollonio, U.: *A. Modigliani*. ("Cahiers d'Art", 1950).

Barnes, Albert C.: *Modigliani*. (in: "The Art in Painting.") New York, 1937.

Basler, Adolphe: *Pariser Cronik: Modigliani und Matisse bei Bernheim Jeune*. ("Der Cicerone." Leipzig. XIV. N. 6, 1922).

Brummer, E.: *Modigliani chez Renoir*. ("Paris-Montparnasse." February, 1930.)

Bucarelli, Palma: *Amedeo Modigliani*. ("Enciclopedia Italiana di Scienze, Lettere ed Arti." Vol. XXIII. Pp. 526-527.) Roma, 1934.

Carco, F.: *L'Ami des Peintres*. Geneva, 1944.

Carli, Enzo: *Modigliani*. De Luca. Roma, 1952.

Cartier, J.: *A Modigliani, l'Homme, l'Artiste*. ("Le jardin des Arts," May, 1958).

Catalogue of the Exhibition of Modigliani's drawings at Tooth Gallery. London, 1927.

Catalogue of the Modigliani Exhibition at De Hauke and. Co. New York, November, 1931. Preface by Maud Dale.

Catalogue of the Exhibition of Modigliani drawings at Art Institute.. Chicago, 1955. Preface by Carl O. Scniewind.

Cocteau, Jean: *Modigliani*. Hazan. Paris, 1951.

Coquiot, G.: *Les Indépendants.* (1884-1920). Pp, 98-99: *Modigliani*. Paris, 1920.

Coquiot, G.: *Vagabondages.* Pp. 205-209: *Modigliani et les portraits d'amour.* Paris, 1921.

————: *Des peintres maudits.* Pp. 99-112: A. Delpeuch. Paris, 1924.

————: *Modigliani.* ("Kunst und Künstler." Berlin. XXIV. 1926 Pp. 466 a 470.)

Dale, M.: *Before Manet to Modigliani.* Knopf. New York, 1929.

————: *Vérisme et Stylisation: Modigliani.* ("Formes." Paris, October, 1931.)

————: *Amedeo Modigliani.* (1884-1920.) *Retrospective Exhibition of paintings at the Demotte Gallery.* New York, November, 1931.

Descargues, Pierre: *Amedeo Modigliani.* Braun, Paris, 1951.

Di San Lazzaro, Gualtiero: *Modigliani, peintures.* Paris, 1947.

————: *Modigliani, portraits.* Hazan. Paris, 1957.

Einstein, Carlo: *Die Kunst des 20. Jahrhunderts.* Pp. 47-48: *Amedeo Modigliani.* Berlin, 1926.

Franchi, Raffaello: *Modigliani.* ("Maestri Moderni" II.) Firenze, 1944.

Gomez De La Serna, Ramon: *Modigliani et Diego Rivera.* ("Paris-Montparnasse." February, 1930.)

Gordon, Jean: *Savage Art and Modigliani* (in "Modern French Painters.") London, 1926.

International Art: Modigliani. ("Times." Sunday Edition. London, May 4, 1930.)

Jedlicka, G.: *Modigliani.* Rentsch. Zurich, 1953.

Lipchitz, Jacques: *Amedeo Modigliani.* Abrams. New York, 1952.

————: *I remember Modigliani.* ("Art News," 1951.)

MacIntyre, Raymond: *The Work of Modigliani.* ("The Architectural Review." London. Vol. LXV. N. 389. April, 1929. Pp. 204-205.)

Modigliani (in: "Thieme & Becker. Allgemeines Lexikon der bildenden Künstler." Vol. XXIV.) Leipzig, 1930.

Modigliani (in: "Edouard Joseph. Dictionnaire biographique des Artistes Contemporains." Vol. III. Pp. 29-32.) Paris, 1934.

Nicolson, Benedict: *Modigliani, Paintings.* Lindsay Drummond. London, 1948.

Omaggio a Modigliani (1884-1920). A cura di G. Scheiwiller, nel decimo anniversario della sua Morte. Milano, 25 gennaio 1930. Tre poesie di Modigliani. Introduzione di Sergio Solmi. Scritti di Baraud, Bernasconi, Braque, Carco, Carrà, Casorati, Cendrars, Chirico, Cocteau, Courthion, Derain, Fels, Friesz, George, Guillaume, Jacob, Jerrans, Kisling, Lipchitz, Marinus, Michel, Montale, Oppi, Piceni, Pisis, Pound, Prampolini, Raimondi, Salmon, Savinio, Segonzac, Severini, Soutine, Vlaminck, Zborowski. Edizione fuori commercio.

Pfannstiel, Arthur: *Modigliani.* Préface de Louis Latourette. Editions Seheur. Paris, 1929.

———: *Modigliani et son oeuvre.* ("La Bibliothéque des Arts.") Paris, 1956.

———: *Dessin de Modigliani.* Lausanne, 1958.

Roger-Marx, Claude: *Modigliani.* ("Apollo." London. Vol. IX. N. 52. April, 1929. Pp. 216-219.)

Roy, Claude: *Modigliani.* Skira, 1958.

Salmon, André: *Modigliani.* ("L'Amour de l'Art." Paris. January, 1922.)

———: *Modigliani, sa vie, son oeuvre.* Editions des Quatre-Chemins. Paris, 1926.

———: *Modigliani.* ("Vogue." April 15, 1951.)

———: *La vie passionnée de Modigliani.* L'Inter. Paris, 1957.

Schaub-Koch, Emile: *Amedée Modigliani.* Mercure Universel. Paris-Lille, 1933.

Scheiwiller, G.: *Amedeo Modigliani.* ("Arte Moderna Italiana." N. 8.) Milano, 1927, 1932, 1935, 1942, 1950.

Schwarz, Marck: *Modigliani* (in yddisch.) Paris, 1927·

Sitwell, Osbert: *Laughter in the Room.* London, 1949.

Soby, J. T.: *A. Modigliani.* The Museum of Modern Art. New York, 1951.

Valentiner, W. R.: *Modigliani and Pascin.* ("Bulletin of Detroit Institute of Arts." Detroit. October, 1930.)

Valsecchi, Marco: *Amedeo Modigliani.* Garzanti. Milano, 1955.

Venturi, Lionello: *Mostra Individuale di Amedeo Modigliani* (in: "Catalogo Illustrato della XVII Esposizione Biennale Internazionale d'Arte.") Venezia, 1930.

Vitali, Lamberto: *Disegni di Modigliani.* ("Arte Moderna Italiana." N. 15.) Milàno, 1929-1936.

Vlaminck, Maurice: *Souvenir de Modigliani.* ("L'Att Vivant." Paris. I. N. 21. November 1, 1925.)

Weill, Berthe: *Modigliani chez Zborowski* (in: "pan!... dans l'oeil....") Paris, 1933.

————: *Exposition Modigliani* (in: "pan!... dans l'oeil....") Paris, 1933.

————: *Utrillo, Modigliani sont venus me voir* (in: "pan!... dans l'oeil....") Paris, 1933.

Werner, Alfred: *Modigliani* ("Tomorrow." April, 1951.)

Zborowski, Léopold: *Modigliani.* (Poème.) ("Paris-Montparnasse." February, 1930.)

Zervos, C.: *Catalogue of paintings by Amedeo Modigliani 1884-1920 to be exhibited at De Hauke and Co.* New York, 1929.

Letters and Documents

33. Letter from Modigliani to Gino Romiti, 1902. 34. Card from Modigliani to his mother, postmarked November 9, 1915.

Mon cher ami.

Je vous embrasse comme...

J'aurai... si j'avai...

...le jour d'entre

quant.

Je t'ai la tueke avec

Sénège au (eg.) d...

t'ai écrite toute les

folg.

Surées vite-/ argent

le Champagne entré à

fêté.

Nous vous souhaitons, à vous et
à votre chère femme les meilleurs
vœux pour la nouvelle année.
Resurrectio Vitae.
Ic incipit vita nova.
Il nuovo Anno!

Modigliani.

Vive Vive vive la première nuit de
la première année

35. Letter from Modigliani to Zborowski, January 1, 1919.

Mon cher ami.

Vous êtes un ballot qui ne comprend pas
la blague : Je n'ai rien rendu du tout.
Demain ou après demain je vous expédierai
la Marchandise.

Maintenant une chose _réelle_ et très
grave vient de m'arriver : On m'a volé
mon portefeuille avec 600 fr. qu'il
contenait. Il paraît que c'est une spécia-
lité d'ici... Vous parlez si je suis
embêté.

Naturellement je suis à sec - ou presque.
c'est idiot c'est entendu. seulement
comme ce n'est ni votre intérêt ni le mien
que je reste en panne voilà ce que
vous propose : Envoyez à l'adresse de
Sturzwage. 500 fr. Télégraphiquement...
Vous trouvez

36. Letter from Modigliani to Zborowski, Nice, 1919.

et je vous rembourserai 100 fr. par
mois c'est à dire que pendant 5 mois
vous pourrez prélever 100 par mois sur une
mensualité. de n'importe quelle façon
en somme je vous tiendrai compte de
la dette. Argent à part la question de
papiers m'embête énormément
Il ne manquait plus que ça au moment
d'être un peu tranquille... enfin
- malgré tout ça ne peut casser rien
d'essentiel j'espère. Croyez moi cher à une
loyauté et à mon amitié et avec
les souhaits que j'adresse à votre jeune mariée
agréez vous même une cordiale poignée
de main. Modigliani

37. Continued from previous page.

Mardi 21.

Voilà la question : ou : faut-il, la question (vous fartez) s'il a lieu

To le ou non. To be or not to be.
C'est ici le problème ou le où c'est entendu : je reconnais ma faute (si toutefois il y a) et ma dette (si toutefois il y aune) mais maintenant la question et c'elle... C'est que je l'ai : si ma fraternité

en panne fortement enlisé. Comprenez vous. Vous avez envoyé 200 fr. dont 100 on dû être naturellement pour Survage à l'aide duquel je dois de ne pas être totalement en panne... mais maintenant... Si vous me libérez je reconnaîtrai ma dette et je continuerai de marcher. Si non je rentrai immobilisé sur place pied et poings ici... quel en sera l'intérêt ? Il y a actuellement 4 Toiles

38. Letter from Modigliani to Zborowski, Nice, 1919.

J'ai vu Guillaume. J'espère qu'il va m'aider pour mes papiers. Il me donne de bonnes nouvelles. Tout irai bien sans ce maudit accident. Pourvu que ne pas le réparer et immédiatement... pour ne pas stopper une chose qui marche.

J'en ai assez dit maintenant. Faites ce que vous voulez ou pouvez... mais répondez... autrement la presse autrement dit... le temps court.

Je vous embrasse. Bonjour à Mad Zborowski

Modigliani.

40. Two letters from Modigliani to Zborowski, Nice, 1919. 41. Card
from Modigliani's mother to Modigliani, postmarked December 27, 1919.

42. Letter from Modigliani to Zborowski, Nice, 1919.

Cher ami,
Mardi le 5 Oct. Je voudrais merci
de votre promptitude. Je ne
vous ai... puis qu'aujourd'hui
les Toiles (+).
J'ai... une mettre à
Rosalba. Il ne... Rosa...
des girontanas, le chargé...
... quoi sais-je... le chargé...
... que leur... le tien...
tout à fait... un charge...
... de ... Thanec... et
d'autres. ... dai...
... le temps de croire
et de ... chaudoui.

'J'ai flâné un peu ces jours-ci
: la seconde partie : le seul travail.
Le bilan Sauvage se résume : petit
cochon. Survolons. Viendrez-vous au
mois d'Avril? Les question des papiers.
vis-à-vis de moi est presque complè-
tement arrangée grâce à mon
frère. Je peux matériellement, maintenant
partir quand je veux.

43. Letter from Modigliani to Zborowski, Nice, 1919.

Rappelez moi : et rien affectueusement
à votre chère femme.
Mon cher ami.

Très sincèrement touché de
votre bonne lettre. C'est à moi
de ... à vous remercier.
Ce qui a trait à la publi-
cité je m'en remets natu-
rellement à vous... si c'est
indispensable... Vos affaires
sont les nôtres, et si je ne
tiens pas, en principe d'abord
et ne me croyant pas assez
mûr après, aux publications,
je ne méprise pas la "vile
monnaie", mais puisque nous
sommes d'accord passons, à
autre chose.

Voilà ma date et lieu de nais-
sance. Amedeo Modigliani
né 12 Juillet 1884 à Livor-
no. Maintenant j'ai écrit
à mon frère il y a deux ou
trois jours et j'en attends
réponse. En plus ma carte
d'; d'identité "réelle" (qui
je n'avais que la ... existe à Paris) au
commissariat de la
rue Camp. Première.
La chose ne devrait pas
être ni difficile à arranger.
Autre chose.

44. Letter from Modigliani to Zborowski, Nice, 1919.

Vous parlez de venir par
ici vers la fin Avril. Je
pense que je pourrai très
bien vous attendre ici jus-
qu'à cette date.
En attendant, et en
marchant, vous viendrez
examiner les possibilités
d'installation à Paris,
car la il y a tô un grand
"hic. (Vous occuperez vous
jamais de l'affaire de
Montmartre ?).
 Ma fille pousse

étonnamment. Je puise
là un confort et une
poussée qui ne peut que
j'agrandir dans le futur.
 Merci des joujoux.
Un peu tôt peut être...
Je ne me sens maintenant qu'à pousser,
avec vous, le grand cri:
"Ça ira, pour les hommes
et les peuples, pensant
que l'homme est un monde
qui vaut des fois les peuples
et que les plus ardentes ambitions sont celles qui ont eu l'organisé de l'...

45. Continued from previous page.

Je m'engage, aujourd'hui
7 Juillet 1919 à epouser Mademoiselle
Jane Hebuterne. aussitôt les papiers
arrivés

Amedeo Modigliani
Leopold Zborowski

Jeanne Hébuterne
Liudwika Crechowska

Paris 7 Juillet 1919

46. Declaration of Modigliani concerning his relationship with Jeanne
Hébuterne, July 7, 1919.

Chère maman.

Je t'envie une photo.
Je regrette de ne pas
en avoir 2 de la
fille de elle et 5 où la
campagne en vacance
Je pense...

Ce n'est pas sûr, quand même.
Je pense revoir Sandro.
Il paraît que Oberto va se lancer
dans la politique qu'il s'y
lance même. — Je t'embrasse bien
fort ddo.

47. Letter from Modigliani to his mother (winter, 1919).

Paris le 27 - 1 - 1920 -

Carissimo Menè,

[handwritten letter in Italian cursive, largely illegible]

48. Letter from Luigi Cesana to Emanuele Modigliani, January 27, 1920.

Paris le 31/I 1920.

Mon cher Modigliani –

Aujourd'hui Amédée, mon plus cher ami
repose au cimetière de Père Lachaise
couvert de fleurs selon ~~votre~~ votre volonté
et la notre. Toute la jeunesse artistique
a fait de funérailles émue et ~~triompha~~
les à notre cher ami et à un artiste
le plus doué de notre époque.
Il y a un moi Amédée avait grande
envie de partir en Italie avec sa femme
et son enfant. Il attendait seulement
l'accouchement de sa femme – l'enfant,
qui devait venir il voulait laisser en
France chez la nourrice où est actuelle-
ment sa petite fille Giovanna.
Sa santé qui était toujours délicate vers
cette époque commençait à être inquiétante.
Mes conseils pour aller immédiatement
dans un sanatorium en Suisse restaient
sans résultat. Si je lui parlait :
"Ta santé est mauvaise va te soigner."
Il me traitait dans ces moments en
ennemi et répondait "Fout pas la mo-
rale". C'était un enfant des étoiles et
la réalité n'existait pas pour lui. Rien
tout de même ne permettait de prévoir la
catastrophe si proche. Il avait de l'appetit,
se promenait et était de bonne humeur.

49. Letter from Zborowski to Emanuele Modigliani, January 31, 1920.

31 Décembre
20? Boulevard Raspail

Mon très cher Ami,
Ma pensée la plus tendre va vers vous à l'occasion de cette nouvelle année que je désirerais être l'année de réconciliation morale pour nous. Je mets de côté toute sentimentalité et réclame une seule chose que vous ne me refusez

pas car vous êtes intelligent et pas un lâche: c'est une réconciliation qui me permettra de temps en temps de vous voir. Je jure sur la tête de mon fils que pour moi est _tout_ qu'aucune idée mauvaise ne passe en mon esprit. Mon ... mais je vous ai trop aimé et souffre tellement que je réclame cette chose comme une

50. Letter from Simone Thirioux to Modigliani, 1919.

dernière supplication —
Je serai très forte — Vous
savez ma situation actuelle.
matériellement je ne
manque de rien gagnant
largement ma vie —
Ma santé est très mauvaise
la tuberculose pulmonaire
fait tristement son
œuvre — Des hauts — des
bas — Mais je n'en peux
plus — Je voudrais avoir
simplement un peu
moins de haine de votre

part — Je vous en supplie
ayez pour moi un
regard bon — Consolez-moi
un peu je suis trop
malheureuse et demande
une petite parcelle
d'affection qui me
ferait tant de bien —
 Je jure encore qu'aucune
arrière-pensée ne me
travaille —
 J'ai pour vous
toute la tendresse que
je dois avoir pour vous
 Simone Thiroux
 204 Bᵈ Raspail

51. Continued from previous page.

Procès verbal de
déclaration par M.
et Mme Hébuterne

Pardevant M⁰ Maxime Aubron
notaire à Paris, soussigné
Ont Comparu :
Monsieur Achille Casimir Hébuterne
chef de comptabilité et Madame Eudoxie
anaïs Tellier, son épouse, qu'il autorise,
demeurant ensemble à Paris rue Amyot
N° 8 bis

Lesquels ont requis le notaire soussigné
de recevoir leurs déclarations faites ci après :
Nous déclarons et attestons pour vérité,
dans le but que nos déclarations puissent
être présentées tout aussi bien aux autorités
judiciaires qu'administratives, en France
et en Italie aux effets que nous allons
expliquer, ce qui suit
De notre mariage est née le sept avril
mil huit cent quatre vingt dix huit, une
fille Jeanne Hébuterne qui, de son
vivant et jusqu'à l'âge dont on parlera
a habité avec nous à Paris. Dans le mois
de Juillet de l'année mil neuf cent dix sept,
notre fille connut un peintre italien
nommé Amédée Modigliani de Livourne
qui habitait Paris. Ils devinrent amoureux l'un

52. Notarized statement confirming the recognition of Jeanne Modigliani
as daughter of Amedeo Modigliani.

...dine jaune. Le Vieux surmontera
En chiny belligue par singulier duelle.
Dans cage d'or les yeux lui crevera:
Deux classes une, puis mourir mort cruelle.

Fait arrivé — l'execution faite
Le vent contraire.
lettres au chemin prises —
Les conjurés XIIII d'une secte.
Par le Rousseau serez les
entreprises.

[Bis adji his non.]

53. Prophecy of Nostradamus transcribed by Modigliani on the back of a drawing reproduced as Plate 98.

Letters and Documents *

33. Letter from Modigliani to Gino Romiti, 1902.

Dear Romiti,

The enlargements should be 18 x 24, exclusive of the head.

Do them properly. I would like to have three or four copies of each, soon. (For you, as many as you like.)

Address them to me here at Pietrasanta, via Vittorio Emanuele, in care of Emilio Puliti. I hope to work and thus finish up and see you soon. Greetings.

Modigliani

34. Card from Modigliani to his mother, November 9, 1915.

Dear Mamma,

It is ·wicked of me to have left you for so long with no news. But... but so many things.... First of all, I have moved. My new address, 13 Place Emile Goudeau. But in spite of all these ups and downs, I am relatively happy. I am painting again, and selling, which is something....

Speaking of Laura, I find that if she retains her intelligence — her marvelous intelligence — it is a great deal. I am very moved that she remembers and takes an interest in me even in the state of forgetfulness of human things in which she finds herself. It seems to me impossible that such a person can't be

* The following are translations of letters and documents reproduced in this section.

led back to life, to a normal life. Give my love to my father
when you write to him. Letters and I are enemies, but don't
think I forget you and the others.

My love, Dedo

35. Letter from Modigliani to Zborowski, January 1, 1919.

On the stroke of midnight.
Dear Friend; I embrace you as I would have done if I could...
the day you left.
 I am hitting it up with Survage at the Coq d'Or. I have sold
all my pictures. Send me some money soon.
Champagne is flowing like water.
We send you and your dear wife our best wishes for the New Year.
Resurectio Vitae.
Hic incipit vita nova. The New Year.

Modigliani

(*Survage*) Happy New Year (*in Russian*) Long live Nice! Long
live the first night of the first year!

36-37. Letter from Modigliani to Zborowski, Nice, 1919.

Dear Friend,

You are naïve and can't take a joke. I haven't sold a thing.
Tomorrow or the next day I'll send you the stuff.
 Now for something that is *true* and very serious. My wallet
with 600 francs has been stolen. This seems to be a speciality of
Nice. You can imagine how upset I am.
 Naturally I am broke, or almost. It is all too stupid, but
since it is neither in your interests nor in mine to have me stop
working, here is what I suggest: wire me, care of Sturvage, 500
francs... if you can. And I'll repay you 100 francs a month; that
is, for five months you can take 100 francs out of my allowance.
At any rate, I shall keep the debt in mind. Apart from the money,
losing the papers worries me enormously. That was all that was

needed... and now, of all times, just when I thought that I had finally found a little peace. Please believe in my loyalty and friendship and give my best wishes to your wife. Most sincerely,

Modigliani

38-39. Letter from Modigliani to Zborowski, Nice, 1919.

Dear Zbo,

Here is the question: or: *that is the question*. (See Hamlet) that is, *To be or not to be*.

I am the sinner or the fool, we agree: I recognize my blame (if there is a blame) and my debt (if there will be a debt) but the question is now this: if I'm not completely broke, I am at least in serious difficulty. Understand. You sent 200 francs, of which 100 naturally went to Survage, to whose help I owe the fact that I'm not completely broke... but now....

If you free me, I'll recognize my debt and go ahead.

If not, I shall remain immobilized at my place, hands and feet tied.... To whose interest would that be.... There are presently four canvases.

I have seen Guillaume. I hope that he can help me with documents. He gave me some good news. Everything would be going well if it were not for this damnable piece of bad luck. Why can't you help me — and quickly — so as not to stop something that is going well? I have said enough. Do what you will — and can — but answer me... it's urgent. Time presses.

With warmest affection to you and best wishes to your wife,

Modigliani

40. Two letters from Modigliani to Zborowski, Nice, 1919.

Dear Zborowski,

I received your 500 francs and thank you. I have gone back to work. I must explain — though real explanations are impossible in

letters — that there has been a "vacuum." I had a charming letter
from your wife. I don't want you to wipe out any of my debts — on
the contrary. Set up, or let us both set up, a credit for me, one
that would take care of the "vacuums" that might be caused by
unforeseen circumstances. I hope to see you very soon at Nice
and to hear from you before then.

With warmest affection,

Modigliani

Dear Zbo,

Thanks for the money. Tomorrow morning I will send you some
canvases.

I am trying to do some landscapes. The first canvases might
possibly look like a beginner's, everything else all right.

Best wishes to your wife. With warmest affection.

Modigliani

See if you can get Guillaume to send me the recommendations so
that my papers can be completed.

41. Card from Modigliani's mother to Modigliani, postmarked December 27, 1919.

I hope, my dearest Dedo, that this reaches you on the first morning
of the year, as if it were a distant kiss from your old mother,
bringing you every blessing and every possible good wish. If
telepathy exists, you must feel me very close to you and yours.

A thousand kisses,

Mamma

42. Letter from Modigliani to Zborowski, Nice, 1919.

Dear Zbo,

Thank you for the money. I am waiting until a head of my wife
is dry before sending you — with the ones you know about — four
canvases.

I am like the Negro, just going on. I don't think that I can send more than four or five canvases at a time, because of the cold. My daughter is wonderfully healthy. Write if all this is not too much trouble. Best wishes to Mme Zborowski. With warmest affection.

Modigliani

Please send the canvases *as soon as possible.* Don't forget the Place Ravignan business and write to me.

43. *Letter from Modigliani to Zborowski, Nice, 1919.*

Dear Friend,

Thank you for the 500 and above all for the speed with which you sent it. I got the canvases off to you today — four.

I am going to start work at 13 Rue de France. All these changes, changes of circumstance and the change of the season, make me fear a change of rhythm and atmosphere.

We must give things time to grow and flower.

I have been loafing a bit for the last few days. Fertile laziness is the only real work....

Are you coming in April? Thanks to my brother, the business of the papers is almost finished. Now, as far as that goes, we can leave when we want to. I am tempted to stay here and go back only in July. Write if you have time and give my best wishes to Mme Zborowski.

With warmest affection,

Modigliani

The baby is very well.

44-45. *Letter from Modigliani to Zborowski, Nice, 1919.*

Dear Friend,

I was sincerely moved by your letter. I must thank you.

Concerning the publicity, I leave it completely up to you, if it is indispensible. Your affairs are ours, and I don't believe in it, above all on principle, and then because I feel I am not mature

enough for publication. I don't despise "vile money," but since we are in agreement, let's go on to something else.

This is my date and place of birth:

Amedeo Modigliani, born on July 12, 1884, at Leghorn.

I wrote to my brother two or three days ago and am awaiting an answer.

In addition, a "real" identity card (I only had a receipt) is in Paris at the Commissioner's office on Rue Camp Premier. It should not be too difficult to take care of this matter.

Something else: you speak of coming here toward the end of April. I think I can easily wait for you here until that time.

Waiting and going ahead, you should examine the possibility of settling in Paris since there is a great "hic" there. (Did you ever have anything to do with the Montmartre business?)

My daughter is growing marvelously. I draw from her a comfort and an enthusiasm that will grow even greater in the future.

Thanks for the toys. A little early, maybe.

The only thing to do now is to let out a great shout with you: "*Ca ira,*" for men and for people, thinking that man is a world worth twice the world and that the most ardent ambitions are those which have had the pride of anonymity.

Non omnibus sed mihi et tibi.

Modigliani

46.

Today, July 7, 1919, I pledge myself to marry Mlle Jane (*sic*) Hébuterne as soon as the documents arrive. (*Signed*) Amedeo Modigliani, Leopold Zborowski, Jeanne Hébuterne, Lunia Cze-chowka.

47. *Letter from Modigliani to his mother, winter, 1919.*

Dear Mother,

I am sending you a photograph. I am sorry that I do not have one of the baby. She is in the country with her nurse. I am

thinking about a trip to Italy in the spring. I want to go through a "period" there. I hope to see Sandro again. It seems that Uberto is about to go into politics. Let him do it.

Kisses,

Dedo

48. *Letter from Luigi Cesana to Emanuele Modigliani, Paris, January 27, 1920.*

Dearest Mené,

I hope that before this you have received my letter of yesterday. Today we accompanied poor Dedo to his supreme rest. In your grief there might be some solace in knowing the display of affection that your dear one received.

This morning several newspapers made the announcement of his death....

At the hospital there was a mob of friends, among them many women. Artists of all races and all countries: French, Russian, Italian, Chinese, etc. A large quantity of fresh flowers; one wreath on which was inscribed, *A notre fils,* and one with the words, *A notre frère.* The entire crowd followed the hearse to the Père Lachaise. At the cemetery a rabbi recited the prayers.

I don't know, as I wrote you yesterday, if you wanted that or if your poor brother would have wanted it, but his friends thought it wise to have a rabbi attend and thought this would please your father. I will tell you also that the rabbi wanted to know the name of the deceased's father, and I believe that no one besides myself would have been able to answer; I don't know the reason for this.

Devotedly, your old friend,

Gigi

49. *Letter from Zborowski to Emanuele Modigliani, Paris, January 31, 1920.*

Dear Modigliani,

Today Amedeo, my dearest friend, rests in the cemetery of Père Lachaise, covered with flowers, according to your wish and ours. The world of young artists made this a moving and triumphant funeral for our dear friend and the most gifted artist of our time....

A month ago, Amedeo badly wanted to leave for Italy with his wife and child. He awaited only the birth of his second child whom he wanted to leave in France with the nurse who is now taking care of little Jeanne.

His health, which was always delicate, became worse at that time. He paid no attention to our advice that he go to a sanitorium in Switzerland. If I would say to him, "Your health is bad, go and take care of yourself," he would treat me as an enemy and would answer, "Don't give me lectures." He was a son of the stars for whom reality did not exist. However, nothing led us to believe that the catastrophe was so near. He ate, he walked and he was in good spirits. He never complained of anything. Ten days before his death, he had to go to bed, and he suddenly began to have great pain in his kidneys. The doctor said it was nephritis (before then he never wanted to see a doctor). He used to suffer from kidney pains, saying they would leave him quickly.

The doctor came every day. The sixth day of his illness I became sick and my wife went to visit him in the morning. Upon her return I learned that Modigliani was spitting blood. We hurried to find the doctor who said that he had to be taken to a hospital but that it would be necessary to wait two days for the bleeding to stop. Two days later he was taken to the hospital; he was already unconscious. His friends and I did everything possible. We called several doctors but tuberculor meningitis began to set in; it had been weakening him for a long time without the doctor recognizing it.

Modigliani was lost.

Two days later, Saturday evening at 8:50, your brother died — unconscious and without suffering.

His last wish was to go to Italy. He spoke a great deal and often about you and your parents. His marvelous wife did not survive him. The day after his death, at four in the morning, she threw herself from the fifth-floor window of her parent's home, killing herself at once.

What a tragedy, dear Modigliani. When I think that just a short time ago I was with them and we spoke and laughed and I said I would come to visit them in Italy.

His wonderful baby, who is fourteen months old, is in the country, not far from Paris, with the nurse with whom Modigliani and his wife had left her. Three weeks before his death, Modigliani — as if he saw the end coming — got up at seven in the morning (something very unusual for him) and went to see his child. He came back very happy.

Answer me, and if there is anything you want, let me know.

Yours devotedly,

Leopold Zborowski

50-51. Letter from Simone Thirioux to Modigliani, 1919.

Dearest Friend,

My thoughts turn to you on this new year which I so hope might be a year of moral reconciliation for us. I put aside all sentimentality and ask for only one thing which you will not refuse me because you are intelligent and not a coward: that is, a reconciliation that will allow me to see you from time to time.

I swear on the head of my child, who is for me *everything,* that no bad idea passes through my mind. No — but I loved you too much, and I suffer so much that I ask this as a final plea.

I will be strong. You know my present situation: materially I lack nothing and earn my own living.

My health is very bad, the tuberculosis is sadly doing its work.

But I can't go on any more — I would just like a little less hate from you. I beg you to think well of me. Console me a little, I am too unhappy; and I ask just a particle of affection that would do me so much good.

I swear again that no hidden thought disturbs me:

I have for you all the tenderness that I must have for you.

Simone Thirioux

52. March 28, 1923

Verbal statement concerning the declaration made by M. and Mme Hébuterne. Before the undersigned, M. Massimo Aubron, notary at Paris, there appeared: M. Achille Casimir Hébuterne, chief accountant, and Mme Eudoxie Anaiis Tellier, his wife, living together in Paris in rue Amyot 8 bis.

Who asked the undersigned notary to receive the following statement:

We declare... as follows:

From our marriage there was born on the sixth of April 1898, a daughter, Jeanne Hébuterne, who, from her birth until the age of which we will speak, has lived with us in Paris. In the month of July, 1917, our daughter met an Italian painter named Amedeo Modigliani, of Leghorn, who lived in Paris. They fell in love....

Plates

Paintings

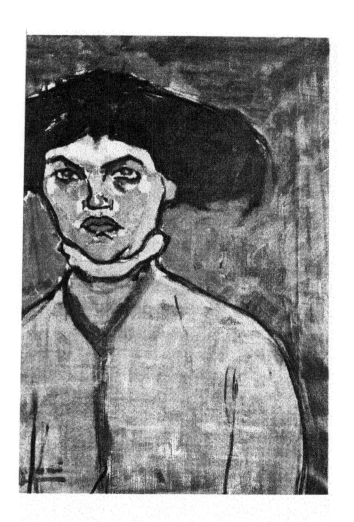

1908-1909. Private Collection.

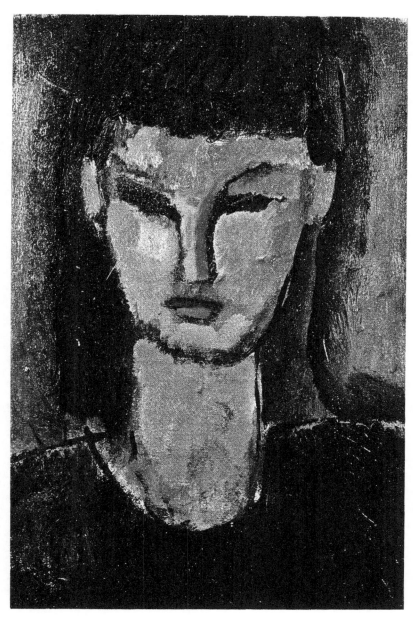

2. Head of a Woman, 1911. Dr. Paul Alexandre Collection, Paris.

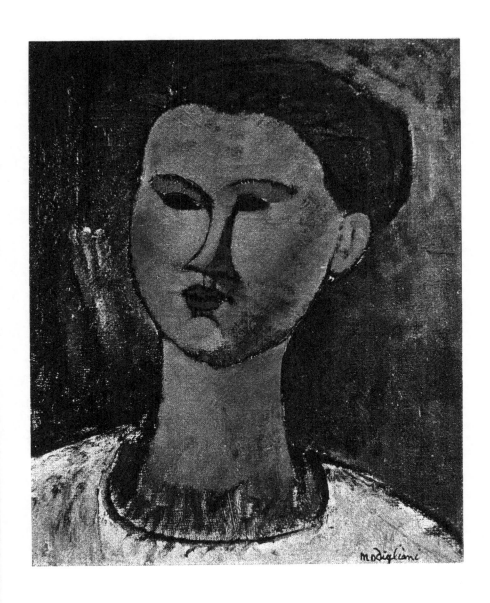

3. Head of a Woman, 1912. Private Collection.

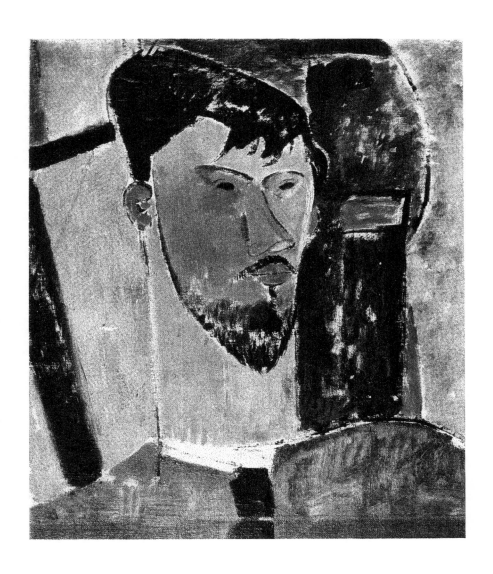

4. Portrait of Laurens, 1913-1914. Private Collection.

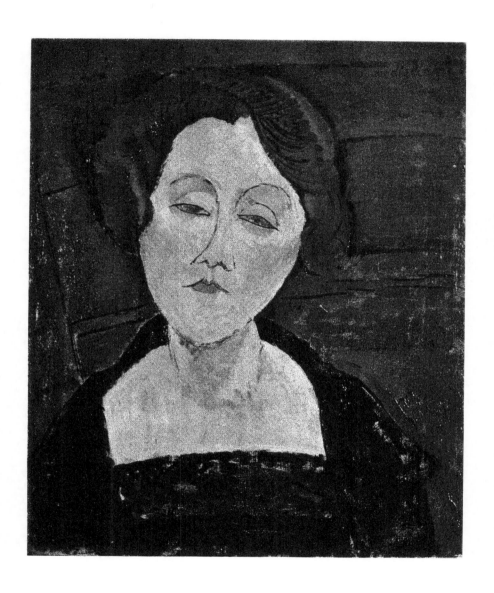

5. Girl with Blue Eyes, 1914-1915. Private Collection.

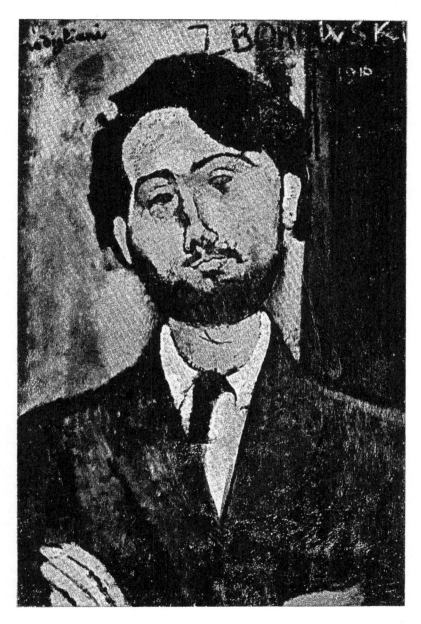

6. Portrait of Zborowski, 1916. Georges Guggenheim Collection, Zurich.

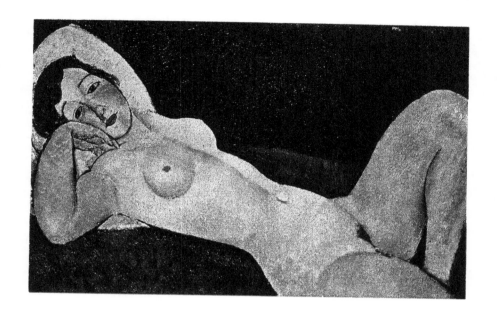

7. Nude Lying on a Sofa, 1917 ?. Private Collection, Paris.

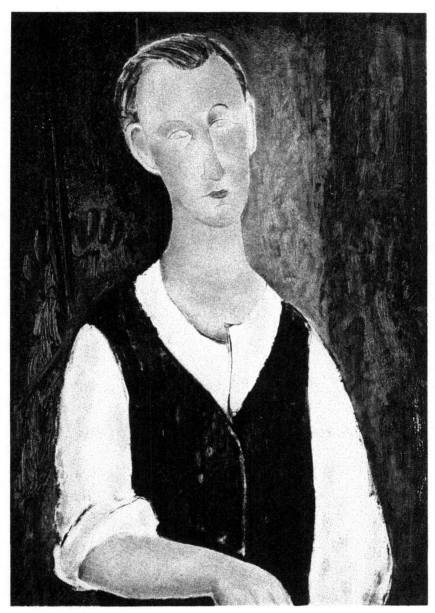

8. Portrait of a Young Farmer, 1918-1919. Private Collection.

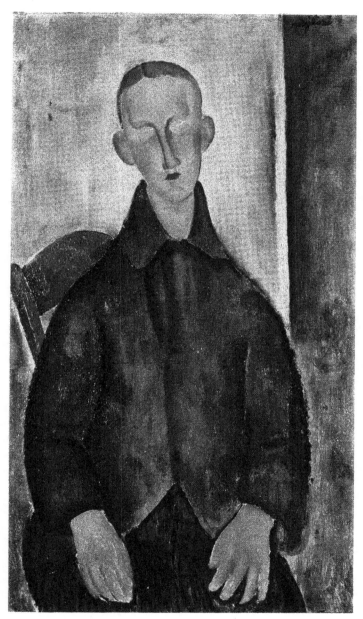

9. Seated Boy, 1917-1918. Private Collection, Paris.

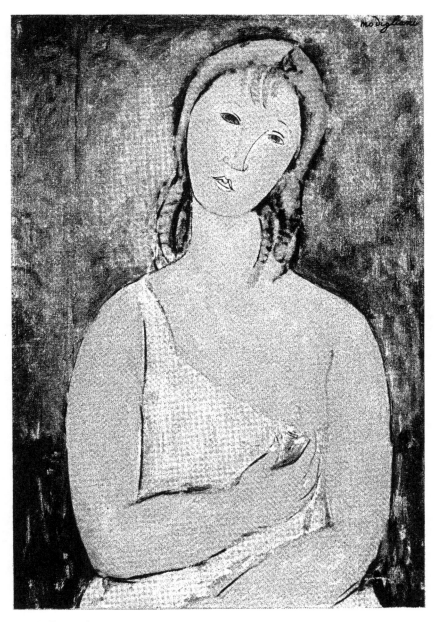

10. Medici Nude, 1918. Private Collection.

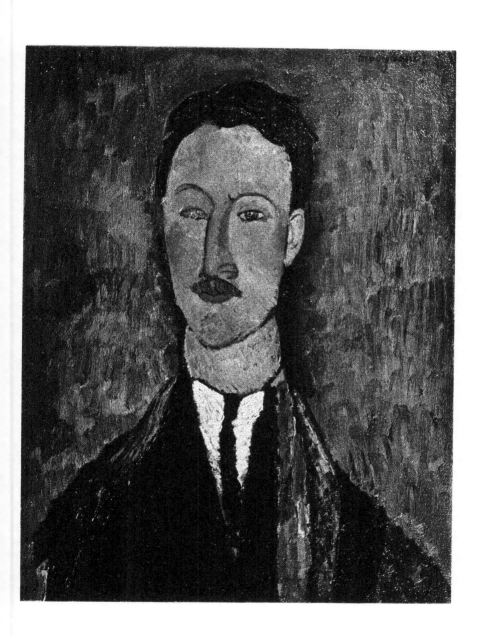

11. Portrait of Leopold Survage, 1918. Atheneum Museum of Art, Helsinki.

12. Portrait

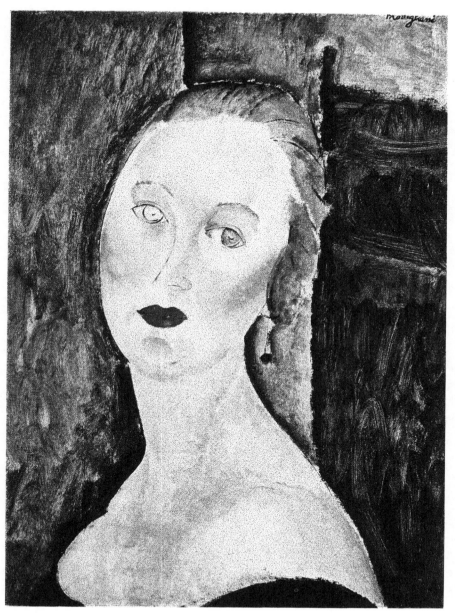

12. Portrait of Germaine Survage, 1918. Private Collection.

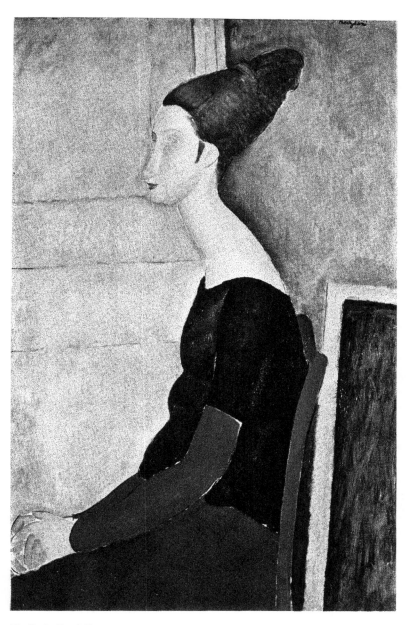

13. Portrait of Jeanne Hébuterne, 1918. Private Collection, Paris.

14. Portrait.

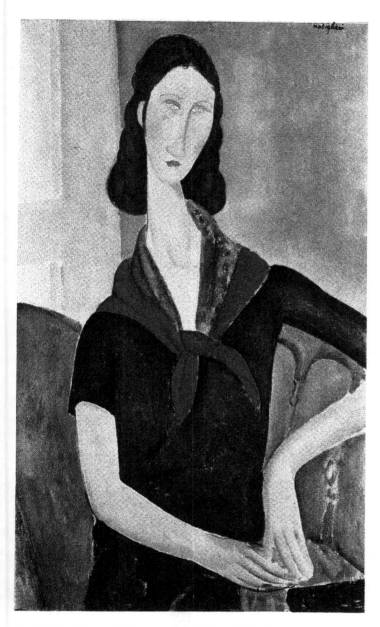

14. Portrait of Jeanne Hébuterne, 1919. Private Collection.

15. Self-p

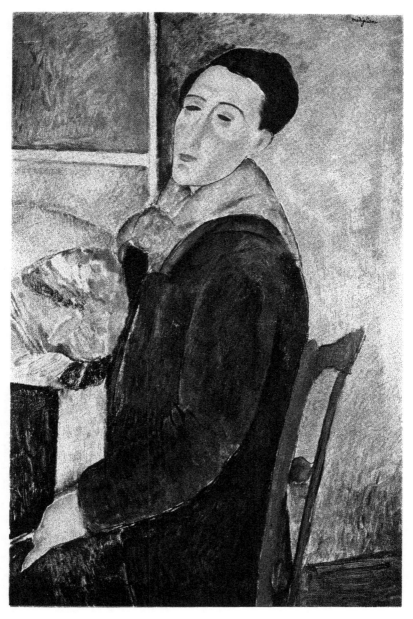

15. Self-portrait, 1919. Francisco Matarazzo Sobrinho Collection, Sao Paulo.

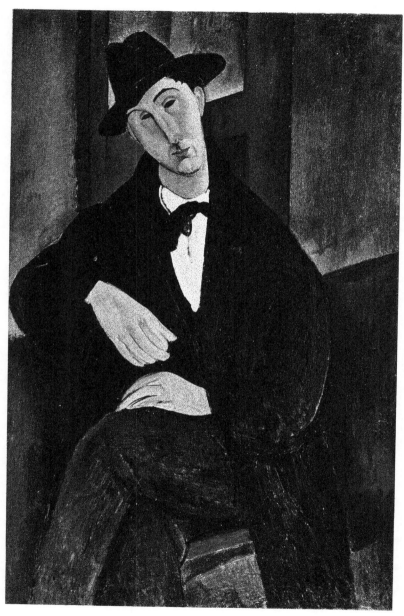

16. Portrait of Mario, 1920. Dr. Franz Meyer Collection, Zurich.

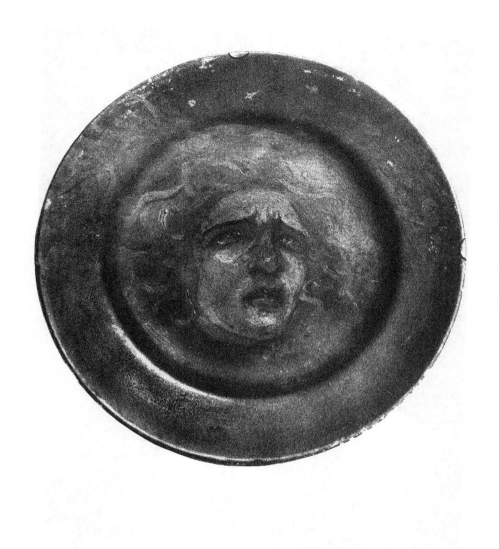

17. Gorgon, 1896. Earthenware. Piccioli Collection, Florence.

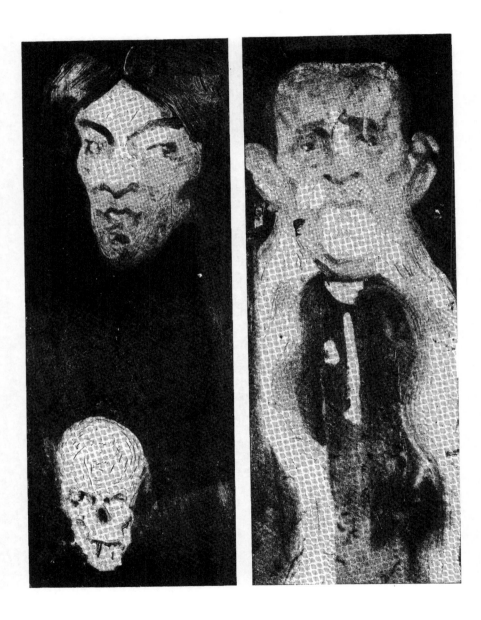

18. Bookcase Panels, 1896. (With Uberto Mondolfi.) Property of A. Mondolfi, Naples.

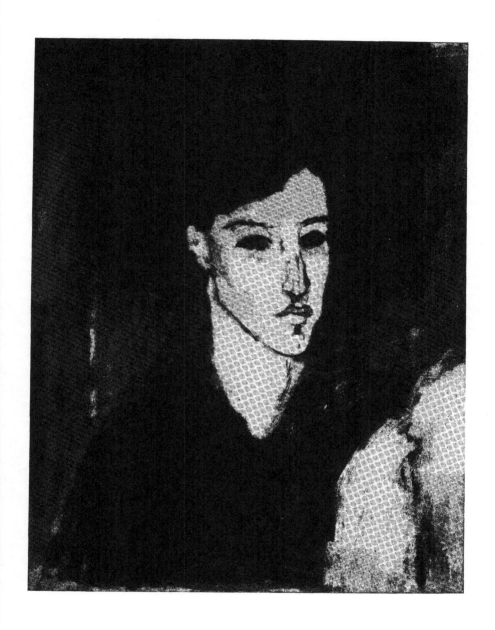

19. The Jewess, 1907-1908. Dr. Paul Alexandre Collection, Paris.

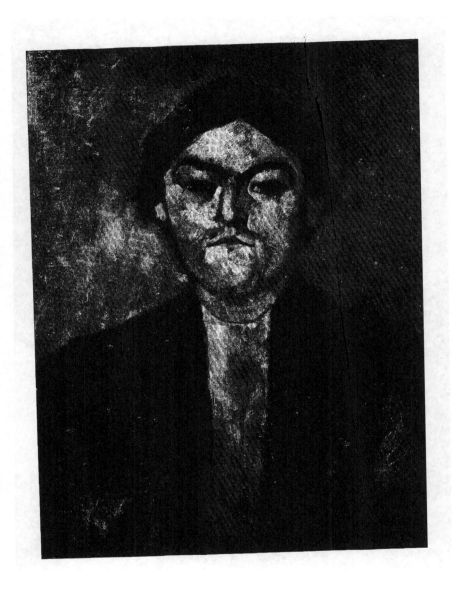

20. Pedro the Printer, 1908-1909. Private Collection, Zurich.

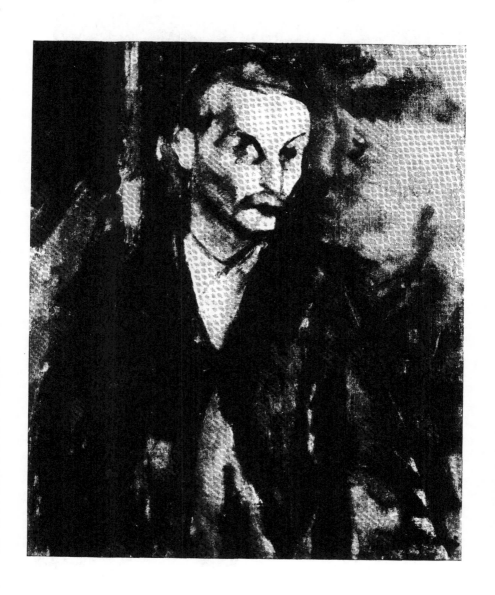

21. The Beggar of Leghorn, 1909. Dr. Paul Alexandre Collection, Paris.

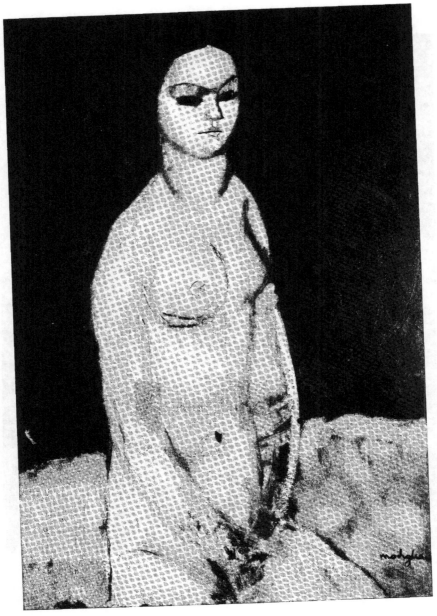

22. Standing Nude, 1908. Dr. Paul Alexandre Collection, Paris.

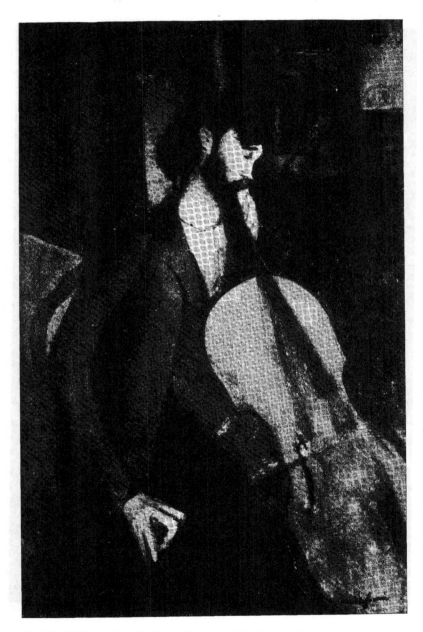

23. The Cellist, 1909. Dr. Paul Alexandre Collection, Paris.

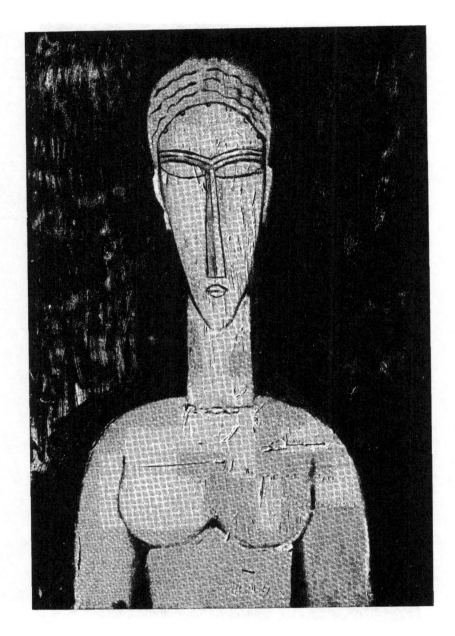

24. Egyptian Bust, 1909. Private Collection, Paris.

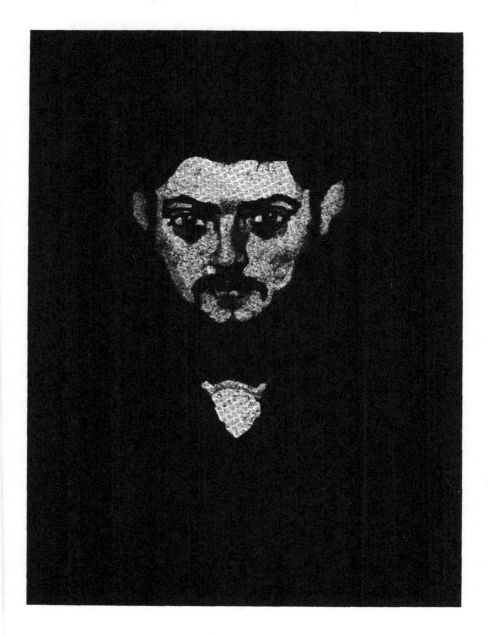

25. Portrait of Maurice Drouard, 1909-1910. Dr. Paul Alexandre Collection, Paris.

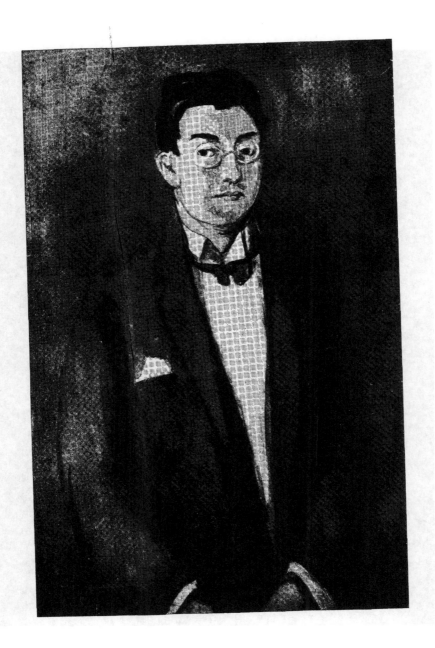

26. Portrait of R. Chantérou, 1911-1912. Marchesini Collection, The Hague.

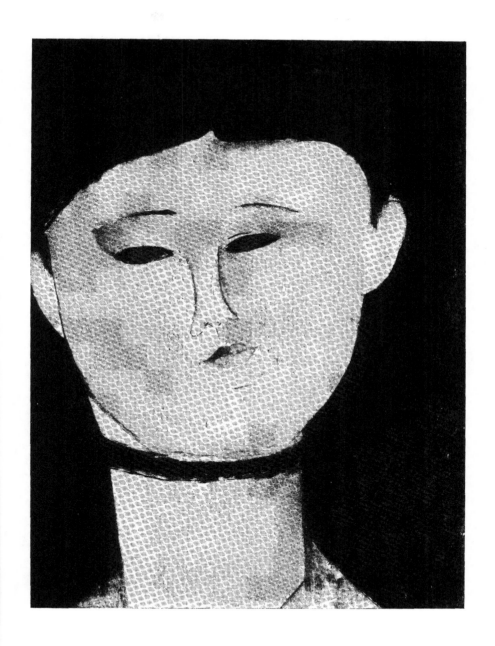

27. Head of a Woman, 1912-1913.

28. Portrait (José Pacheco?), 1913-1914.

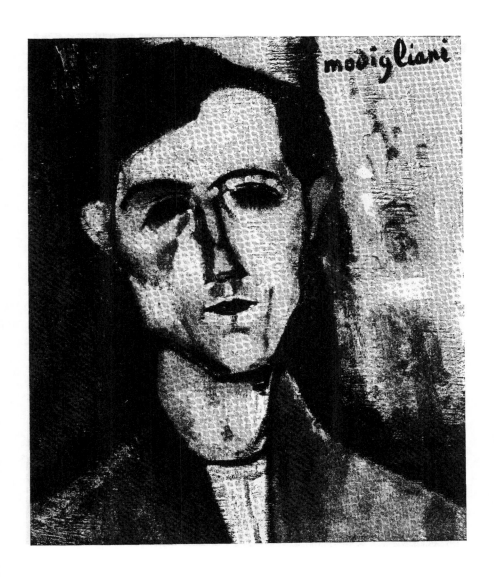

29. Portrait (José Pacheco?), 1913-1914.

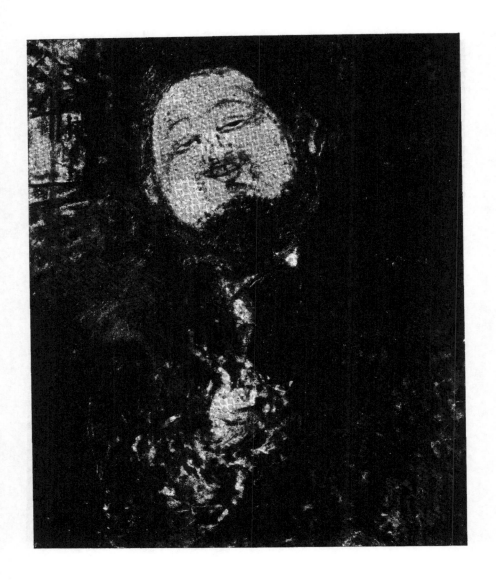

30. Portrait of Diego Rivera, 1914-1915. Museu de Arte, Sao Paulo.

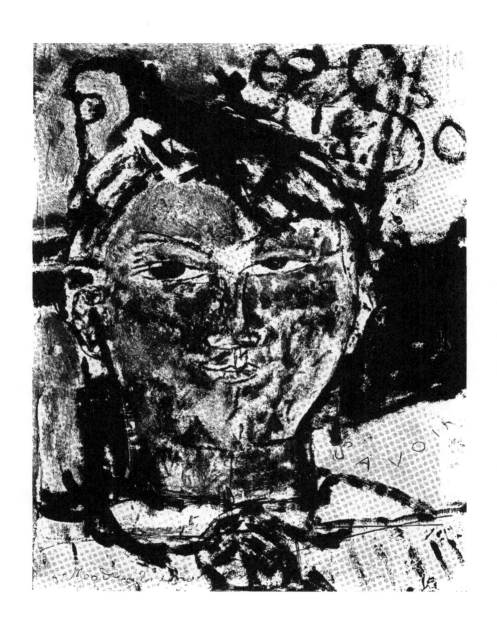

31. Portrait of Pablo Picasso, 1915. Georges Moos Collection, Geneva.

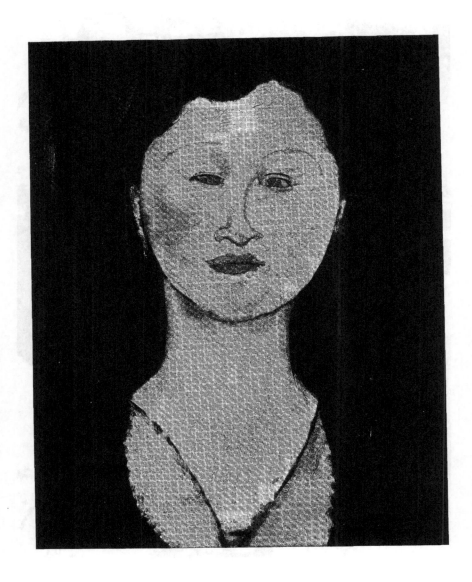

32. Head of a Woman, 1913-1914.

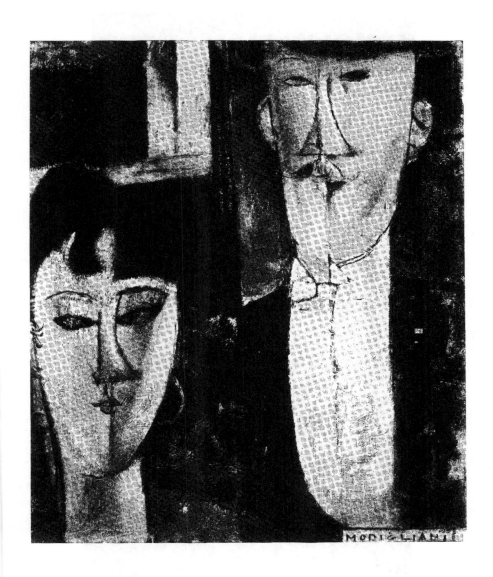

33. Bride and Groom, 1915-1916. Collection Museum of Modern Art, New York.

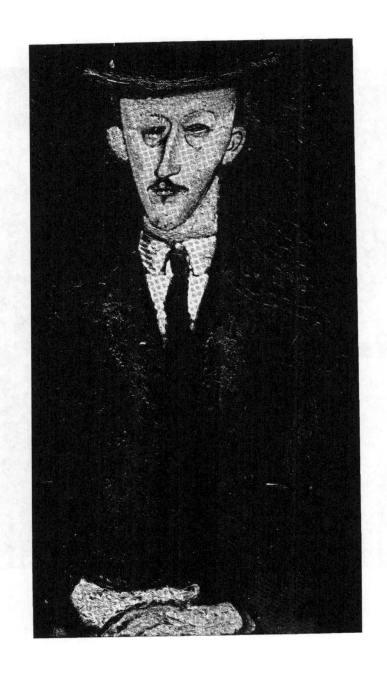

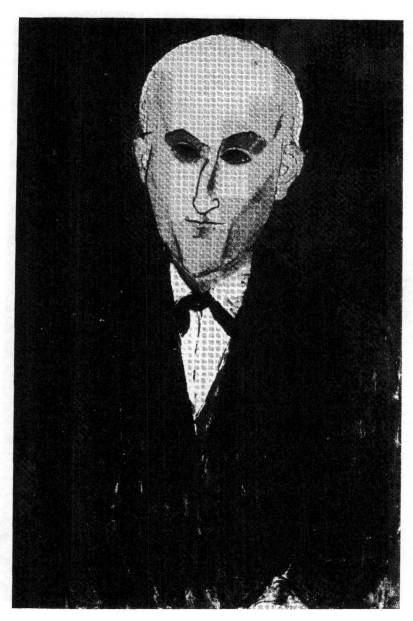

35. Portrait of Max Jacob, 1915-1916. H. P. Roché Collection, Paris.

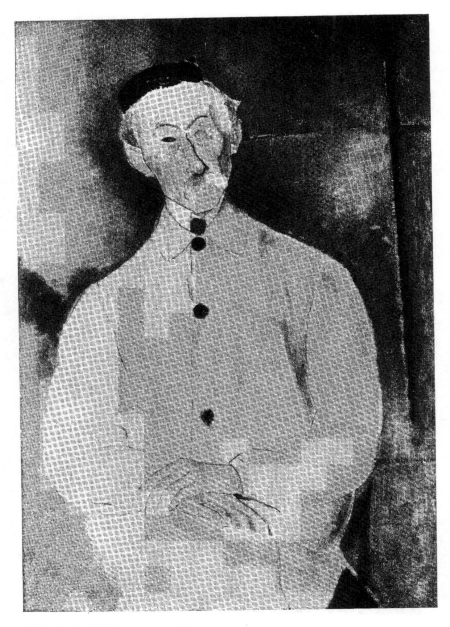

36. Portrait of M. Lepoutre, 1916.

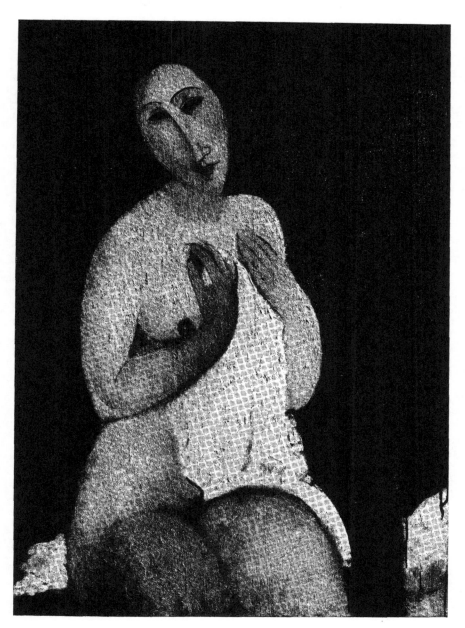

37. Nude with a Blouse, 1916.

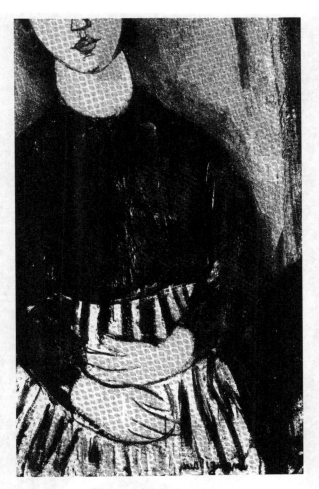

rl, 1916. Private Collection, Paris.

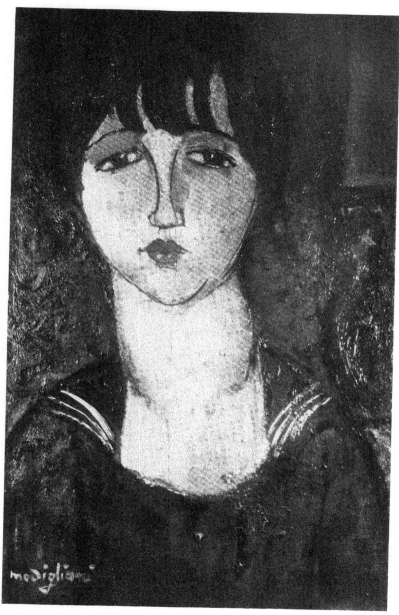

39. Portrait of a Young Girl, 1916. Toso Collection, Venice.

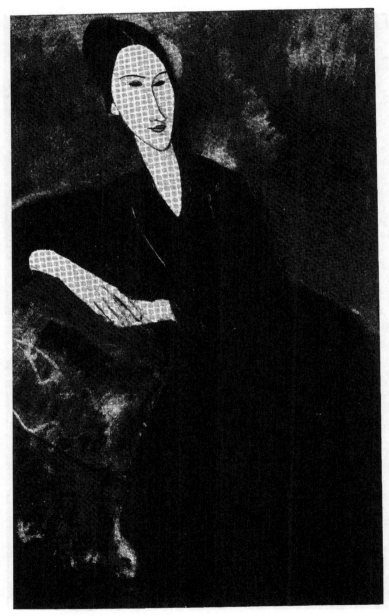

Portrait of Anna Zborowska, 1917. Collection Museum of Modern Art, New Y

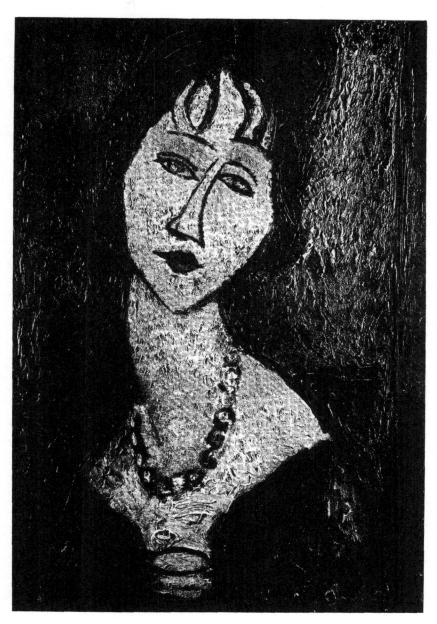

41. Woman with a Necklace (Portrait of Jeanne Hébuterne), 1917.
R. Eichholz Collection, Washington.

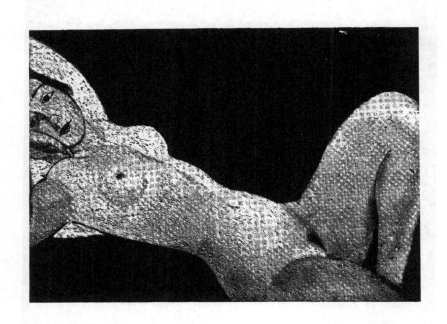

Lying on a Sofa, 1917?, Private Collection, Paris.

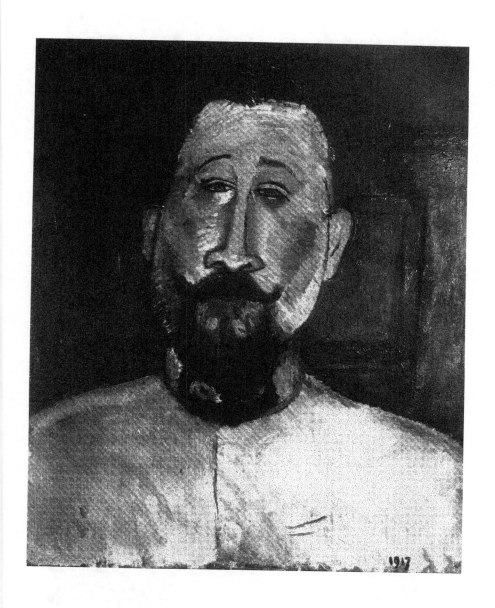

43. Portrait of Dr. Devaraigne, 1917. John W. Garrett Collection, Baltimore.

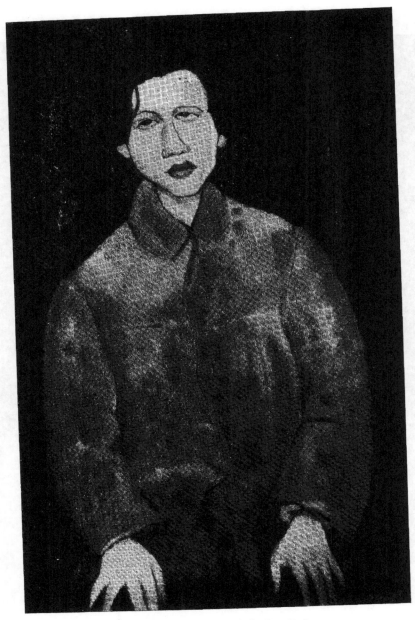

44. Portrait of Chaim Soutine, 1917. Private Collection, Paris.

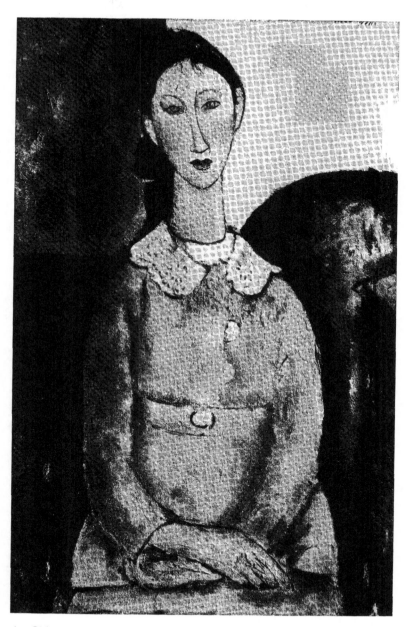

45. Girl with Lace Collar, 1917. Private Collection, Paris.

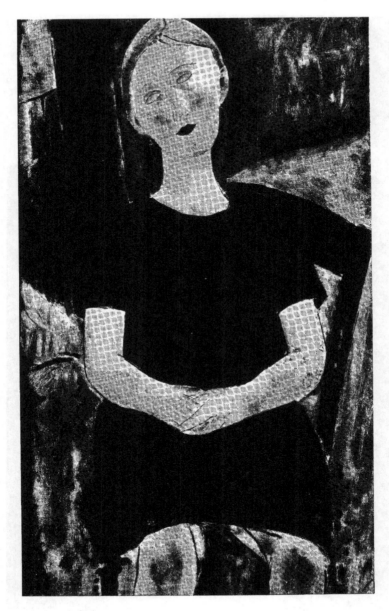

46. Seated Girl, 1917-1918.

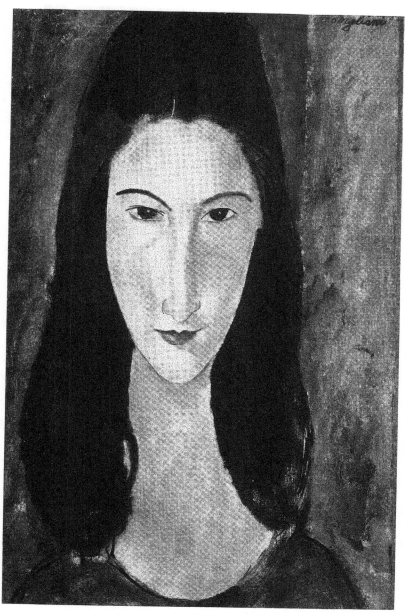

47. Portrait of a Young Woman, 1918. Private Collection, United States.

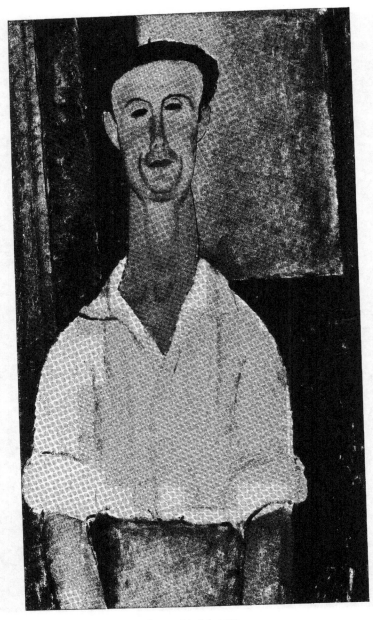

48. Portrait of the Actor Gaston Modot, 1918.

49. Portrait of a Bald Man, 1918. Private Collection, Paris.

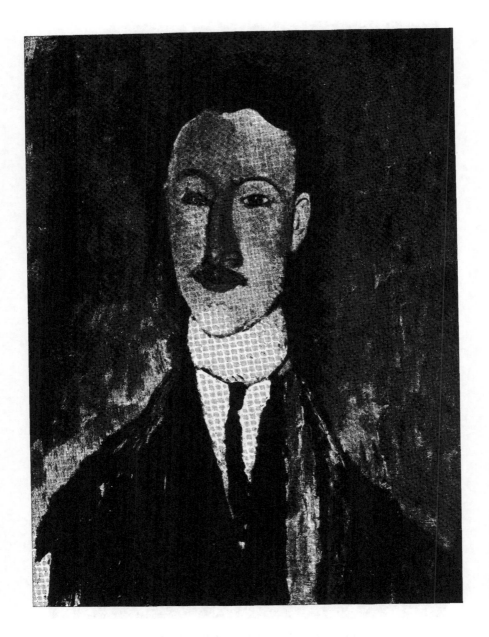

50. Portrait of Leopold Survage, 1918. Atheneum Museum of Art, Helsinki.

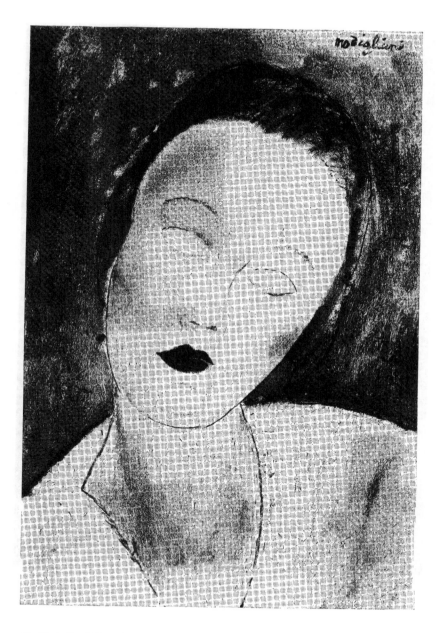

51. Portrait of Germaine Survage, 1918. Private Collection, Paris.

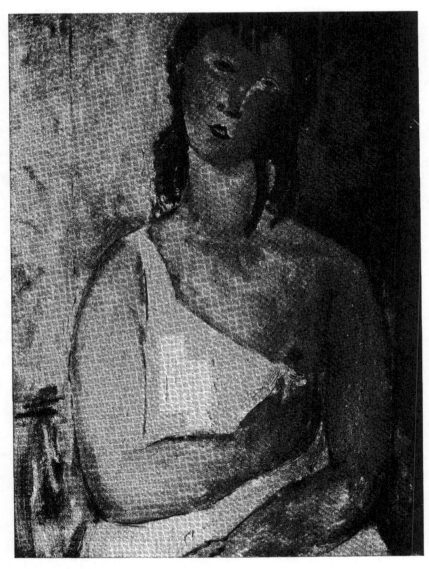

52. Medici Nude, 1918. Private Collection.

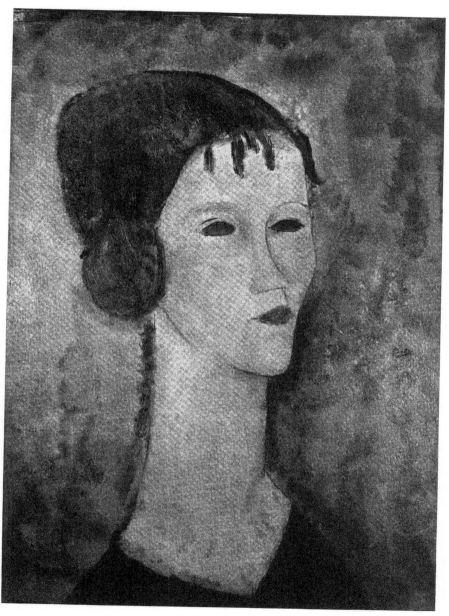

53. Portrait of a Woman, 1918. Private Collection, Paris.

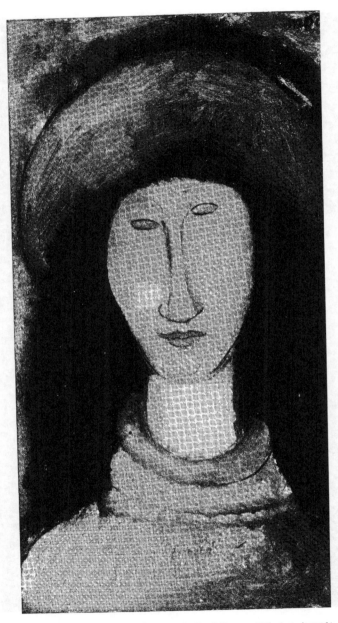

54. The Young Swedish Girl (Portrait of Jeanne Hébuterne), 191&
Lévy Collection, Troyes.

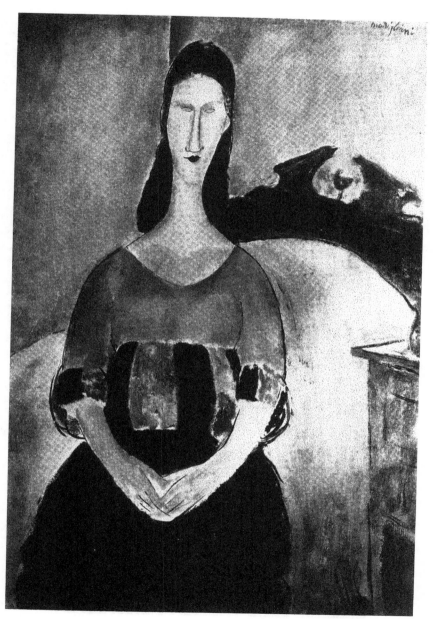

55. Portrait of Jeanne Hébuterne, 1918.

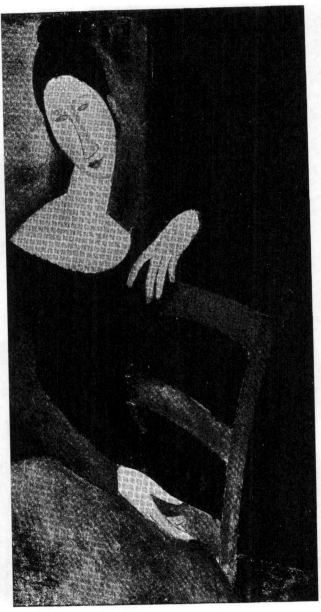

...nne Hébuterne. 1918. Collection of Mr. and Mrs. Bernard J. R...

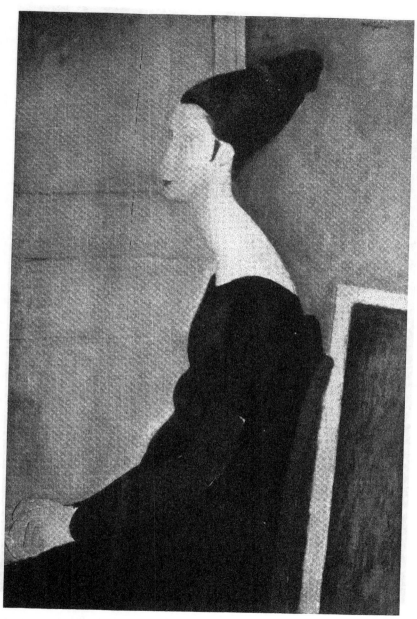

57. Portrait of Jeanne Hébuterne, 1918. Private Collection, Paris.

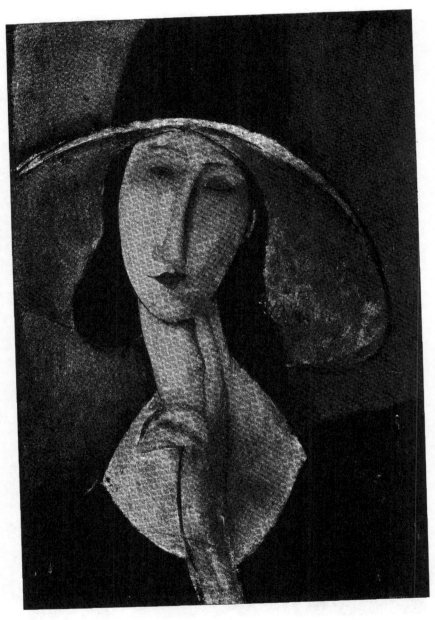

58. Portrait of Jeanne Hébuterne with a Cloche Hat, 1918-1919. Belien
Collection, Brussels.

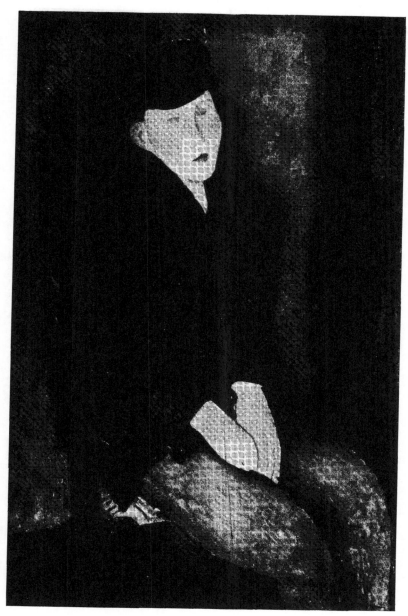

59. Seated Boy, 1918-1919. Private Collection, Paris.

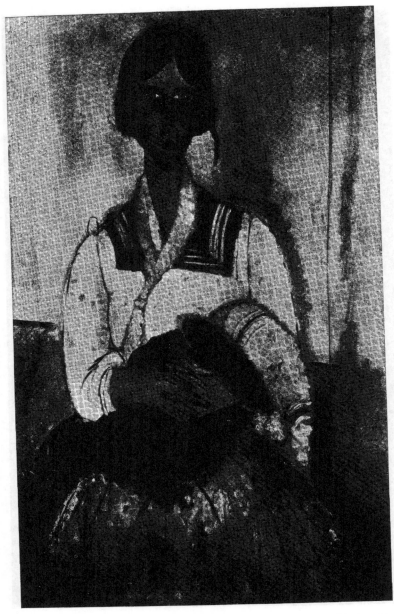

60. Gypsy Woman with Baby, 1919. National Gallery of Art, Washington, D. C.

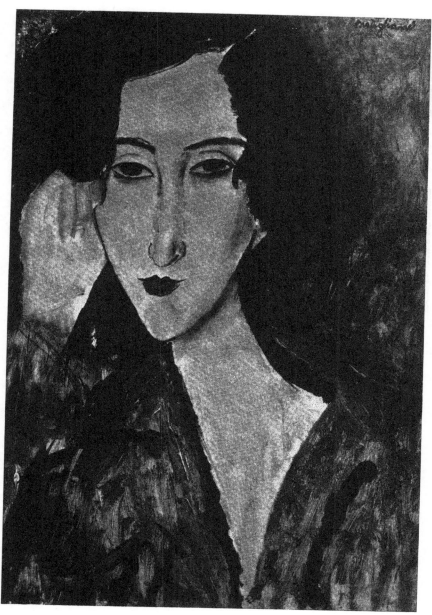

61. Portrait of Rachel Osterlind, 1919.

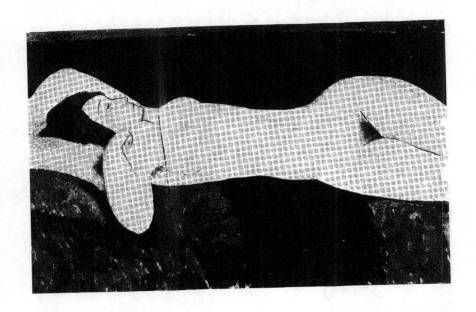

Reclining Nude, *c.* 1919. Collection The Museum of Modern Art, New York.

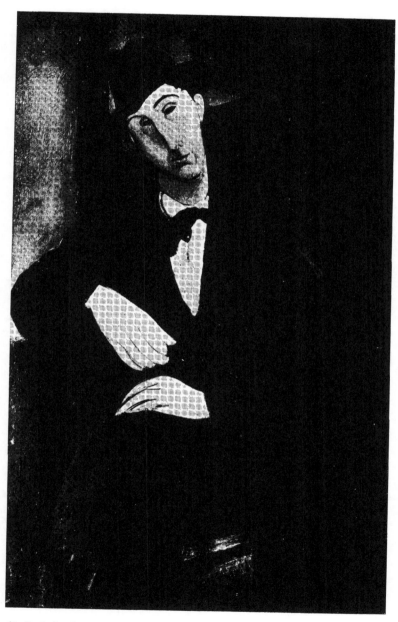

63. Portrait of Mario, 1920. Dr. Franz Meyer Collection, Zurich.

Sculpture

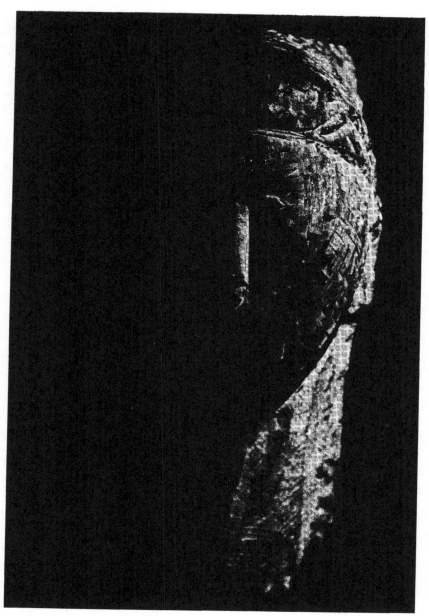

64. Head, 1910-1911. Stone.

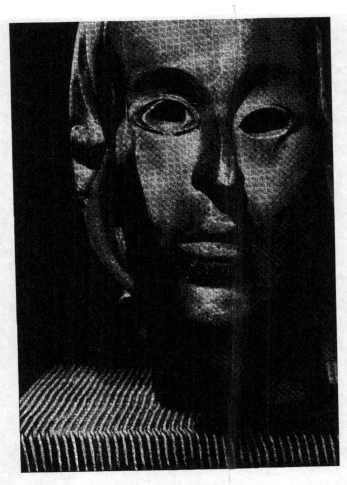

65. Head, 1906?. Private Collection, Paris.

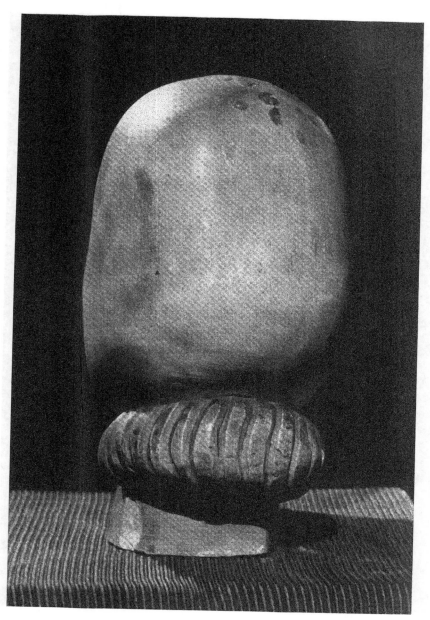

66. Same, seen from behind.

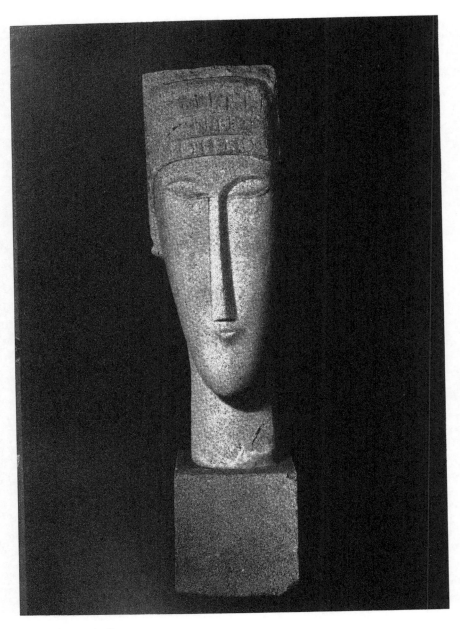

67. Head, 1910?. Stone.

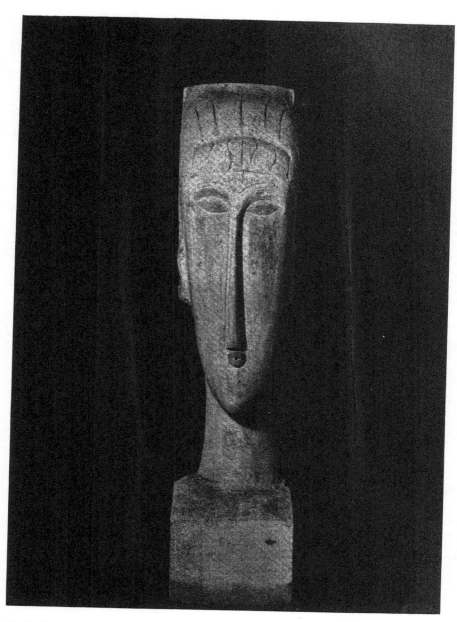

68. Head, 1910?. Stone.

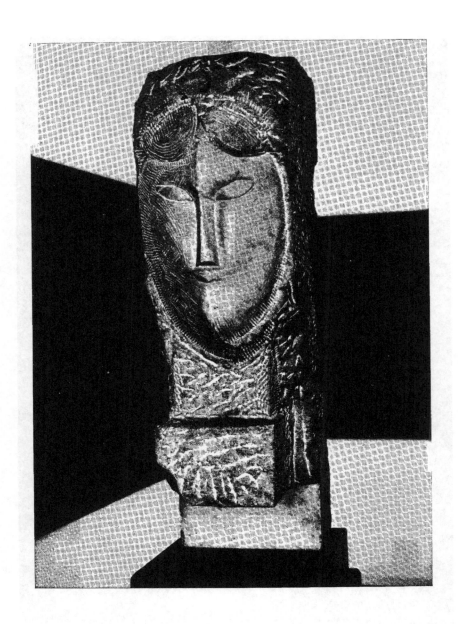

69. Head, 1912. Stone. Musée d'Art Moderne, Paris.

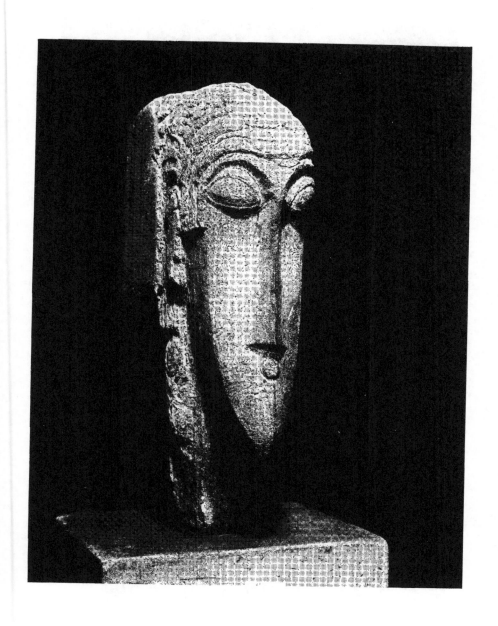

70. Head, 1915?. Stone. Collection The Museum of Modern Art, New York.

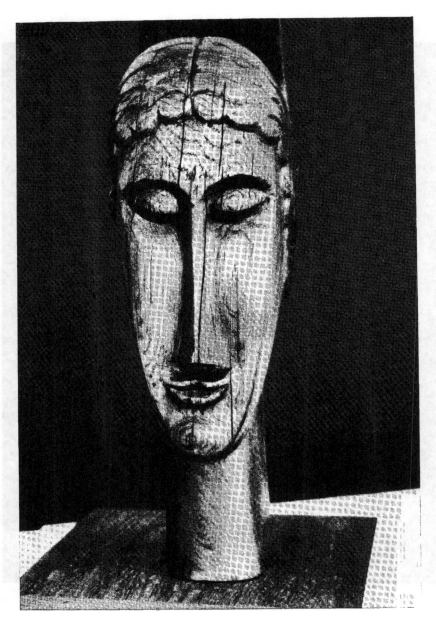

71. Head, 1912-1913. Oak. Private Collection, Paris.

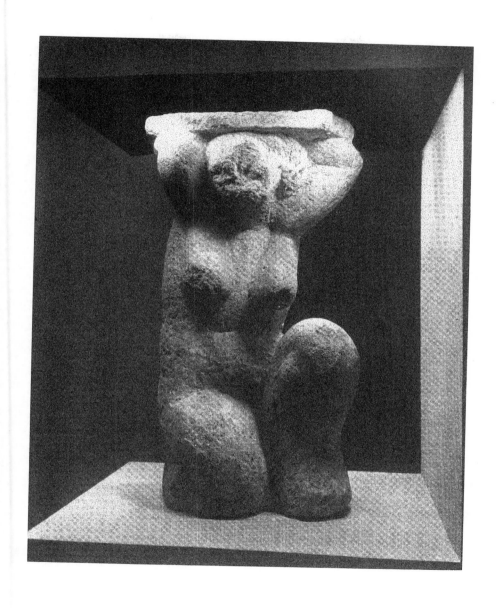

72. Caryatid, *c.* 1914. Limestone. Collection Museum of Modern Art, New York.

Drawings

73. Portr

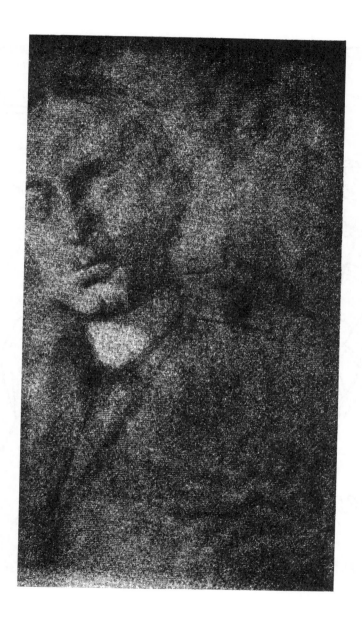

, 1905.

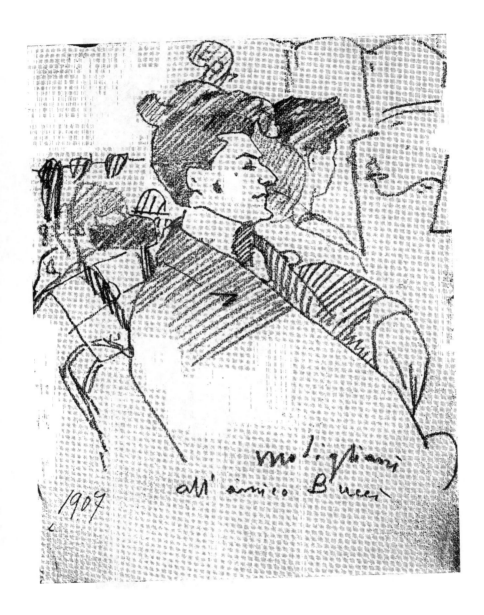

74. Portrait of Mario Buggelli, 1907. Property of Maria Bucci, Monza.

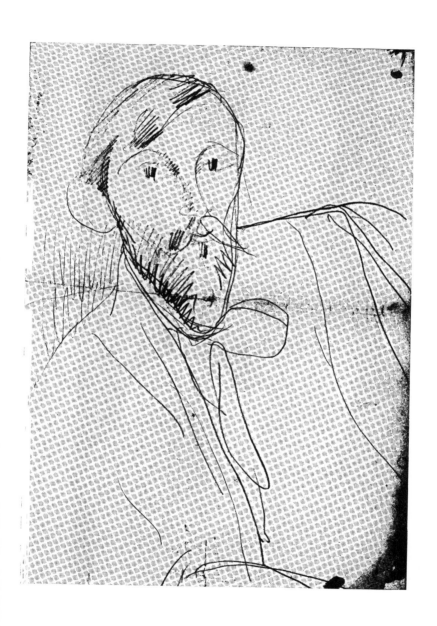

75. Portrait of Piquemal, 1910. Property of the author.

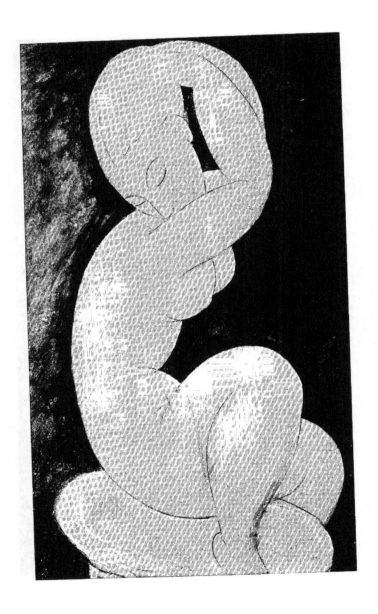

76. Caryatid, ?. Gouache. Private Collection.

77. Caryatid, ?. Private Collection, Paris.

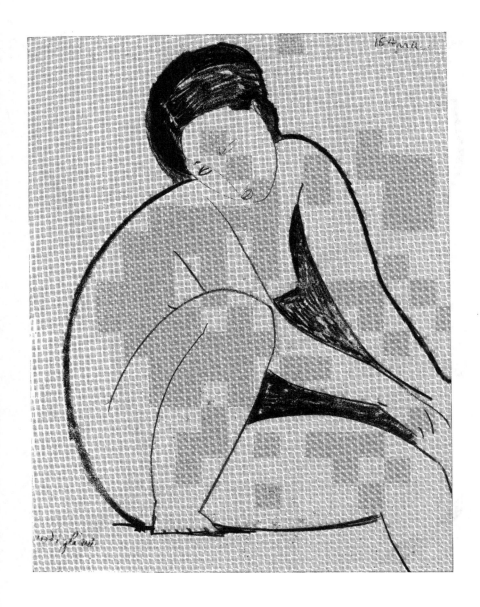

78. Nude, 1914. Giovanni Scheiwiller Collection, Milan.

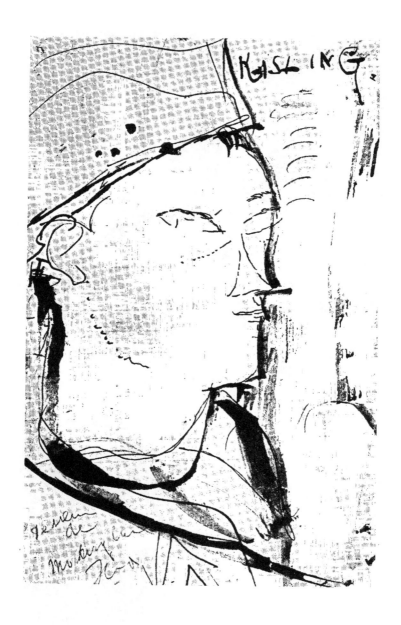

79. Portrait of Kisling, 1915. Galerie Jourdain, Paris.

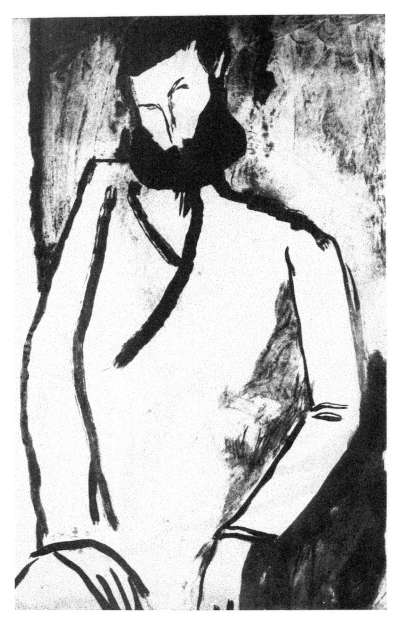

80. Portrait of Kohler.

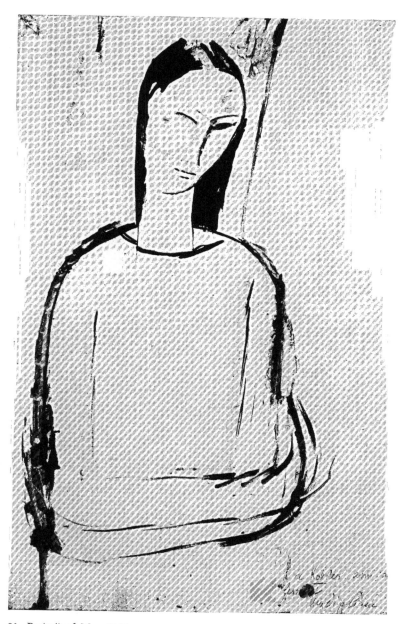

81. Portrait of Mrs. Kohler.

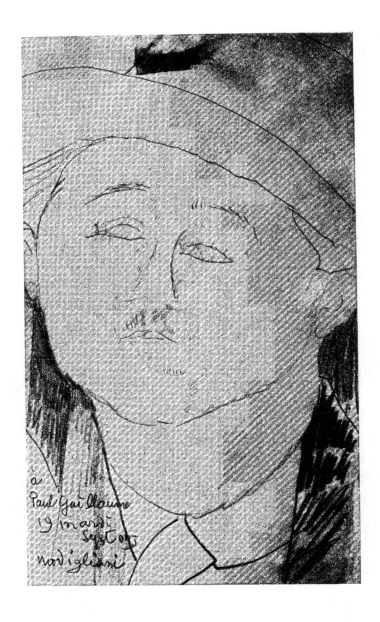

82. Portrait of Paul Guillaume, 1915.

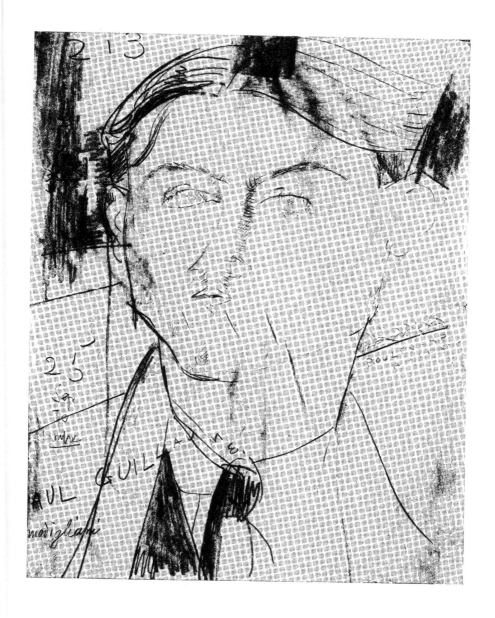

83. Portrait of Paul Guillaume, 1915.

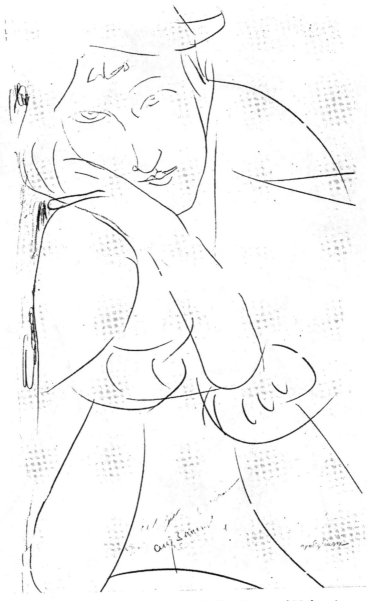

84. Woman's Head on Hand, 1914-1918?. Collection Museum of Modern Art, New York.

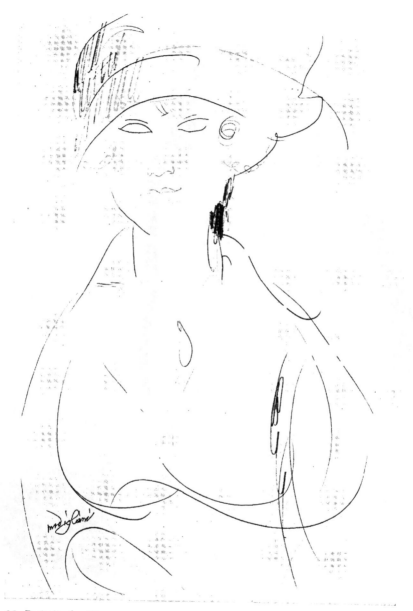

85. Portrait of a Woman, 1914-1918?. Collection Museum of Modern Art, New York.

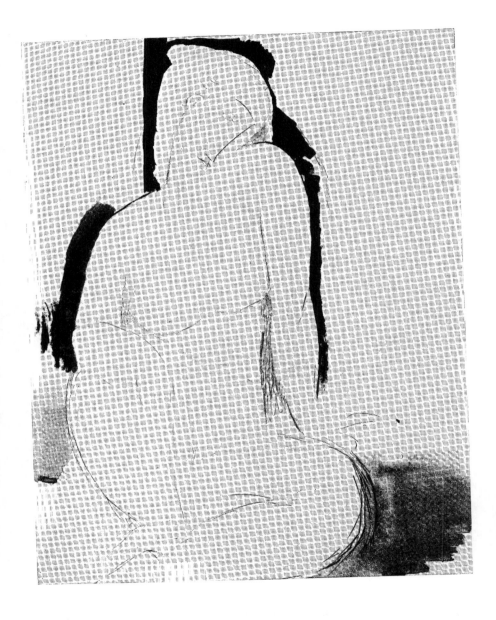

86. Seated Nude, *c*. 1914?. Collection Museum of Modern Art, New York.

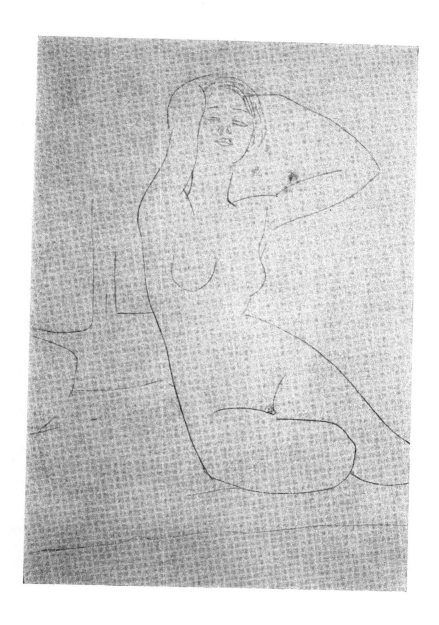

87. Seated Nude, *c.* 1918. Collection Museum of Modern Art, New York.

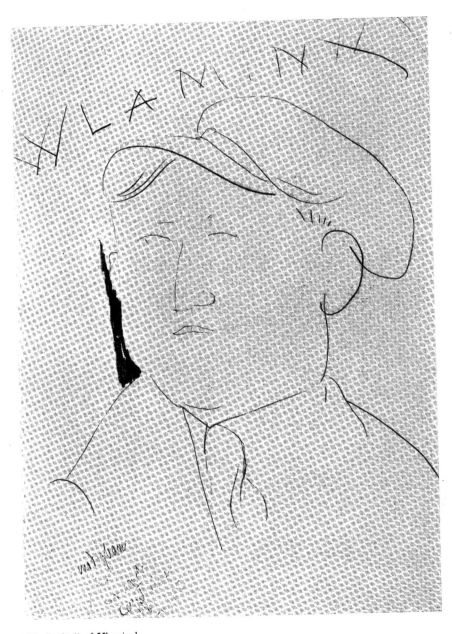

88. Portrait of Vlaminck.

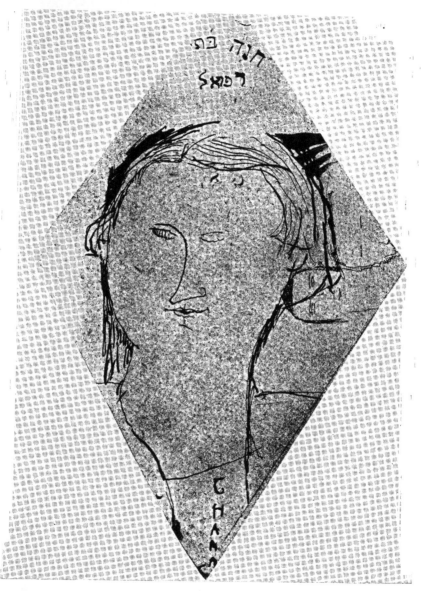

89. Portrait of Chana Orloff. Property of Chana Orloff.

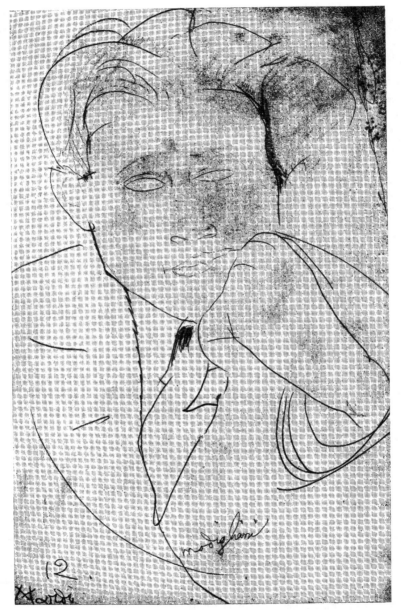

90. Portrait. Property of Chana Orloff.

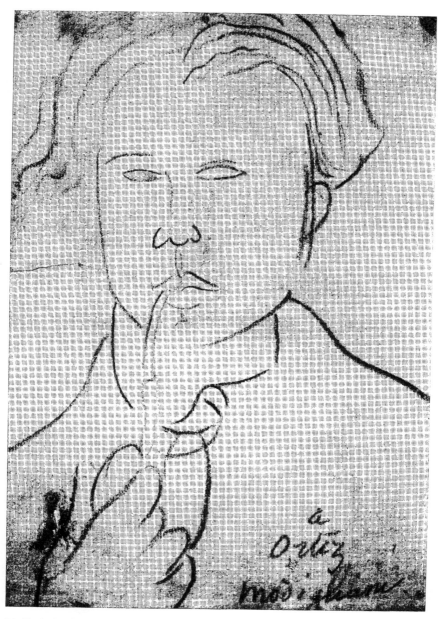

91. Portrait of Ortiz de Sarate.

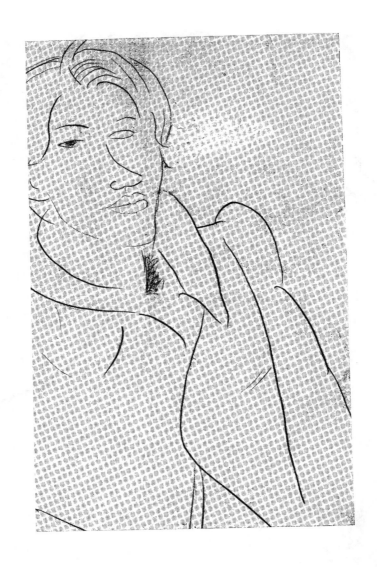

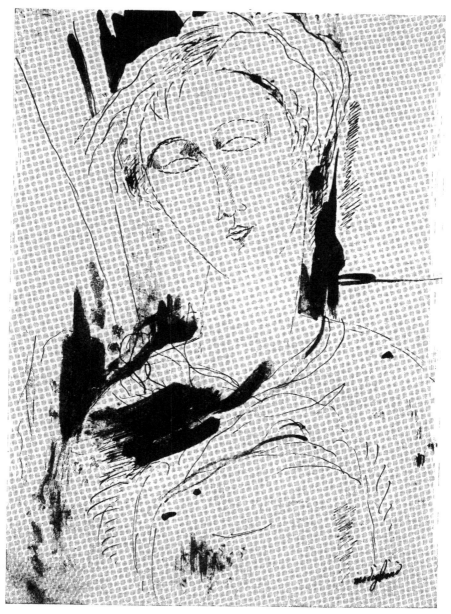

93. Head of a Woman.

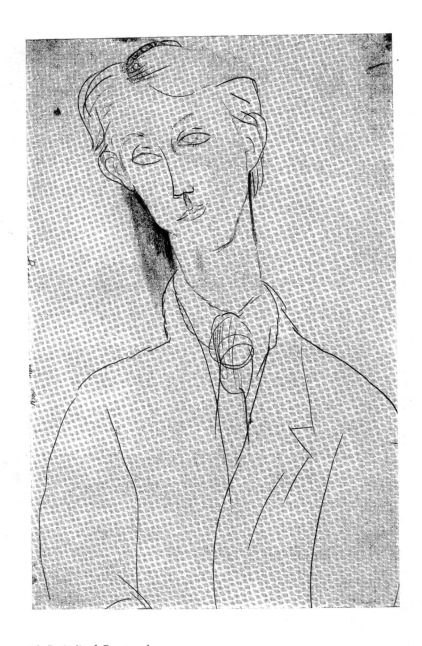

94. Portrait of Bernouard.

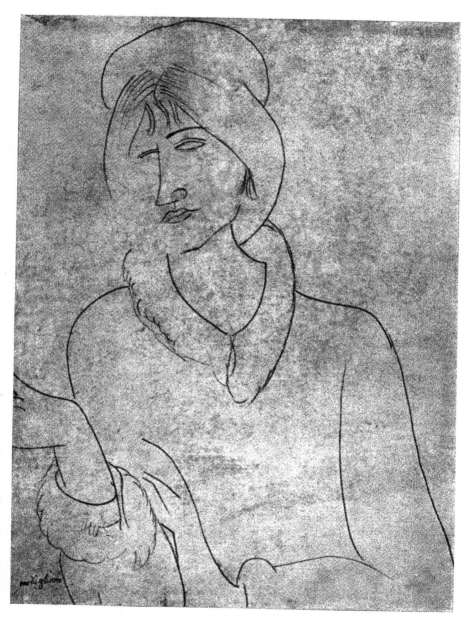

95. Portrait of Jeanne Hébuterne, 1917-1918.

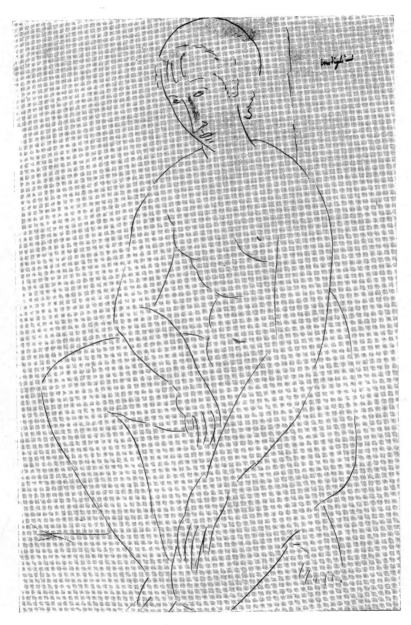

96. Nude, 1918?. J. W. Alsdorf Collection, Chicago.

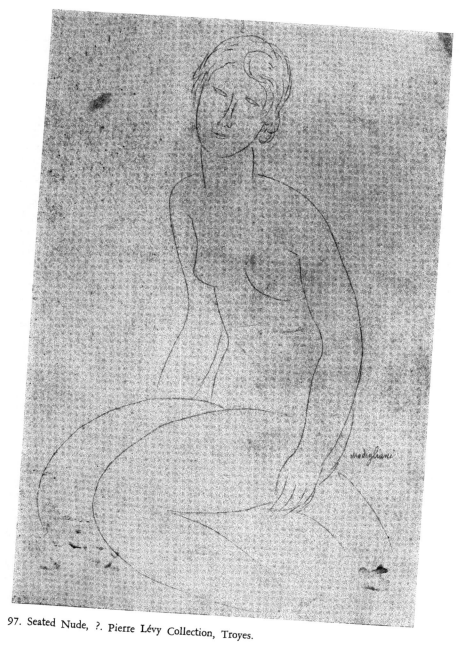

97. Seated Nude, ?. Pierre Lévy Collection, Troyes.

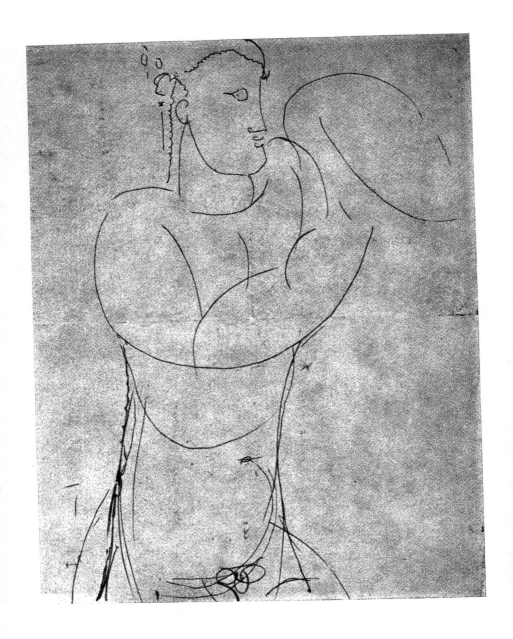

98. Nude with Raised Arm, 1918. Private Collection, Paris.

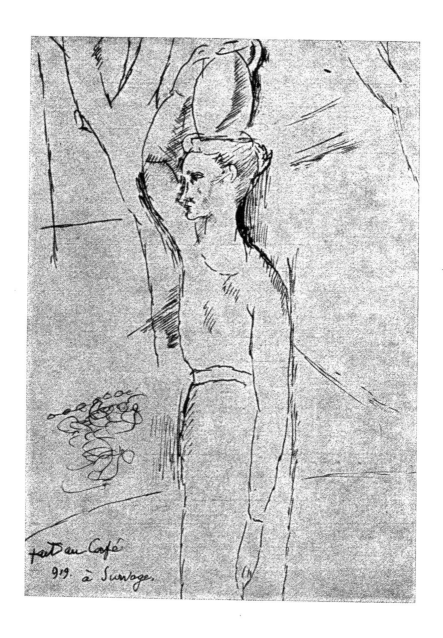

99. Water Carrier, 1919. Survage Collection.

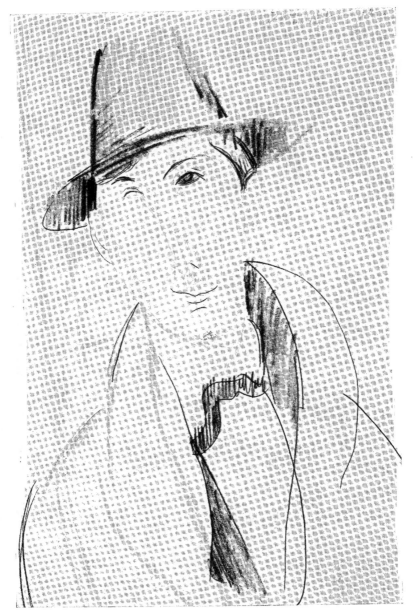

100. Man with a Hat (Study for Mario), 1920. Collection Museum of Modern Art,
New York.

This volume was first published in 1958
by The Orion Press, Inc., New York.

The text was printed by Stabilimenti Grafici Vallecchi, Florence.

Illustrations by A. Conti & Figli, Florence;

plates engraved by Altimani, Milan.

Photographs by Arlette Rosa, Paris (Pls. 1-16, 53, 80, 81, 93); Galerie Charpentier,
Paris (Pls. 25, 31, 48, 61, 95); A. Frequin, The Hague (Pl. 26); Marc Vaux, Paris
(Pls. 27, 28, 30, 34, 35, 37, 44, 50, 82, 89, 92); J. and H. Bernheim-Jeune, Paris
(Pls. 29, 39, 41, 43, 46, 55, 60, 76, 96); Giraudon, Paris (Pls. 32, 47, 58); Collection
Museum of Modern Art, New York (Pls. 33, 40, 62, 70, 72, 84, 85, 86, 87, 100);
L'Illustration, Paris (36, 52); A. Godin, Troyes (Pls. 54, 97), Jacques, Marseilles
(Pls. 69, 71); Gianni Meri, Milan (Pl. 74)

Lightning Source UK Ltd.
Milton Keynes UK
UKHW02f1100271117
313424UK00006B/702/P